KILN FORMING GLASS

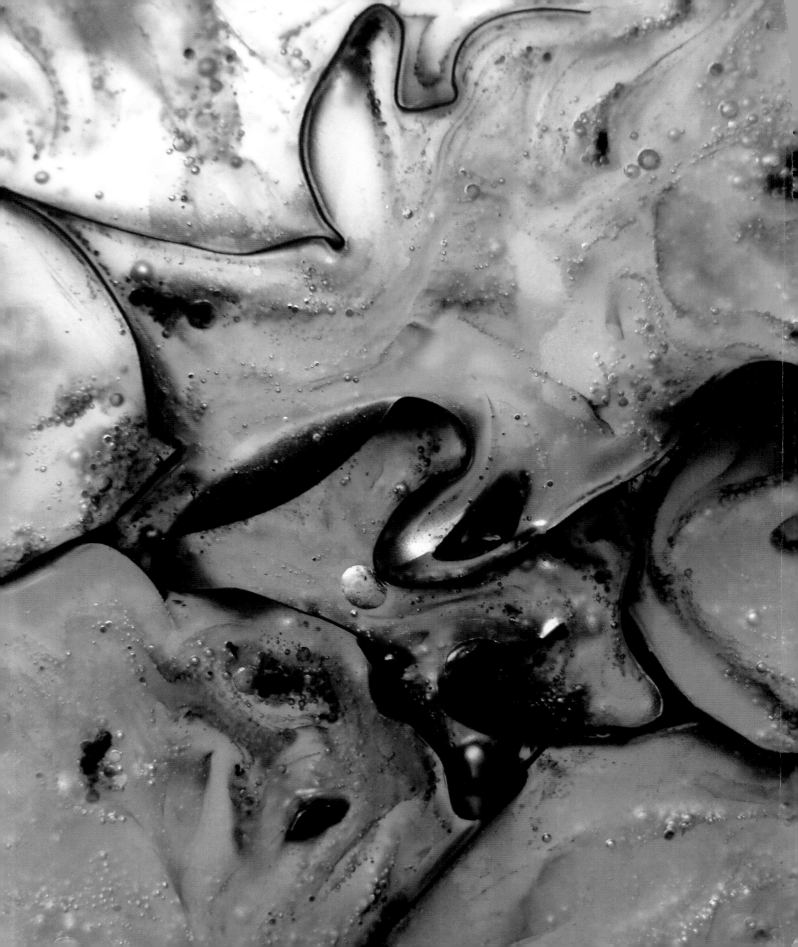

KILN FORMING GLASS

Helga Watkins-Baker

THE CROWOOD PRESS

First published in 2010 by
The Crowood Press Ltd
Ramsbury, Marlborough
Wiltshire SN8 2HR

www.crowood.com

British Library Cataloguing-in-Publication Data
A catalogue record for this book is available from the British
Library.

ISBN 978 1 84797 176 0

Cover credits
Front cover (top): 'Synergy Series', Cathryn Shilling, kiln-formed
glass, H: 50cm, W: 50cm, D: 10cm (each piece) (Photograph
by Ester Segarra); front cover (bottom): 'Waterscape', Karen
Lawrence, 2008, kiln-formed glass; fused, etched, textured float
glass, gold leaf, L: 5.5m, W: 1.5m, commission for Guy's and
St Thomas' Charity, sited at Bereavement Centre, St. Thomas'
Hospital, London (Photograph by John Haxby @ The Art Surgery).
Back Cover (bottom left): 'Inner Ombrae', Fiaz Elson, 2008, kiln-
cast optical glass with veils, cut and polished, L: 40cm, D: 9cm,
H: 34cm; back cover (bottom right): Photograph courtesy of the
Liquid Glass Centre.
Front Flap: 'The Ghost of Taxis Yet to Come' (Detail), Rachel
Elliot, lost wax kiln cast, lead crystal, L: 5.5cm, D: 2cm, H: 2cm
(Photograph by Ester Segarra).

Frontispiece: 'Starlight' (Detail), Helga Watkins-Baker,
kiln-cast glass, copper inclusions.

Typeset by Servis Filmsetting Ltd, Stockport, Cheshire
Printed and bound in Malaysia by Times Offset (M) Sdn Bhd

CONTENTS

ACKNOWLEDGEMENTS

I would like to thank Anthony Rogers and Maureen Scott for proof reading. Thanks also go to Thomas and Kim Atherton at the Liquid Glass Centre for their help and the students at LGC for the use of photographs of their work; to Jill Thomas-Clark and Mary Chervenak at the Corning Museum of Glass; and to Mary Kay Nitchie at Bullseye.

And a big thank you to the artists who have contributed images of their work to the book: Kim Atherton, Kim Bramley, Jackie Calderwood, Sabrina Cant, Penny Carter, Vanessa Cutler, Sally Dunnett, Rachel Elliot, Fiaz Elson, Joseph Harrington, Crispian Heath, Adam Hussain, Tlws Johnson, Amanda Lawrence, Karen Lawrence, James Maclachlan, Gail Matthias, Joanne Mitchell, Tolly Nason, Lisa Pettibone, Tania Porter, David Reekie, Colin Reid, Steve Robinson, Bruno Romanelli, Paula Rylatt, Ruth Shelley, Cathryn Shilling, Debbie Timperley, Margareth Troli, and Kylie Yeung.

DEDICATION

To Anthony, Astrid, Silvana and Orla

INTRODUCTION

Kiln-forming is the process of heating glass in a kiln until it becomes malleable enough to melt together or flow into a mould. This book will show you the practical steps you will need to take to undertake these and many other aspects of kiln-forming, providing clear and accurate information which will shortcut trial-and-error. The techniques will be outlined and discussed in a logical progression throughout the next few chapters, with practical hands-on projects which can be followed, so that a full understanding of basic through to advanced procedures can be achieved. The projects which are detailed are intended to provide guidelines for specific techniques, while encouraging your own creativity in glass rather than being prescriptive about the exact design.

The techniques will cover the full range of methods available in the sphere of 'warm glass', as it has come to be termed, from fusing and slumping through to kiln-casting, lost-wax casting and pâte de verre. The term 'warm glass' refers to the fact that kiln-forming glass generally involves working with the glass in the temperature range of around 650–900°C, as opposed to 'cold glass' (where the glass might be etched, engraved or manipulated in its cool ambient state) or 'hot glass' (where it is blown or shaped at anything above 1100°C, direct from a furnace).

The phrase 'warm glass' is useful, because it allows us to begin to understand a quality unique to glass, which is its gradually decreasing viscosity as it becomes hotter. In other words, as it becomes hotter it also becomes more fluid. An understanding of this and many other technical aspects of glass are essential tools for the prospective kiln worker.

The chapters will look at the range of kiln-forming or 'warm

OPPOSITE PAGE:
'Balance', Helga Watkins-Baker, kiln-cast glass, copper inclusions, Dia: 18cm.

glass' techniques, from fusing and slumping through to basic open-faced moulds for kiln-casting, lost-wax casting, and other advanced methods as well as, most importantly, firing techniques and schedules for glass, and the finishing or cold working of forms, i.e. cutting, grinding and polishing. This as a whole will provide a solid grounding in the principles of kiln-forming glass. As you become familiar with the processes involved you will learn to work intuitively with the material, responding to the inner and outer landscapes of colours, patterns and forms in the glass. We will also look at the work of some of the most inspiring kiln-glass artists in the UK, showing the breadth and virtuosity of their artwork, as well as allowing us an insight into some of the techniques they employ.

When you first begin to work in glass you may find that the material itself is a great source of inspiration, with its wonderful translucency and colour, combined with its potential for pattern and texture, flowing and merging to create autonomous, vessel and sculptural forms. Many people are attracted to these special and unique qualities in kiln-formed glass. Looking for sources of inspiration for expressing ideas, patterns and forms through this distinctive medium is a key starting point for your development as a glass maker, and the beginning of your journey through the various techniques and processes involved. Have a look at the major works created over the past two centuries by some of the foremost glass artists around the world, and you will start to appreciate the amazing versatility of this material.

Keeping a sketch book in which you can jot down ideas is an essential part of beginning the creative process. Synthesize these ideas into essential forms and patterns to help create designs and models which are a good working point to start your glass pieces from. Look around for inspiration – nature can be one of the most stimulating sources for creative thinking. Thought-provoking activities such as taking rubbings and

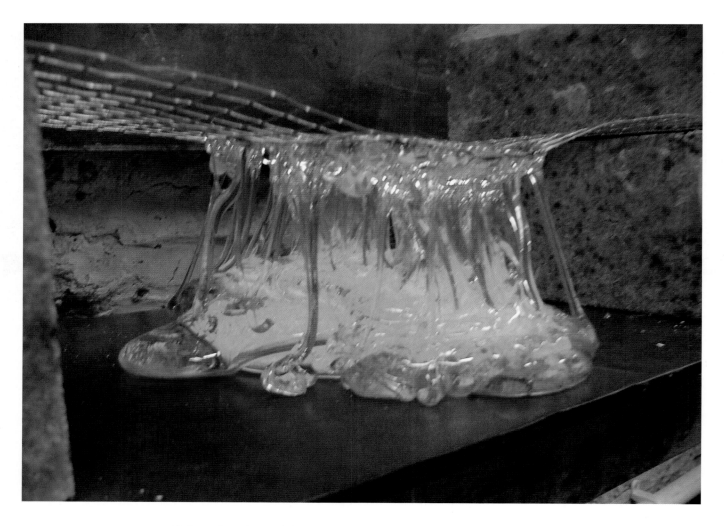

Molten glass slumped through wire mesh (Courtesy Liquid Glass Centre).

using found objects to print with can all contribute to the process.

For three-dimensional work it can be useful, after sketching and drawing, to make small maquettes (small scale models) in clay. By thinking about what you want to make in some detail before you start the actual making process, you will undoubtedly benefit from a clearer line of development in your work. But it is also worth pointing out that there is much to be learned from experimenting with the techniques of kiln-formed glass, in as many creative ways as possible – trying avenues you didn't think you wanted to explore, or new colours and forms, will help you to make progress and widen your creative range. Most of all, you should enjoy discovering the new possibilities and opportunities which working in kiln-formed glass will offer you.

For many years a mystique has existed around glass techniques in general, and kiln-forming in particular, mainly because information and new ways of working were closely guarded by those who 'discovered' them. In fact, as we shall see, many of these techniques have existed for hundreds if not thousands of years, and it has been more a case of rediscovery than discovery. The nature of this secrecy was, perhaps, more concerned with the sometimes laborious nature of the techniques – when it can take a long time to model, mould, fire and finish a complex or unusual piece of glass, there was a tendency to stand guard over the precise methods and procedures involved. Thankfully, these days the spirit of sharing such information prevails, and it is in this spirit that this book is written.

Inspiration from nature.

Creative mould-making.

Coloured glass.

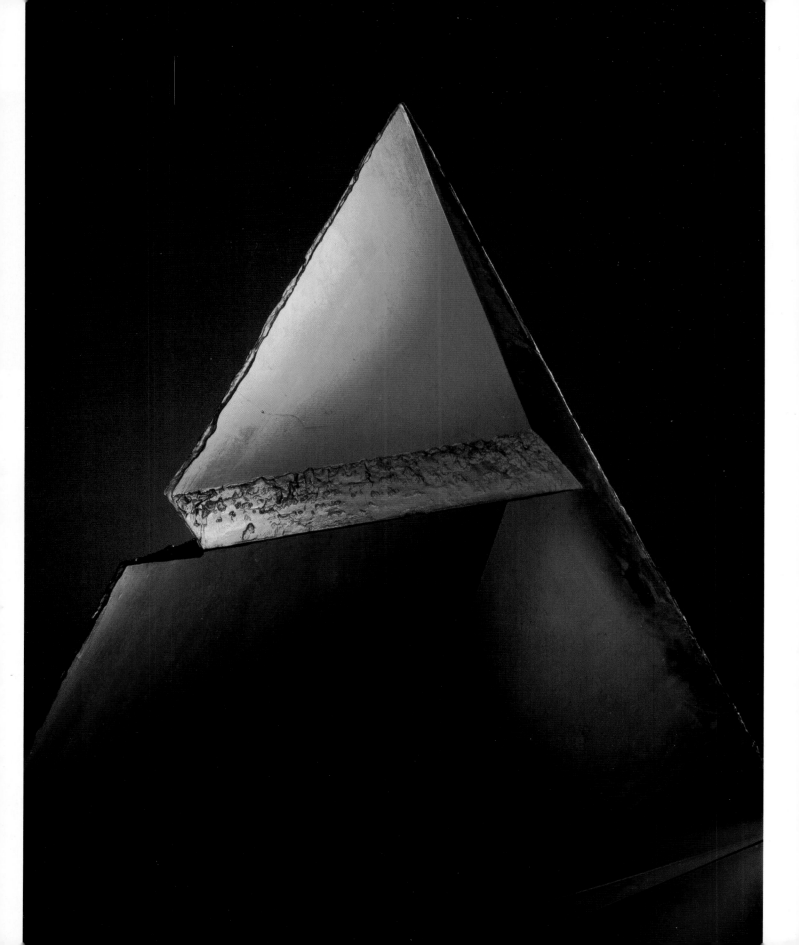

A SHORT HISTORY OF GLASS

Glass as it is used in the world today is an entirely synthetic, man-made material. This is may seem a surprising fact, especially when we gaze at a beautiful piece of cast glass, imbued with colour and the strata of bubbles and veils as the glass flows and melts together, all of which seem to echo natural processes and microcosms of nature.

The only naturally occurring forms of glass, created by natural or geological processes, are those which are formed as a result of a high-temperature incident, such as a volcano erupting, or lightning striking, causing rock to melt. If this is then quenched rapidly, before the atoms in the rock can rearrange themselves into the constituent minerals, then a glass is formed. Obsidian, a black volcanic glass, and fulgurites, formed when lightning strikes sand, are examples of natural glass. Somewhere along the line in humankind's history, perhaps whilst examining a fulgurite, we deduced that it was possible to produce this dense, crystalline material ourselves, using intense heat, sand and other materials, and hence glass as we know it was born.

Pliny, the Roman historian, has a more romantic version of the story. According to him, Phoenician merchants transporting stone discovered glass in the region of Syria around 5000BC. Pliny tells how the merchants, after landing their ships, rested cooking pots on blocks of saltpetre, a form of soda they had in their cargo, which they had placed by the fire because they couldn't find any rocks. With the intense heat of the fire, the blocks eventually melted and mixed with the sand of the beach to form a translucent liquid, which then solidified into glass. This story does give us the prerequisites for glass – silica (sand), soda (also achieved with plant ash) and lime in the sand. The soda (or plant ash) was used as a flux, and the lime ensured the stability of the glass. Although we now know that the Mesopotamians and Egyptians were making glass before the Phoenicians, it is true that the Phoenicians were probably the first people to widely transport and trade in objects made from the material.

Glass fulgurite, formed by lightning strike (Courtesy Darby Dyar, Mars Mineral Spectroscopy Database).

OPPOSITE PAGE:
'Red Pyramid', Stanislav Libensky (1921–2002) and Jaroslava Brychtova (b. 1924), Czech Republic, Zelezny Brod, 1993, mold-melted, H. 83.9cm (Collection of The Corning Museum of Glass, Corning, NY, gift of the artists; 94.3.101).

Obsidian, volcanic glass (Courtesy of Mila, GNU Free Documentation License).

So the more likely story is that glass was discovered around 3500–3000BC in Egypt or Mesopotamia. It may be that at first glass was used as the glaze on clay pots, but by 1500BC a logical leap had been made into producing glass objects by the 'core-forming' method. This involved dipping a core mould into molten glass so that it covered the core, with the glass then being smoothed down, and decorations made in the glass whilst still hot and soft. The glass being produced at this time was not transparent, or in any way as refined as we know it today. It was opaque, and was viewed more as a material that could be used to produce objects which imitated vessels then in use, such as clay pots and vases, in much the same way as we use plastic now. It could also imitate precious stones, and so was used in jewellery and adornments. By this time colour had become one of the most important aspects of glass, and the creation of vivid colours, through the addition of metal oxides and complex heating, showed a hitherto unseen degree of skill and craft.

The glass furnace, the source of molten glass.

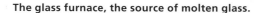

Core-formed glass vessels with applied thread decoration,
late 6th–5th century BC, possibly from Greece
(© Victoria and Albert Museum, London).

Core-formed glass, with applied thread decoration, mid
4th–3rd century BC, possibly from Italy
(© Victoria and Albert Museum, London).

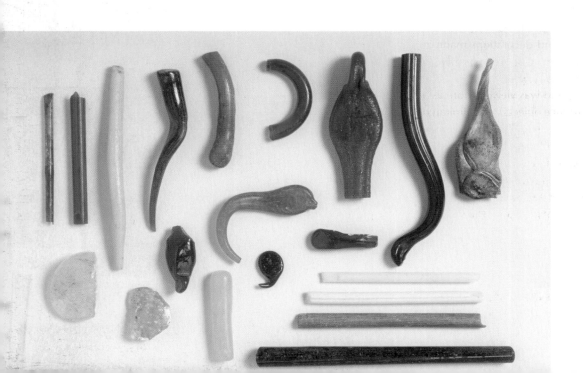

Glass manufacturing waste,
1353–1335BC, Tel-el-Amarna,
Egypt (© Victoria and Albert
Museum, London).

KILN TECHNIQUES AND GLASSBLOWING

In terms of kiln techniques for glass during this early period, we can see much evidence of the use of moulds to form glass. The Egyptians were using shallow open moulds to melt glass grains into small cast pieces, used for jewellery or inclusions in other materials such as stone or wooden panels. In Mesopotamia we find the use of mosaic-type techniques to construct vessels with vivid and defined patterns as their decoration, from about 1400BC. This technique involved creating glass rods by drawing out the molten glass into canes, cutting these up, and then setting them into a mould in various patterns, with a softer crushed glass placed into the gaps. When supported on the inside with mould material, and fired in a kiln to effectively 'fuse', this technique becomes very similar to the way we fire *pâte de verre* work today. The Greeks took this technique to its height, making multi-coloured fused rod bowls, often formed as a two-firing process, fusing first, and then shaping by 'slumping' over or into a mould. The ability

to heat glass to different temperatures, to exploit the gradual viscosity of the glass, must have led to technological advances and discoveries. Indeed the use of glass was simply a matter of the heat used – hotter temperatures could be created to melt glass in crucibles for casting slabs and mosaic-type pieces, even ingots for trade; lower temperatures were used to cast and fuse glass.

The similarity to our use of plastic is most striking with the discovery of glassblowing in the first century BC, which was to utilize its 'plastic' nature to the utmost. This can almost definitely be claimed by the Phoenicians, but the true dawning of a new epoch in glass manufacture came under the Romans. The development of glassblowing involved heating glass to a much hotter temperature than before, to exploit the viscosity of the material so that it could actually be blown into a bubble, and therefore a significant degree of specialist knowledge about furnace building was required, something the Romans excelled at. For glassblowing, a hollow iron tube was used, about 1.5m long with a mouthpiece at one end and a bulge for holding molten glass at the other end. A blob of molten glass was collected on the bulged end and rolled into a suitable shape on a flat surface of iron or stone called the marver. This was then blown freely into shape, utilizing the skill of the glass blower, or into a mould, enabling more complex forms to evolve. Clearer glass was also achieved, with the discovery of the addition of manganese. The Romans took glassblowing

Core-formed glass flask with applied thread decoration, 1336–1213BC, Malkata or Tel-el-Amarna, Egypt (© Victoria and Albert Museum, London).

Composite cane for inlay, 1st century BC, Egypt (© Victoria and Albert Museum, London).

Glass bowl assembled from sections of cane, fused and slumped, mid 3rd–2nd century BC, Italy (© Victoria and Albert Museum, London).

Bowl, probably Eastern Mediterranean, late 2nd–1st century BC, multicoloured canes; fused, slumped, H: 7.3cm, D: 12.4cm (Collection of The Corning Museum of Glass, Corning, NY; 55.1.2). This bowl was probably formed by fusing slices of the canes into a disk and slumping the disk over a mould. Most of these objects have rims that were fashioned by spirally twisting threads of different colours to produce a striped effect.

to a technological highpoint, and it was the material of the age. Throughout the Roman world blown glass became very common. It has been suggested that it was more widely used than it is today, certainly in all contexts other than window glass.

In spite of the popularity of glassblowing, however, kiln techniques continued to be used and developed during the Greek and Roman periods. Glass had, after all, been utilized for two to three thousand years before glassblowing was discovered, the primary techniques revolving around kiln-forming, so it made sense to continue this tradition to achieve certain effects. More and more elaborate fused and slumped bowls and vessels were created, with complex cane and mosaic patterns incorporated. By the third century AD the Romans were casting elaborate glass bowls into moulds which, when

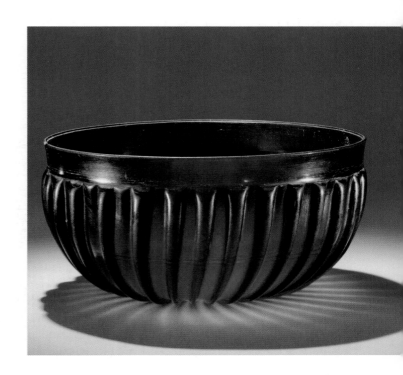

Bowl with Ribs, Roman Empire, about 50–75AD, translucent deep blue, cast, H: 9.7cm, D (rim): 19.8–20cm (Collection of The Corning Museum of Glass, Corning, NY, gift of Mrs. Joseph de F. Junkin; 67.1.21). Among the earliest and most numerous types of glass produced by the Romans were cast monochrome vessels. The glass was impressed, slumped, lathe-cut and polished.

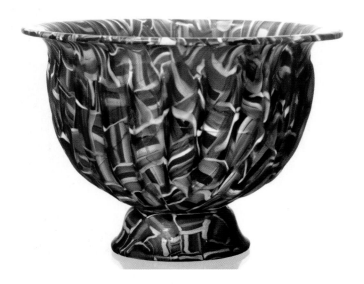

Mosaic glass bowl, fused and slumped, with applied foot, 25BC–50AD, Italy (© Victoria and Albert Museum, London).

and the small-scale production of glass vessels, as techniques and craftsmen disseminated throughout Europe, despite a code of secrecy being set up by the Venetian government.

By the seventeenth century glass was being produced throughout Europe, and some major technological innovations occurred. In the 1670s George Ravenscroft developed a recipe for a lead-based glass, producing a brilliant, crystal clear glass which was soft and malleable, easy to blow, and perfect for cold working. This led to a resurgence in the techniques of brilliant cutting and wheel engraving which had been largely neglected since the Roman period, now centred in Bohemia (now part of the modern Czech Republic) which had plentiful raw materials for glass production. This growing preference for cut and engraved glass vessels took over from the previous fashion for Venetian-type glass, and persisted into the nineteenth century to the threshold of the Industrial Revolution.

Elevation, interior, and use of glassmaking furnace, John Barrow, *Polygraph Dictionary*, London, 1735, vol. 1, plate 19 (Collection of The Rakow Library of The Corning Museum of Glass, Corning, NY; bib. 40940).

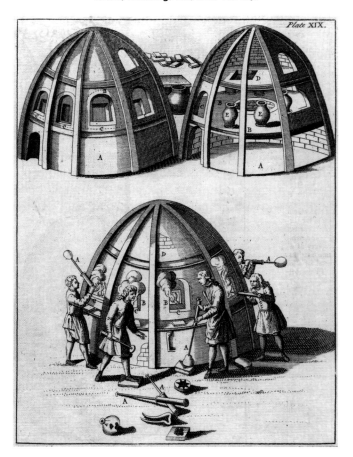

combined with the intricate cold working techniques they were capable of, involving grinding, cutting and polishing, produced objects which would be difficult to make today, perhaps impossible. However, these objects were being made for the rich, and in terms of labour intensity it was hard to compete with the speed and economy of glassblowing, and gradually the techniques and skill in kiln-forming died out. It was not until the nineteenth and twentieth centuries that we see the techniques of kiln-forming rise from the ashes of the Dark Ages, as the craft movement gained momentum in reaction to the mechanization of production seen during the Industrial Revolution.

During the Dark Ages (about 500–1000AD) glass continued to be explored and used – glassblowing flourished in Venice, where craftsmen rapidly developed the skills and proficiency of counterparts throughout the Mediterranean and further afield due to their wide-ranging trade routes. These Venetian wares were often decorated with gilding and enamelling, and defined the beginning of a new era for glassblowing techniques. Sheet glass was developed in the eleventh century as crown glass, made by spinning a large disc of molten glass, and refined over the next two centuries by the Venetians who came to produce it by blowing large glass cylinders which were cut at either end, and then split along the side, so that the glass unfurled into a sheet when reheated. Outside Venice the mid and later medieval periods in Europe became focused around the use of sheet glass for stained glass windows in churches

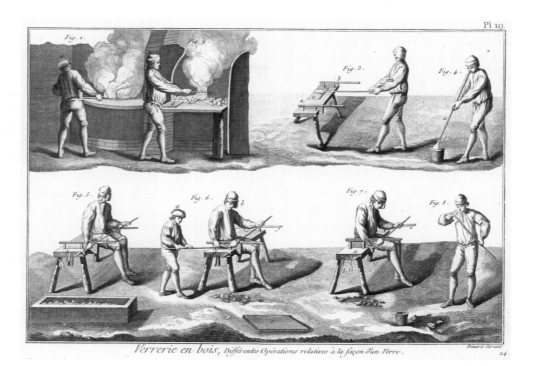

Crown Glass Factory, Denis Diderot (1713–1784), et al., *Verrerie en bois, différentes operations relatives à la façon d'un verre, L' Encyclopédie*, 1751–1772, engraving (Collection of The Rakow Library of The Corning Museum of Glass Corning, NY; bib. 95284).

KILN-FORMING IN THE MODERN PERIOD

The Industrial Revolution saw the development of processes for glass such as continuous furnaces and the mass production of bottles and containers. The rediscovery of many lost, ancient glass techniques in the nineteenth and twentieth centuries was a direct reaction to the loss of the handmade traditions and aesthetics of the preceding centuries, if not millennia, brought about by the mechanization of the processes of production. Kiln-formed glass techniques had lain dormant for almost two thousand years, but towards the end of the nineteenth century a renewed interest in the often laborious and highly specialized nature of this method of glass making was reborn. The techniques of *pâte de verre* and lost-wax casting were embraced by Art Nouveau artists in France such as Henri Cros, Albert Dammouse, Gabriel Argy-Rousseau, Amalric Walter, Emile Gallé and Rene Lalique, and in America by Frederick Carder. Whilst artists, such as Gallé and Lalique, began to mass produce objects of this kind, others remained true to the idea of hand-production, and most of all to the rediscovery, over years of experiment and trial, of these ancient techniques.

Pâte d'email bowl (enamel paste glass), Albert-Louis Dammouse, ca. 1900 (© Victoria and Albert Museum, London).

It was Henri Cros who could be said to be the first of these artists to fully explore the rediscovery and modern definition of *pâte de verre*. He had worked for many years with ceramics and wax, and started experimenting with glass while employed at the Sevres porcelain factory. After much experimentation he achieved success in packing glass powder or grains which were moistened, or mixed with a binder to form a sort of glass paste, into refractory moulds, and then firing in a kiln until the grains fused and became solid when cooled. The glass paste could be coloured with different oxides and laid into particular areas of the mould, to gain control of colour within the glass piece. He experimented at first with flat, bas reliefs and went on to produce more sculptural and three-dimensional works such as vases. Although his work did not reach the aesthetic heights of those who followed him, he was certainly the great innovator in kiln glass. There is usually quite a high failure rate with *pâte de verre* work, such as small voids in the fused glass, or sections which are too thin, so it is a testament to the patience of these artists that they managed to produce such accomplished work.

In the early years of the 1900s Gabriel Argy-Rousseau met Jean Cros, the son of Henri Cros, whilst at technical school, and learnt the technique of *pâte de verre* from him. He then went on to refine the process and in 1914 exhibited his first

Making *pâte de verre* (Courtesy Liquid Glass Centre).

designs. The colours he achieved, the accuracy of the moulds and castings, were instantly praised, and he went on to produce a range of vases, bowls, lamps and shades.

It is worth mentioning here that many of the pieces created by the *pâte de verre* process were opaque or translucent, because of the use of crushed glass. The characteristic appearance of an Art Nouveau piece of kiln-formed glass had this quality because the smaller the grains of glass used, the greater the surface area of the glass itself, and the more 'facets' it had, reducing transparency after melting. Also in true *pâte de verre* the glass is not being melted to a high level of viscosity, but fused, therefore the glass surface does not achieve liquidity, and stays granular. Translucent glass was usually achieved by firing the glass for longer, or to a higher temperature, which added some transparency to the glass surface. The glass itself could never achieve full transparency, however, because of the use of small particles, trapping air and reducing clarity.

Pâte-de-verre **Mask, Henri Cros, ca. 1890–1895, given by Victor Arwas (© Victoria and Albert Museum, London). This mask was made when pâte de verre was a new technique. Henry Cros (1840–1907) first used moulded powdered coloured glass when he was trying to make small-scale coloured sculptures like those of Ancient Greece, Rome and Egypt. Cros was a very private man who kept his techniques a closely guarded secret. He nevertheless influenced a generation of glass makers who worked with pâte de verre and other forms of glass paste.**

There has long been a misuse of the term *pâte de verre*, where it has mistakenly encompassed all techniques of glass kiln-forming. Argy-Rousseau and others took kiln-forming into new spheres, in that their pieces sometimes crossed over into true castings, i.e. the glass grains of the *pâte de verre* were heated to a temperature whereby the glass melted and flowed into the mould, rather than simply fusing. This had the advantage of producing smoother glass surfaces, less crystalline and opaque, but had the disadvantage of losing control of where the colour was positioned in a mould, as the glass flowed. The term should be used to refer to the amount of movement of the glass itself – *pâte de verre* stays relatively static, and does not move around the mould, whereas cast glass flows into and fills the mould. Some forms which were created could only be made by casting, as to lay glass paste into the mould you need to gain access to its interior, something which is not always possible, dependent on the size of the opening in the mould and final glass shape desired. These glass innovators developed many elaborate ways of creating moulds in different sections, and with multiple firings, to overcome the problems. Their contribution to kiln-forming in the later twentieth century was pioneering and directly contributed to the interest and technological impetus for making glass which came in the 'studio movement' of the 1950s.

ARGY-ROUSSEAU'S LEGACY

1885 Born near Chartres into a farming family; childhood interests included drawing, physics and chemistry.

1902 Enrolled at the Ecole Nationale Cèramique de Sèvres, met Henri and Jean Cros, father and son, who were also experimenting with glass.

1906–14 Graduated with diploma in engineering, chose title of 'engineer-ceramist', taught by Albert Dammouse, established his own business; researching dental porcelain, privately researching *pâte de verre*.

1914 Exhibited glass *pâte de verre* bowls and vases for the first time at Salon des Artistes Français, to great critical acclaim.

1916–17 During the war worked on engineering projects; patenting electrical inventions.

1920 Producing many *pâte de verre* and enamelled glass pieces; hailed as 'worthy successor to Cros and Dammouse'.

1921 Met Gustave Moser-Millot, a gallery owner, and established the Société Anonyme des Pâte de Verre d'Argy-Rousseau, making decorative glassware.

1923 Business producing vases, lamps and nightlights in increasing numbers.

1925 Exhibited at the Exposition Internationale des Arts Décoratifs et Industriels Modernes; work leaning towards geometric stylization.

1926–7 Showed work at major Salons des Artistes; the terms 'pâte de crystal' and 'pâte de verre' appear for the first time.

1929–31 Financial crash in America; decline in sales of glass range; business with Moser-Millot dissolved.

1932 Set up studio in Paris as independent artist, producing 'sculpted *pâte de verre* enamels'; produced thirteen new models by end of the year.

1933–45 Producing 'cut *pâte de crystal*' and enamelled glass, decorated with gold and platinum enamels; other glass popular at this time was being produced by Daum, Lalique, Sabino and Verlys.

1934–45 War affected the availability of materials; Argy-Rousseau worked as an engineer in a porcelain factory.

1946–52 Had financial difficulties and suffered from health problems and a painful heart condition; worked up to 1952.

1953 Died 20th February 1953 in Paris.

Argy-Rousseau produced between 15,000 and 20,000 glass pieces from 350 models. His most productive years were from 1922 to 1931. He also developed an astonishing range of translucent colours, including very rich reds.

Lampshades, Gabriel Argy-Rousseau, 1920–1925, at The Corning Museum of Glass, Corning, NY.

LATER TWENTIETH CENTURY GLASS

The two world wars hindered the artistic production of glass, and it was not until the 1950s and 1960s that artists came to look at glass again. This was part of a general movement in America which explored alternative ways of living and the production of craft objects to support an artistic lifestyle. One of the major impetuses was the advance of technology in many aspects of life, and the idea that artists could make their own equipment for glass making, kilns, and furnaces on a small scale in their own studio. The movement was led by Harvey Littleton and Dominick Labino, who in 1962 built a small glass furnace, and began experimenting with glassblowing. This interest in small-scale glass investigation and the rediscovery of many glass techniques was gradually disseminated throughout the USA and Europe, leading to the revival of the artistic exploration of glass techniques across the board – kiln-forming, blowing and lampworking – not seen since the Art Nouveau period and before that the ancients. Kiln-formed glass techniques, despite general technological developments in the studio movement, remained very labour intensive, with many time-consuming steps involved in mould making, firing, and finishing. Like the glass artists in the Art Nouveau period, it was the dedication to the material and belief in the possibilities that led to the continuing exploration of kiln-forming.

Whilst the American studio glass movement remained largely focused on the immediacy and freedom of artistic glassblowing, during the 1950s outside of the western sphere in Czechoslovakia glass techniques were being explored and developments made in kiln-forming. Glass has played an important part in the history of the Czech and Slovak Republics for over six hundred years. The role of the glass craftsperson was important throughout this period, and this has, in no small way, contributed to the high level of technical skill that currently exists in the Republics. They boast the oldest surviving glassmaking schools in the world. Since World War Two, glass became Czechoslovakia's most exportable commodity, due to the long history of cooperation between industry and craft practitioners. Under state patronage from 1948, the glass industry flourished and also created a unique set of circumstances, in which highly skilled glass artists of great individuality and with a high degree of technical expertise evolved. In the late 1950s Czechoslovakian glassmakers were the first to realize a new concept in glassmaking – that glass could be used for non-utilitarian art objects, pre-dating the studio glass movement of the USA. These artists developed

FLOAT GLASS

Whilst artists were rediscovering important glass techniques, major developments in the mass production of glass were taking place after the war. In the 1960s, Alastair Pilkington had a brainwave about the production of window glass. There was a high demand for distortion-free glass, because the then production method of plate glass involved molten glass being rolled out to form a sheet, which caused deformations in the surface. This would then be ground and polished, a costly and lengthy process. Apparently whilst washing up and watching a plate float on the surface of the water, Pilkington had the idea to 'float' molten glass to form sheet glass. In the process, which took many years to perfect, a continuous mass of glass is dispensed out of the melting furnace and floats along the surface of a bath of molten tin. The glass is held at a high enough temperature over a long enough time for the irregularities to melt and for the surfaces to become flat and parallel. Molten tin is dense enough for the glass to float on top, and its surface is very smooth and flat, so the glass also becomes flat and flawless. The glass is gradually cooled down whilst still on the molten tin, until its surface is hard enough (at about 600°C) for it to be taken out of the bath without the rollers marking the bottom surface. (The molten tin does not solidify until it reaches 230°C.) And so a glass of uniform thickness and with bright, fire-polished surfaces was produced without the need for grinding and polishing. This process has become one of the most important industries in the world; it is said to be second only to the production of steel.

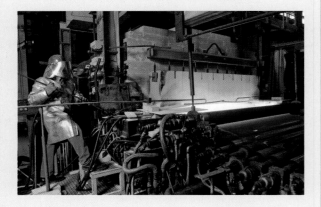

Furnace operator adjusts a machine producing sheet glass (© AGC Solar).

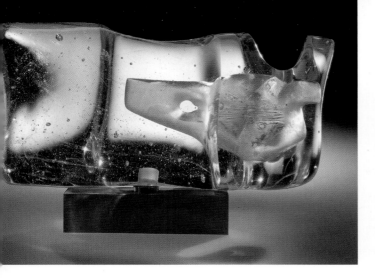

'The Inner Space', Jan Fisar (Czech, b.1933), Czechoslovakia, Zelezny Brod, 1968, mould-melted glass, metal, H: 19.4cm, W: 11cm, L: 31.9cm (Collection of The Corning Museum of Glass, Corning, NY, gift of the artist; 97.3.58).

glass craft into a medium for creative expression, and contributed important works which helped to redefine the role of glass.

At the time the Czech glass movement did not have the same impact as the American movement because it was relatively unknown after the closing of borders in the 1940s.

'Big Arcus/Arcus III', Stanislav Libensky (1921–2002) and Jaroslava Brychtova (b. 1924), Czech Republic, 1993, mold-melted, H: 104.1cm (Collection of The Corning Museum of Glass, Corning, NY, gift of the artists; 93.3.26).

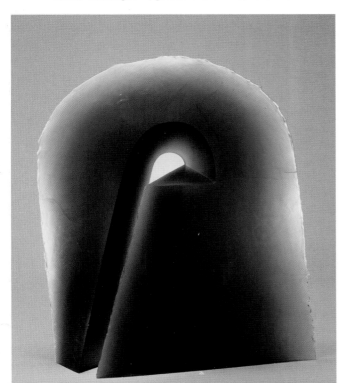

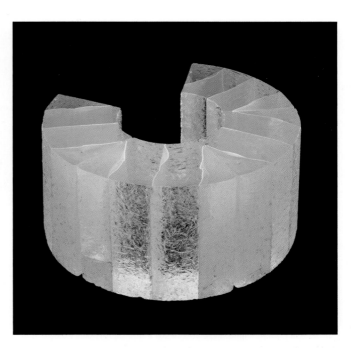

'Cercle (Circle)', Bernard Dejonghe (French, b. 1942), France, Briancon, 1995, cast optical lead glass: devitrified, ground, polished, assembled, H: 30cm, D: 60cm (Collection of The Corning Museum of Glass, Corning, NY, purchased with funds from the Ben W. Heineman Sr. Family; 97.3.72).

It was not until the 1958 World Expo, held in Brussels, that Czechoslovakian glass made an appearance on the world stage. There was some feeling at the show that glass designs were showing a tendency to appear mechanized and mass-produced, with a movement towards limiting the production of hand-produced pieces. In the exhibition not only the innovative new techniques employed by the Czech artists, but the appearance of free-standing, sculptural glass objects in the exhibition, proved a revelation. The reaction amongst those present was amazement – it had not been realized that the Czechs were producing work of this standard, and they were awarded the Grand Prix at the exhibition.

The leading glass artists from this period in the sphere of kiln-formed glass were Stanislav Libenský and Jaroslava Brychtová, who began to produce very large scale castings, made possible by working hand-in-hand with the glass industry and its equipment. This arrangement, however, had the disadvantage of an obligation to continue producing a certain amount of state commissioned work. By the 1980s their success meant they could stop being dependent on the production company at Zelezny Brod and set up their own

'Untitled', Colin Reid, Cast Optical Glass, Commission for Burton Agnes Hall, Yorkshire, 2009, inspired by medieval stone carving, H: 64cm, W: 33cm, D: 15cm.

'Something of a Relationship IV', David Reekie, 2009, kiln-cast glass, H: 39cm, W: 26cm, D: 17cm.

melting furnaces. After the revolution of 1989 Czech glass artists became freer to become involved in the international activity of glass art, attending conferences and other leading glass events, thereby passing on some of the important developments they had made in kiln and cold glass techniques to the rest of the world. The impact of the Czech kiln casting era led to the development in the 1980s of other formative *pâte de verre* and cast glass from around the world, most notably by Diana Hobson, Keith Cummings, David Reekie and Colin Reid in the UK, the Leperliers and Bernard Dejonghe in France, and Ann Robinson in New Zealand. These and many others have contributed to the lasting legacy of kiln-formed glass.

GLASS IN THE TWENTY-FIRST CENTURY

Progress in the scientific world marches on, and glass is amongst the forerunners in the development of innovative materials and processes. We now have self-cleaning glass, as well as 'smart' glass which can change from transparent to opaque at the touch of a button, and even bioactive glass implants, whose glass content is high in calcium, able to bond to human bone to encourage its repair. Today kiln glass artists can take advantage of the technological development of their equipment, utilizing very large kilns, more efficient high temperature insulation, sophisticated computer controls, and thermocouples (for measuring high temperatures) in the mould itself, giving them very precise control over the heating and cooling of the glass.

Nevertheless, making kiln-formed and in particular cast glass is a measured process requiring skilled craftsmanship. The beauty of kiln-formed glass is this connection to the technique and material, something which would be hard to contemplate as a mechanized process. The investment in artistic vision, time and procedure, produces work which at moments touches on the sublime. But it must be remembered that it takes commitment and experience to achieve this, and strong determination to overcome setbacks, such as a mould breaking or a piece of glass cracking after days of work. The results can be truly spectacular.

The next few chapters will introduce you to the materials, equipment and techniques which will help you understand the fundamentals of kiln-forming for glass, and make your learning experience as straightforward as possible.

'Divide & Separate', Fiaz Elson, kiln-cast glass: cut, sandblasted and polished, L: 60cm, W: 8cm, H: 30cm.

'Girder', Joseph Harrington, lost-ice process, kiln-cast glass, H: 16cm, W: 154cm, D: 9cm.

Making 'Girder'.

'Droplets', Ruth Shelley, clear and coloured glass placed on wire mesh in the kiln, heated until it dropped through the mesh to form droplets (Photograph by Ruth Shelley).

TECHNICAL ASPECTS OF GLASS

PROPERTIES OF GLASS

There are many aspects of the properties of glass which are important to understand in order to use glass successfully as a material for kiln-forming. The word 'glass' comes from the Latin term *glesum,* a resin or amber, and probably originated from an ancient Germanic word for a transparent, lustrous substance. In technical terms, glass is an inorganic product of fusing various materials, cooled to a solid condition without crystallizing. Glass is a fairly unique material for a solid, by virtue of the fact that it does not have a distinct melting point, but rather it decreases in viscosity as it becomes hotter – in other words, it becomes more fluid as it becomes warmer, gradually turning from a solid to a liquid. Only a few other materials which are solids act in this way, such as rubber and polymers.

'Opening Pod', Amanda Lawrence, fused float and float dichroic glass, enamelled and slumped in two sections, part-sandblasted and assembled using optically clear silicone (Photograph by Simon Bruntnell).

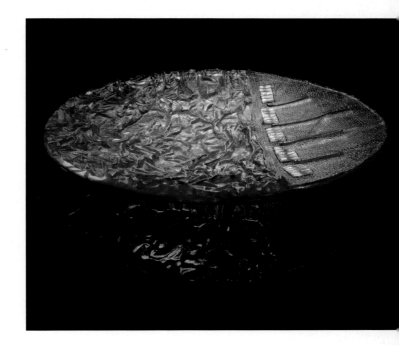

'Crinkle, Crease and Line', Deborah Timperley, Lilac glass with 23.5ct gold, Dia: 35cm, kiln-formed (open cast), slumped and polished.

We will look at these technical aspects in turn, as they combine to give us a material that is highly adaptable as well as being aesthetically versatile for creative use. It may be tempting to ignore the more technical aspects of glass, but if you read and digest the information that follows then you will have a better grasp of what is happening when you kiln-form your glass, and will therefore achieve more successful results. Although we will cover topics such as firing and annealing glass whilst working on individual projects, it is important to gain an overview of the principles involved.

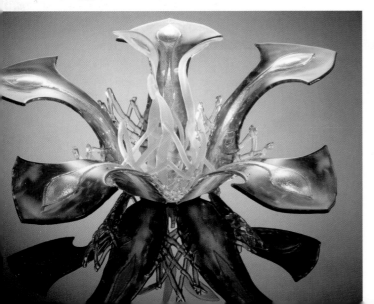

SUPERCOOLED LIQUID – AN URBAN MYTH

Glass is often referred to as a supercooled liquid. It defies normal categorization because of its ability to transform slowly from a solid to a liquid over a range of temperatures, rather than the usual behaviour of a solid, which is to have a specific melting point. Because of this quality scientists came up with the term 'supercooled liquid', which hinted at the idea that glass, in technical terms, is not a solid at all, but a liquid which at our ambient 'room' temperature, is only acting like a solid.

It all sounds a bit confusing, so to illustrate the point, others cited the example of glass in medieval stained glass windows as an illustration of the liquid quality of glass. When medieval stained glass windows were taken apart for restoration, it was often observed that in each individual piece of flat glass the bottom was thicker in section than the top, thus suggesting that the glass must, over hundreds of years, be flowing downwards due to gravity.

This has proved to be something of a contemporary legend in the world of glass. The true reason for the thicker and thinner sections of glass is due to its method of manufacture. Sheets of glass were made during the period in question by the crown method. This involved blowing a quantity of glass into the shape of a hollow vessel, and then spinning it fast, either on the end of a blowing iron or, later, on a revolving table like a potter's wheel. The centrifugal force caused the molten glass to spread outwards and flatten into a crown or bullion of glass, which could then be cut into small sheets. These sheets varied in thickness from one end to the other, because of the spreading action as the glass was spun. When assembling stained glass windows with lead, the whole window was much stronger if the two edges of glass slotted either side of the lead channel comprised one thicker piece of glass matched with a thinner, rather than two very thin pieces of glass, which would be weaker and more vulnerable to damage. The thicker glass was mainly positioned at the bottom of each section for stability and to prevent water accumulating in the channel.

No movement of glass, or flow, has been detected in solid glass over any period of time, when tested by scientists.

'The Corning Wall', Dale Chihuly (American, b. 1941) and James Carpenter (American, b. 1949), with the assistance of Darrah Cole, Kate Elliott (American, b. 1950), Phil Hastings, and Barbara Vaessen (Dutch, b. 1949), Pilchuck Glass School, Stanwood, WA, and Rhode Island School of Design, 1974, blown glass, iridized, cut, overall H: 199.4cm (Collection of The Corning Museum of Glass, Corning, NY; 74.4.186).

COMPOSITION

Glass is made from a mixture of silica, soda and lime. Silica is found in a wide variety of natural sources including, most commonly, sand. Sodium carbonate, or soda, is used to lower the fusion point of silica, making glass light and workable. Soda is called a flux, because it brings the melting point of the mixture down. Lime, ground from limestone, makes the mixture more viscous, as well as making the glass tougher and less susceptible to erosion and damage from water and acids.

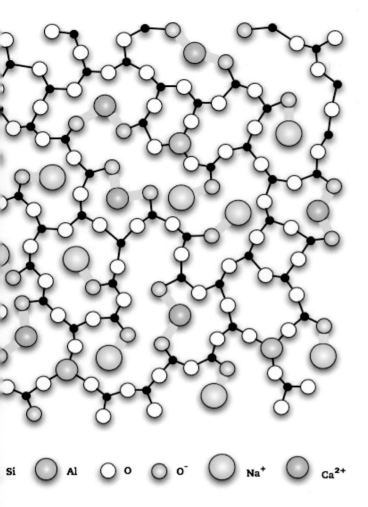

The amorphous structure of glass (glassy silica).

Si ◯ Al ◯ O ◯ O⁻ ◯ Na⁺ ◯ Ca²⁺

Other materials are added to glass to give different characteristics, such as lead to make glass softer, or boron to make glass harder, as in borosilicate glass, or Pyrex, as it is known. Metallic compounds are added to give colour, for instance copper to make green or turquoise glass, or manganese to make purple.

So, many materials, or 'ingredients', are added to make the final 'recipe' of glass. There are hundreds of different glasses manufactured today, each with their own characteristics and qualities specifically chosen to make the glass suitable for its intended use. In kiln-forming, for the most part we use soda glass in sheet or chunk (cullet) form, although lead glass has been used greatly in the past and is still available from some sources. Soda glass tends to be slightly harder than lead glass and is therefore stronger and more resilient to scratching,

whereas the addition of lead makes the glass softer and more fluid when melted, but also gives the glass a brilliance and sparkle. In the next chapter we will see the variety of glass available for use by the glass artist, in terms of quality, colour, and characteristics.

TYPES OF GLASS

Nearly all glasses can be categorized into one of six types:

Soda-lime glass is the most common, representing 90% of glass made, and is the least expensive form of glass. It contains 60–75% silica, 12–18% soda, 5–12% lime.

Lead glass has 20% or more percentage of lead oxide, and is quite soft, with a high refractive index which gives a marked brilliance when cut and polished.

Borosilicate glass has at least 5% of boric oxide in its composition; its principal quality is its high resistance to temperature change and chemical corrosion.

Alumino-silicate glass has aluminium oxide in its composition; it is similar to borosilicate glass but has greater chemical durability and can withstand higher operating temperatures.

96% silica glass is a borosilicate glass which has been processed to remove almost all the non-silicate elements from the mix; this glass is resistant to thermal shock up to 900°C.

Fused silica glass is pure silicon dioxide in the non-crystalline state; it is very difficult to fabricate, so it is the most expensive of all glasses; it can withstand operating temperatures up to 1200°C for short periods.

VISCOSITY AND SOFTENING

Viscosity is the resistance of a liquid to flow. The viscosity of glass is very important, as it is this characteristic which enables us to melt the glass and transform its appearance. In its behaviour when heated, as we have discussed, glass lacks a stage which is termed 'phase transition' and which applies to most other materials. In simple terms this means that there is no abrupt change from solid to liquid, and instead glass displays a continuous stage of transition rather than a sudden one, as it gradually becomes more liquid. It is perhaps useful to view this process as a *softening* of the glass until it becomes

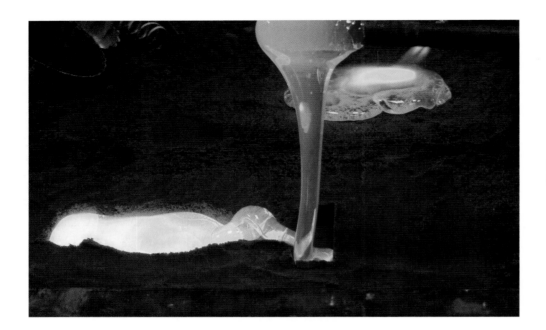

Molten Glass (Courtesy Liquid Glass Centre).

a liquid. The great thing about this characteristic is that we can stop the heating and at any point in this gradual transition 'freeze' it in the state it has reached. It is then cooled to a solid, but significantly, it is frozen in the state of flow and viscosity it previously attained. This enables us to create a multitude of effects in glass, from glass that has just become soft and can be distorted or bent, through to glass that has been melted to a very runny liquid – so liquid in fact, that it can be poured into a mould, or blown into a bubble.

EXPANSION AND COMPATIBILITY

Glass also expands when it is heated, and this leads us onto another important consideration when working with the material, and that is compatibility. Because of differing rates of expansion between them, we cannot combine two different glasses using kiln-forming techniques such as fusing or casting, without knowing whether they are compatible, or expanding at the same rate. Two different glasses, i.e. differing in colour, form, manufacture or in any other respect, are not necessarily compatible with each other. If we do combine incompatible glasses then this leads to stress, as the two glasses are fused or mixed together but they are expanding at different rates. We will look at stress more closely later in this chapter, but stress in glass usually results in cracks and breaks.

Cracked incompatible glass.

CO-EFFICIENT OF EXPANSION OF COMMON METALS AND MATERIALS

Lead	9
Aluminium	23
Brass	19
Silver	18
Stainless Steel	17.3
Copper	17
Gold	14
Nickel	13
Concrete	12
Steel	11 to 12 depending on composition
Iron	11.1
Platinum	9
Soda Glass	8 to 9 depending on composition
Tungsten	4.5
Borosilicate Glass	3.3 depending on composition
Silicon	3
Silicon Carbide	2.77
Diamond	1

As with all other physical materials which change in volume in response to a change in temperature, glass expands when heated due to its constituent particles moving around more vigorously and thereby increasing the space between these particles. The degree of expansion divided by the change in temperature is called the glass's coefficient of expansion, which is really a measurement of its capacity for an increase in size. Different types of glass, for instance soda glass, lead glass etc., have differing coefficients of expansion. In fact all the different 'recipes' for glass manufacture will all have slightly different coefficients. This is because the materials added to make that particular mix of glass will affect its expansion. So, for instance, soda glass expands slightly less than lead glass, and borosilicate glass has a very low coefficient of expansion. The measurement for expansion is expressed as a figure which looks like this for various glasses:

Borosilicate glass	33 $(\times 10-7)/°C$
Float glass	82 $(\times 10-7)/°C$
Soda Lime glass	90 $(\times 10-7)/°C$
Lead glass	92 $(\times 10-7)/°C$

These figures mean that soda glass expands by 0.0000090 of an inch per degree change in temperature. To make things easier, we use the last two digits as the commonly referred to figure for the coefficient of a particular glass – for instance we would say that window or float glass has a coefficient of expansion of 82. Again it is important to stress that these are just examples of the rate of expansion – the exact rate will depend on the exact mix of glass constituents. We cannot even assume that for instance, different coloured glasses from the same manufacturer will have the same coefficient, as the metal oxides added to the glass can affect the expansion. The rate of expansion, the coefficient, will usually be known by the manufacturer of the glass, so that it becomes essential to find out that rate if we intend to combine two different glasses.

COEFFICIENTS OF MANUFACTURED GLASSES

Float Glass	82–86 COE
Bullseye	90 COE
Artista	94 COE
Spectrum	96 COE
Uroborus	90 or 96 COE
Baoli	85 or 90 COE

COMPATIBILITY PROBLEMS

There are some further issues associated with coefficients. We have seen that in order to fuse two different glasses together, we need to obtain glasses with the same coefficient of expansion in order to combine without cracking. We would naturally assume then that if the coefficients were the same, this would lead to compatible glass. However, as we shall see, the coefficient issue is not quite that straightforward.

In recent years glass artists have become reliant on the quoted coefficients as a guarantee of success in fusing or casting, without realizing that in fact the coefficient figures are often based on testing the glass over a temperature range from room temperature up to 300°C. As kiln-forming is conducted at higher temperatures than this, and it has been demonstrated that the expansion of glass through the full temperature range used by kiln workers is not uniform, we cannot safely assume that the manufacturers' quoted glass coefficients will enable successful fusing between different glasses. This is why many glass artists have had problems when fusing glass from different ranges with the same coefficients. Some glass makers also believe that the inherent

Compatible sheet glass.

viscosity of the glass – or fluidity, dependent on the soft-ness or hardness of a particular recipe, which can again vary between different manufacturers – will affect the compatibil-ity. This would explain why sometimes glasses with different coefficients seem to fuse together successfully.

In practical terms however there has to be a starting point with which to experiment with combining glasses. We can use the quoted coefficient to form a basis from which to work, but as ever the best course of action is to test the compatibil-ity on a small sample first, and then look at the glass to see if there is stress or strain. Fortunately, the compatibility problem is becoming less of an issue for glass artists today, as so much glass is now made and tested to be compatible. Within a range of fusible sheet glass we therefore have many colours which are all manufactured and guaranteed to be compat-ible, and we can therefore work with these with confidence. However, there can be other causes of stress, so we will look at the issue of stress in glass next, and how to test for it.

STRESS

As we have discussed, incompatibility between glasses which are bonded together by fusing or casting and then expand at different rates causes stress. There are also alternative causes of stress, such as adding other incompatible materials, such

as metal, to fused or cast glass, or not annealing the glass correctly.

Stress or strain in glass becomes more apparent when the glass is cooled back to a solid, as it is at this point that glass becomes brittle and is unable to withstand the pressure of the incompatibility. The result of extreme incompatibility is crack-ing and possibly breaking when cooled from the kiln. Lesser incompatibility may not be evident at first, as the glass may come out of the kiln with no visible defects and may remain so for days or weeks or months. It may crack however when subjected to extremes of temperature, i.e. being washed in very cold or hot water, where thermal shock is aggravating the stresses.

The best way to determine if you have stress in glass is to look for it visually. As it is not something that is evident until there is a crack, we have to use special methods to determine stress. The simplest test is the thread test. You can see incom-patibility by taking two equal pieces of glass and fusing both pieces together using a gas torch. As soon as they are fused together, the pieces are pulled apart. The glass should pull out in a string – if the pulled string stays straight, the glass is compatible, but if the pulled string bends then the glass is not compatible.

There are, however, two more accurate methods which can be used – one utilizing polarizing lenses, and the other making a bar test. Polarizing film can be used on a fused sample of two glasses you want to test for compatibility, by

Glass losing heat through
exterior surfaces

An illustration of stress caused by insufficient annealing – as glass cools down, the surfaces lose heat more readily than the interior and become less mobile, causing an imbalance between the still moving interior. If allowed to continue to cool in this way, the strain becomes 'trapped' in the glass. Annealing, or holding at a given point in the firing cycle, so that the temperature can equalize throughout the glass, relieves this stress.

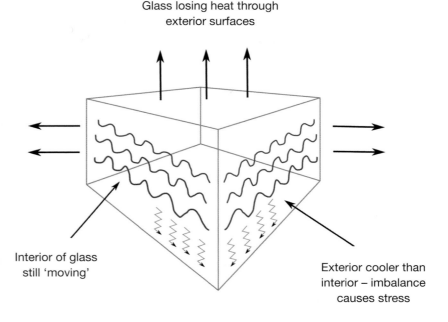

Interior of glass
still 'moving'

Exterior cooler than
interior – imbalance
causes stress

viewing the sample between the lenses to check for strain. Using polarizing lenses is also the quickest and most convenient method for checking for stress in a piece of glass you have already made. This means you can sell or instal glasswork safe in the knowledge that it is free from strain. Polarizing lenses can be bought as small squares of film or alternatively as part of a stress testing kit with a light source built in.

The limitations of this test are that you are reliant on using

Polarizing lenses testing for strain.

transparent glass as you will be looking at the light passing through it. One way around this would be to use the base test – fuse the samples of glass you want to test for compatibility to a clear sheet, before you start your project, and look for the halo around the opaque glass fused in the clear glass. The strength of the halo will indicate the degree of stress. Using a base of clear 'control' glass with several samples fused to it will allow you to test for compatibility, with the control glass as the base, over a range of samples.

Another way of testing incompatibility is called the bar test, and involves fusing two glasses together to see if they have contracted at the same rate. It is similar to the thread test, but gives more accurate, measurable results. As two bars of glass, laid on top of each other and fused together in the kiln, contract, they will bend if they are contracting at different rates. This would indicate incompatibility. If, however, they remain flat, then they are compatible.

In practical terms you may find it unnecessary to test for stress, as you will predominantly be using two or more glasses that have already been tested for compatibility, such as Bullseye glass, but it is good practice to become familiar with the principles involved and the testing methods. The polarizing test is the easier and more versatile test to perform, and has the additional benefit that it can detect stress from annealing as well as incompatibility, which is very useful. However how can we determine which of these two triggers has caused

HOW TO USE POLARIZING LENSES TO TEST FOR STRESS

To observe stress place the glass between two polarizing lenses, in front of and behind the glass, aligned so that when you look through them the area of glass you want to test is between the two lenses, and in front of a light source such as a lamp or at a bright window. Slowly rotate the lenses until light stops passing through both of the lenses. If there is stress in the glass you will see a halo in the glass, or around any fused material, but if there is no stress no halo will appear. There are differing degrees of stress, and you may need to test a few different glasses to see the range of halos which can result from less or more stress.

Polarizing lenses showing strain in glass.

USING THE BASE TEST FOR COMPATIBILITY

Cut a strip of glass, 20mm wide and 200mm long, from a base glass. Lay small squares of other glasses which you want to test for compatibility, as well as a piece of the base glass itself as a 'control', on top of the strip and full fuse in the kiln. When the bar has cooled, view the fused strip using polarizing lenses, and you should be able to see the samples which are incompatible. The brighter the halo the more incompatible the sample is. If you keep your test strips and continue to test using the same base glass you will be able to build a record of samples which are compatible.

A base test.

Strain in the base test.

stress once a crack has occurred? This can be established by looking at the type and position of the crack within the glass. Cracking due to incompatibility often follows the line of the meeting point of the two glasses, so that if you fuse two pieces of incompatible glass together, a crack will usually form along the point where they meet. Over time, these cracks will increase and eventually the piece will completely separate.

Cracks from insufficiently annealed glass will usually be spread randomly across the piece of glass, running across areas where two glasses have been fused. Cracks from insufficient annealing can also occur in kiln cast pieces, causing fractures within the glass piece, or more often than not, where the form of the glass goes from thin to thick, indicating that there is stress in the thicker parts of the form. We will look at the whole topic of annealing shortly, as it is another area which can be problematical for glass makers. There is a third cause of strain in glass which can also lead to cracking, and that is thermal shock, which we will look at next.

A crack caused by incompatibility.

A crack caused by insufficient annealing.

35

HEATING AND FIRING

As we have seen, glass slowly transforms as it is heated from a solid into a liquid. There are various factors which we need to understand and observe whilst heating glass in order to kiln-form it. When heated in the kiln, glass has to be treated very carefully to avoid thermal shock, because it is inefficient in conducting heat. Thermal shock occurs when glass is rapidly heated or cooled, because the heat is not spread uniformly, and as the glass expands or contracts, this causes strain in the glass and therefore cracking or breaking. In other words, when glass is exposed to high temperatures, it absorbs heat and expands but at the same time its inner surface remains cooler, causing thermal stress. This only happens in the lower temperature range of glass, i.e. below around 400°C or so,

when it is a solid. Therefore we need to heat glass slowly, in order for it to absorb heat gradually, until the point at which it starts to become soft, or more liquid, and thereby avoid cracking. It is evident that it is impossible to 'break' glass when it has become more malleable.

The same slow cooling on the way down from firing the glass is called annealing, and is necessary in order to avoid cracks for exactly the same reason. If we look at a diagram of a typical firing for kiln-forming glass, it shows an initial long, slow heating ramp, followed by a faster one after the glass has softened. The glass is then held at the top temperature, at which it 'forms' the desired effect, it is cooled quickly down to annealing temperature, held for a period of time there, and then cooled very slowly. A ramp is the rate at which the kiln is heated, by degrees of heat expressed as '°C', over a given time.

Technique	Description	Temperature (dependent on glass)	
Combing	Raking flat molten glass with a steel tool whilst still hot in the kiln, to create coloured patterns in the glass	900°C – 950°C	↑ Hotter
Kiln Casting	Melting glass cullet into a plaster based mould to form glass casts	820°C – 870°C	
Pâte de Verre	A fusing technique, with glass frits formed into a paste and fired to fuse together	800°C – 850°C	
Full Fusing	Joining pieces of glass by fusing, but with the glass fully melted so that they merge into one	760°C – 820°C	
Mid Fusing	Joining pieces of glass by fusing, but with the edges of the glass becoming softened	750°C – 800°C	
Fire Polishing	Re-melting the surface of the glass so that it acquires a polished appearance	700°C – 760°C	
Tack Fusing	Joining pieces of glass by fusing, but with the glass retaining well defined edges and shape	700°C – 780°C	
Slumping	Bending or shaping glass so that it distorts and sags under its own weight, or into or over a mould	650°C – 720°C	

Different techniques in kiln forming, and their temperature ranges.

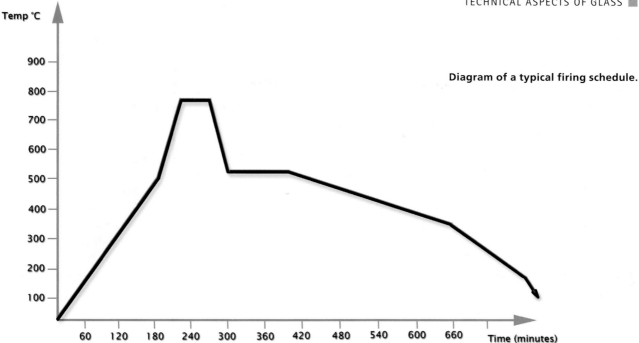

Diagram of a typical firing schedule.

An example of the temperatures you would fire glass to, or a 'schedule', for a simple fused glass project such as a glass tile, would look something like this:

FULL FUSING FLOAT GLASS		
Heating		
1st Ramp	200°C per hour to 550°C	Initial heating
2nd Ramp	Full, or kiln firing continuously, to 820°C	Rapid heating
	Soak, or hold at 820°C for 20 minutes	Soak as glass is forming
Cooling		
3rd Ramp	Full, or kiln off, to 550°C	Rapid cooling
	Soak or hold at 550°C for 10 minutes	Annealing
4th Ramp	50°C per hour to 450°C	Slow cooling over transformation range
5th Ramp	150–200°C	Final Cooling

The last column provides a description of the process which is being applied to the glass. It must be stressed that this schedule is purely illustrative of the heating and cooling processes, as we will look at specific firing schedules as we progress through the projects that follow. This is also the simplest schedule for firing fused glass – for many projects as they become thicker in section there are many more annealing ramps, as the thicker the glass is the longer it takes to anneal. Notice that the control of the firing is stopped at 200°C; this is because after this temperature there is no chance of trapping stress in the glass, but also because most kilns cool very slowly in this last phase of the firing, so there is little need to program a ramp below this point. We will look at annealing and the exact process a little more closely, as it is the most crucial factor in the success or failure of the final piece.

Firing glass in a kiln.

ANNEALING

Imagine a fused or cast piece of glass is cooling down in the kiln. At the annealing temperature the outer surface is losing heat more rapidly than the inside and is shrinking as it does so. The inside of the glass is still hot, and with the outer face of glass cooling, this causes a discrepancy. If we allow this imbalance to continue down to cooler temperatures, when the glass has become a solid, it will cause stress and a fracture. If, however we soak the glass at the specific point at which it is just still soft, for a length of time, we can allow the outer edges and inner matrix to 'catch up' with each other, i.e.

A mould with glass in a kiln.

equalize the temperature throughout the glass. Then, as the glass becomes more solid, we are on a much better footing, with very little or no stress trapped in the glass.

Annealing is the process of slowly cooling glass to relieve internal stresses after it has been formed. We need to be particularly careful about annealing glass that we have kiln-formed, or indeed any glass that has been heated, because if we do not deal with the stresses which result from cooling the glass too rapidly, they will become trapped in the glass and cause, as we have seen, cracks and breaks. Although cooling has to be a slow process in the lower glass temperatures, we usually start the slow cooling by holding or 'soaking' the glass at something called the annealing point. There is a definitive temperature (which varies from one glass to another, depending again on the physical properties of the glass) at which we can hold the kiln-formed glass and alleviate stress – this is the point at which the glass is still too hard to deform, but is soft enough for the stresses to relax. The piece is then allowed to soak until its temperature is even throughout. The time necessary for this step varies depending on the type of glass and its maximum thickness. Strain can be eliminated throughout a range of temperature when cooling the glass, but the annealing point is a temperature where it will equalize most rapidly. One of the most important factors when annealing glass is achieving this equilibrium of glass temperature throughout the body of the glass, ideally with no more than a 5°C variation as it cools, which will effectively eliminate all strain.

As we have seen, glass does not suddenly become a solid, it happens gradually. When it is cooling, after the annealing point the glass goes through what is called the *transformation* range as it cools, gradually becoming more viscous, until it reaches the *strain* point, which is where it finally becomes a solid. Depending on the thickness of the glass, at the annealing point stress can be alleviated within several minutes, whilst at the strain point this can take several hours. Stress that is still present below the strain point is permanent. For this reason a firing schedule for anything but the simplest fused project will usually incorporate additional slow ramps through the transformation range, where the glass can still hold stress, until the strain point is reached. Below the strain point ramps can still be slow, to avoid thermal shock.

Another important factor to remember in the firing and annealing of glass is that each kiln has a unique set of conditions. There are many varying factors between kilns, for instance, pyrometers – which read the temperature inside the kiln – varying in accuracy, or the position of the pyrometer

HALE TELESCOPE LENS – LARGE SCALE ANNEALING

One of the largest pieces of kiln-formed glass ever made was the lens for the Hale telescope, in San Diego, California. The first telescope, built in 1917, had a very large mirror which went out of focus easily, due to temperature variations. In 1928 a grant was received which enabled a bigger telescope to be produced.

From 1934 to 1936, a huge glass mirror was constructed. Borosilicate glass was used to reduce expansion and distortion. The molten glass was poured into a huge mould, and then loaded into a specially constructed kiln to anneal, which the scientists calculated would take eleven months. The first attempt failed, as several cores in the brick mould broke away from the metal anchor rods and floated on top of the molten glass when it was being poured.

However, on the second attempt the casting was successful. The resulting glass blank was huge: 17 feet in diameter, 3 feet thick and weighing more than 20 tons. A special train, moving less than 25 miles per hour, took 15 days to transport the blank across the continent from Corning in upstate New York to California for polishing. The glass was ground and polished for over ten years, until finally, the mirror was mounted in 1947, at that point the largest telescope mirror ever made.

The current record holders for the largest single piece of cast optical glass are the two mirrors made for the telescope at the Steward Observatory in Arizona. They are each 8.4 metres across (27.6 feet) and were polished to an accuracy 3,000 times thinner than a human hair.

200-inch disk, Corning, NY, Corning Glass Works, 1934, Borosilicate (Pyrex) glass, cast, overall W: 508 cm (Collection of The Corning Museum of Glass, Corning, NY; 99.4.91).

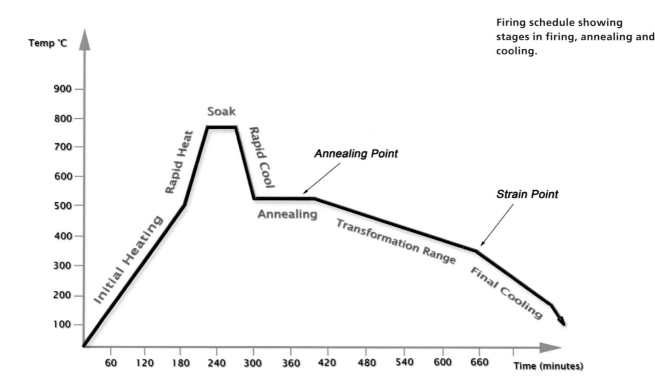

Firing schedule showing stages in firing, annealing and cooling.

in the kiln being far above or below the glass, both of which will give a false reading of the true temperature of the glass. Any firing schedule which recommends a specific firing temperature for a desired effect would need to be tested in your own kiln to check that it is operating at the same temperature – if not you may need to calibrate schedules to your own kiln by adding or subtracting a few degrees. The same also applies to annealing your glass – if your pyrometer reading is a few degrees out then this can affect whether your glass has annealed successfully or not. This would become more appar-

ent when making larger, thicker glass pieces. Testing with polarizing lenses will help you determine how effective your annealing cycle has been.

Keeping accurate records of every firing you make is essential in order to fully understand the behaviour of glass when fired in your own kiln. This would include information on the type of glass you are firing, the firing schedule you have used, the effects which have resulted etc. If you do so, you will be able to add and amend firing schedules as you learn more about the processes.

Firing Schedule	°C/hr	to	°C	Hold
	150°C/hr		515°C	
	999°C/hr		760°C	30 mins
	999°C/hr		516°C	30 mins
	75°C/hr		370°C	
	150°C/hr		200°C	
	End			

Example of a record of a kiln firing schedule.

As we have seen, there can be many factors which affect the successful outcome of your kiln-formed glass piece, and it can be daunting for those beginning the process of understanding the techniques. Because glass is an unusual material it takes more time, patience and determination to comprehend its behaviour and master it. The information in this chapter will prove useful, whether you have digested it now, before starting to work with kiln-formed glass, or if you already have some experience and are building on your knowledge.

Glass loaded in moulds in the kiln (Courtesy Liquid Glass Centre).

Loading moulds into a kiln (Courtesy Liquid Glass Centre).

MATERIALS AND EQUIPMENT

'Synergy Series', Cathryn Shilling, kiln-formed glass, H: 50cm, W: 50cm, D: 10cm (each piece). (Photograph by Ester Segarra.)

There are many types of glass available to the kiln-former. These range from sheet glass for fusing through to chunks of glass, known as 'cullet', for kiln-casting. Within the range of sheet glass we have fusing compatible glass, transparent glass, opaque glass, wispy glass – the list goes on. There are also many items of equipment which you will need to obtain, from a glass cutter through to a kiln.

Some years ago it was relatively difficult to find materials specifically for kiln-forming glass. This meant trying to find glasses that were compatible and having to test them, searching for mould-making materials from individual suppliers, and generally having a difficult time trying to get hold of things. Nowadays however, there is sufficient interest in kiln-forming that suppliers have responded to demand and stock a ready supply of fusing compatible sheet glass, other fusing materials like kiln papers, mould-making supplies, as well as kilns. Indeed, there is a plethora of glass manufacturers and equipment makers, with many choices to be made about what to use for specific techniques and projects, so we will now look at some of the main categories of materials and equipment available. (Information about where to obtain everything mentioned is included in the resources section at the end of the book.)

OPPOSITE PAGE:
Glassblowers spin glass gather into crown, let gravity elongate gather into a cylinder. Innovation Center, The Corning Museum of Glass, Corning, NY.

Sheet glass manufacturer.

SHEET GLASS METHODS OF MANUFACTURE

BLOWN CROWN GLASS

An ancient technique, whereby molten glass is gathered on a blowing iron, and a balloon shape is blown. The glass is spun rapidly until a disc is formed. The outer portion beyond the central bulge where the iron was attached is then cut into panes. By the eighteenth century, the quality was often very good with an almost unmarked fire-polished surface.

BLOWN CYLINDER GLASS

This is a hand-blown method of producing sheet glass, common in the nineteenth century. Glass is blown on a blowing iron, sometimes into a mould, to form a large glass cylinder. When it has cooled down the end of the cylinder is removed, and a score is made down the side of the cylinder. The cylinder is then reheated, so that the score breaks and the glass unfurls, making a sheet of glass, which is cooled again. This is still manufactured and known as 'antique' glass.

MACHINE DRAWN GLASS

The first mechanical method of drawing glass, 40ft high cylinders of glass were drawn vertically from a circular tank. The glass was annealed and then cut into 7–10ft cylinders, which were then cut lengthways, reheated and flattened. This process was used in the UK up to the end of the 1920s.

ROLLED GLASS

The glass is taken from the furnace in large iron ladles and poured onto the cast-iron bed of a rolling-table. It is then rolled into a sheet by an iron roller, and quickly transferred to a shelf in a kiln for annealing, or onto a conveyer which proceeds through an annealing oven.

FLOAT GLASS

A layer of molten glass is 'floated' on to a bath of molten tin and produces a fine quality of glass, but with a mirror-like reflection, without any ripples or distortion. It is the standard modern method of producing window glass today.

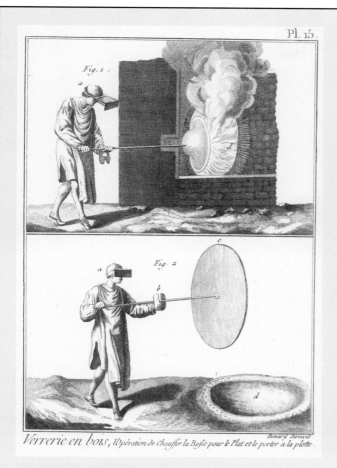

**Crown Glass Factory, Denis Diderot (1713–1784), et al.,
*Verrerie en bois, différentes operations relatives à la
façon d'un verre*, L' Encyclopédie, 1751–1772, engraving
(Collection of The Rakow Library of The Corning Museum
of Glass Corning, NY; bib 95284).**

Blown cylinder glass before flattening.

GLASS MATERIALS

It is useful to look at the glass materials necessary for kiln-forming in terms of the techniques they are to be used for – for instance, fusing, slumping or casting glass.

Glass for Fusing and Slumping

SHEET GLASS
Sheet glass is predominantly used for fusing or slumping projects. Most sheet glasses today are made by the techniques of float, drawing, rolling or, less commonly, blowing. Sheet glass is a very useful material which has become one of the commonest forms of glass in existence – it surrounds us, in every window in every building we use. For the purposes of kiln-forming, any sheet glass can be used, i.e. window glass, coloured sheet glass for stained glass work, antique sheet glass, but only specific glasses which have been tested to be compatible can be used in combination with each other. There are many ranges of compatible sheet glass available, which enable the kiln-former to use any colour or patterned glass within the range without fear of cracking or breaking.

**Furnace and raw materials for glass manufacture
(© AGC Solar).**

Rolling sheet glass at a glass factory.

WINDOW OR FLOAT GLASS

One of the first glasses used by beginners for fusing is often window or float glass. This is because it is so readily available – it can be obtained from any glazier – and is very cheap. It is a clear glass – no coloured float glasses are made, as there is little demand in the worldwide market. It is easily identified by its smooth surface and, when viewed on edge, its green colouration. Float glass is a soda-lime glass in composition, with little added or necessary to refine the basic recipe, and as such is a relatively crude form of glass, which is quite hard and therefore takes a longer time to soften. This means that it often needs higher temperatures and longer firing times when used for kiln-forming.

Because of the 'float' technique of producing this glass, small amounts of tin oxide are deposited onto one side of the glass (known as the 'tin side') as it is floated on a bath of the molten metal. This condition can cause a cloudy or hazy effect on the glass when fired in a kiln, although it is not always the case and can be associated with the conditions and firing temperature in the kiln. To avoid this effect the tin side can be fired downwards, i.e. facing down on the kiln shelf, or inwards in an assemblage of glass for fusing. The tin side is not visible to the naked eye, but it can be detected using an ultra violet light. It is also possible, though somewhat difficult, to detect for the presence of tin by feeling the surface of the glass with your finger – the tin side will be rougher. Some people have even claimed that if you clean the glass with a cloth and some water the air side will be squeakier. Both these methods are very subjective and difficult to assess, so a UV lamp is the more reliable, but you can try. (The opposite side of the glass is known as the 'air side'.)

Inside a float glass furnace (© AGC Solar).

The continuous ribbon of float glass (© AGC Solar).

TESTING FOR THE TIN SIDE

The best way to identify the tin side is with ultraviolet (UV) light. You can use a shortwave UV flashlight, called a tin side detector.

Safety note: *When performing this test do not look directly at the UV light source, as exposure to UV light can cause vision problems.*

Hold the light source beneath the glass at a 45° angle to the glass. If the tin side is facing down, you'll see a slight blue-white hazy fluorescence. Turn the glass over and repeat this to confirm which is the tin side. On the air side you will merely see a dull image of the UV lamp.

Testing with a UV lamp.

COLOURED SHEET GLASS

There is a wide variety of coloured sheet glass produced today, most of which is intended for the creation of stained glass items. Most coloured sheet glass is rolled or machine drawn. There is no need to test for the tin side of coloured sheet glass, as it is not produced by that method. There are also a few ranges of hand-blown glass, known as 'antique' glass, which have natural variations in thickness. Coloured sheet glass comes in transparent, opaque, streaky, wispy (or semi-opaque), iridescent and textured forms. All of these sheet glasses can be used for fusing or slumping, as long as they are used on their own, i.e. they are not mixed with other colours, even if they are made by the same manufacturer. The only guaranteed compatibility for a given glass, unless you test it first with other glasses, is with itself.

There is also a wide range of fusing compatible glasses available. These are glasses which have been manufactured and tested across the whole range, so that any colour of sheet glass, any decorative glass powders etc. within that range are all guaranteed to fuse without compatibility problems. As we have seen in the previous chapter, ranges are not inter-compatible, unless the manufacturer states so. For instance, the Bullseye range of compatible glass, with a co-efficient of 90, is not compatible with the Spectrum range, which has a co-efficient of 96. However, Uroborus Glass has produced a range of glass which is compatible with Spectrum, as part of their 'System 96' programme. These items carry the red System 96 logo and have been tested Compatible to Spectrum master samples. Bullseye, the manufacturer of the largest range of compatible glass in the world, is all hand-rolled, sheet by sheet, at their factory in Portland, Oregon.

Compatible sheet glasses/colours.

Sheet glass cullet.

DECORATIVE GLASS FUSING PRODUCTS

To complement the range of fusing compatible glasses, there are many decorative products produced for adding to sheet glass to create the fused 'assemblage'. These include:

Stringers Thin spaghetti-like glass strands, which can generating lines and shapes; can be cut to length and may also be shaped using a torch.

Confetti Irregular shaped very thin shards of glass.

Powders and frits Crushed glass in various grades, from powder to granular form, up to small lumps; used to add coloured effects.

Metal leafs, foils and wire Thin sheets of metals suitable for glass, such as copper, aluminium and silver.

Mica A crystalline mineral found in rock, which is ground up and coloured for use in glass; it is highly resistant to heat and provides a sparkly metallic effect.

Dichroic glass Glass coated with multiple layers of metal oxides which give it dichroic optical properties, i.e. transmits and reflects different colours.

Metal leafs and foils, as well as mica, can be used with any glass, not just the compatible glasses, as they are not made from glass and therefore do not have the compatibility problems. Strictly metals have a different co-efficient to glass and therefore no metals are compatible with glass. But if we use the softer metals such as copper, silver, gold, and aluminium, they will be tolerated in small quantities by the glass. This is because glass does not bond to metal as much as it does to another glass, and there is some tolerance in the metal itself. Hard metals are impossible to use because they have such a low co-efficient, radically different from glass. However, excessive amounts or thicker sections of even soft metals can still cause problems, so it is best to use foils and thinner wires. Mica can be used in small quantities for the same reasons.

Fusing stringers.

Compatible sheet glass, frits confetti and rods.

Copper in a large fused glass panel.

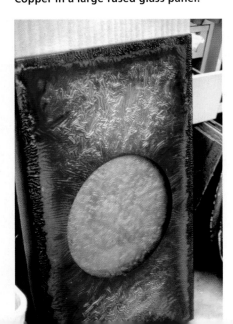

Copper
foil and
wire.

DICHROIC GLASS

Dichroic glass was originally developed by NASA for use in optical lenses in satellites and spacesuit visors. It is made from sheet glass coated with multiple layers of metal oxides which give the glass interesting optical properties. The metal oxides are vaporized in a special chamber, and the vapour then floats upward and attaches onto the surface of the glass in the form of a crystal structure.

When many coatings have been applied to the glass, colours appear on the surface of the glass. As light hits the glass, it either passes through or is reflected by the coatings. This causes a range of colours to be displayed, which shift as the glass is viewed at different angles.

The metal oxides used are derived from silicon, magnesium, zirconium, aluminium, chromium, titanium, silver and gold.

As a decorative material dichroic glass is used for fusing, and since it is essentially layers of oxide deposited onto sheet glass, it can be obtained in a variety of compatibilties, such as Bullseye compatible, float compatible etc.

Dichroic glass can also be obtained with a clear or black base. Patterned dichroic glass can also be obtained – this is made by either masking the glass whilst the dichroic layers are being added in the chamber, or etching the coating with a laser.

Here are some common colour combinations for the Transmitted and Reflected colours you will see in dichroic glass. Note that on black base glass you only see the reflected colour:

Transmits	Reflects
Yellow	Violet
Yellow	Purple
Yellow	Blue
Pink	Teal
Magenta	Green
Blue	Gold
Cyan	Copper
Cyan	Red
Cyan	Dark Red

Dichroic glass.

'Circle of Light', Frome Community Hospital, Helga Watkins-Baker, 2008, Dia: 2.5m.

There is also a range of powders, frits, stringers and confetti which are compatible with float glass. These have been especially made to match the co-efficient of most float glasses, and provide a cost-effective way of working with colour on an inexpensive clear glass.

Glass for Casting

Casting requires a different form of glass from the sheet glass used for fusing and slumping. A variety of sizes of glass can be used, from frits through to large blocks of glass, all of which will give a different effect in the glass when it has been cast. The larger the block of glass used to cast from, the more transparent the finished cast glass will be (assuming you are casting from transparent glass). Frit or chunks of glass, on the other hand, will trap more air and produce air bubbles, leading to a more 'diffused' effect, while the smaller frits for example will make a much more opaque effect in the glass.

Glass frits, chunks and ingots, or 'cullet', are now produced by some of the leading art glass manufacturers, as there has recently been renewed interest in this technique and more

Billets for casting glass.

Compatible glass frits.

demand for high quality cullet. Previously, glass artists had difficulty, and had to obtain cullet from wherever they could find it – cast-offs from glass-blowing studios or crystal manufacturers. If no other glass was available they would crush bottle or sheet glass, with often poor results in the cast-glass produced. The key to good glass-casting is the quality of the glass, and this is why obtaining glass from glass blowers or manufacturers of lead crystal would help with this issue – the addition of lead to the glass meant an easy flowing, clear glass perfect for casting. However, as the demand for decorative crystalware has reduced over recent years, lead crystal has been more difficult to obtain.

Bullseye, Spectrum, Uroborus and Gaffer Glass all produce frits, ingots or 'billets' for use in glass-casting. These are high-quality glasses which have been made especially for the glass caster, in a variety of colours. The ingots or billets are particularly useful for obtaining larger blocks of glass and therefore much clearer casts. The Gaffer Glass range of casting billets is also made from 40–45 per cent lead glass, which means it is very soft and excellent for casting. Some of these glasses are compatible within the range of glass produced by that manufacturer, i.e. the Bullseye casting billets are compatible with their fusing glass, leading to many possibilities for creative freedom. Powders and frits can also be used on their own to cast more opaque forms, or to add colour to castings from larger chunks or billets.

Materials for Firing

There are certain materials which are needed by the kiln-former in order to prepare your glass, and the kiln, for firing.

Fusing Glue

This is used to hold assembled glass pieces in position when assembling and prior to firing in the kiln. Many glues are produced specifically for fusing, so they are guaranteed to leave no marks or residues on the fired glass. Watered-down PVA glue can be used, but this must be tested first to ensure it burns away cleanly.

Batt Wash or Shelf Primer

This is a special blend of refractory materials including zirconium silicate. It comes in the form of a powder which is mixed with water and applied to kiln shelves or 'batts' to prevent glass sticking. Compared to kiln paper it can be time consuming to apply, as it needs to be painted on in many layers and dried, but it has the advantage of lasting for many firings. It is essential for coating slumping moulds and forms which kiln paper cannot line.

Kiln Paper or Ceramic Fibre Paper

This eliminates the need for batt wash or shelf primer, and is used for lining the kiln shelf quickly. It is made from thermal ceramic fibres, and comes in a variety of thick-

Ceramic paper for kiln.

nesses, from 1mm to a thick blanket used for insulation in kiln construction. The thicker papers can last for a number of firings if treated carefully. The thicker papers can also be used for carving relief to slump glass into. One disadvantage is that the fibres are bound with a glue which needs to be pre-fired to prevent a haze forming on the fired glass. A much thinner paper, which is as thick as a sheet of paper and is impregnated with ceramic binder, is available, which is smoother and needs no pre-firing, but can be used for only one firing.

Safety note: *Due to their ceramic nature, these materials need to be cleaned from the glass and kiln wearing a dust-mask, and preferably with a vacuum cleaner.*

Ceramic Fibreboard or Duraboard
Used for forming shapes to fuse or slump glass over. Sometimes used with Mould Hardener, it is brush applied to the board to harden your mould. Can also be used as more basic kiln shelves.

Safety note: *Ceramic content – cut and handle wearing a dust-mask.*

Mouldable Fibre
A ready-to-use wet, mouldable fibre and mould mix blanket which can be used to take imprints of three dimensional objects such as shells. It can be moulded to any desired shape, and then used in the kiln for slumping.

Kiln shelves.

Modelling and Mould-Making Materials

We will now look at the materials necessary for creating moulds for kiln-forming glass. Many of the materials are available from art glass suppliers, but it can be useful to look at other suppliers such as potters' and sculptors' suppliers for more economical sources of some of the materials, such as the clay, plaster and silica, and wax.

CLAY
Used purely as a modelling material, it is not fired. The best type to use is smooth buff clay, or any other smooth clay without any grog. Avoid terracotta clay as this can contaminate the mould.

Clay for modelling.

Plaster and flint for mould making.

FIBREGLASS STRANDS

These are added to the mould mix to provide extra strength to the mould. You will need fibres which are preferably 10mm long or more. They are often called 'soft loose strands' at fibreglass suppliers.

WAX

There are many different wax blends for glass mould-making. Some are good for modelling, others for pouring, and there

Microcrystalline wax.

PLASTER

You will need potters' or fine casting plaster for making glass-casting or 'refractory' moulds. Both forms of plaster can be obtained from potters' suppliers.

SILICA – QUARTZ OR FLINT

This is added to the plaster to make the refractory mould, to strengthen it for firing in a kiln. Both flint and quartz are forms of ground silica, which bind the plaster particles together at high heat. There is no difference between the two materials for mould-making, except that flint is often packed slightly damp, which can help minimize dust when working with it.

Safety note: *Respiratory masks should always be worn when working with silica materials.*

are even very hard waxes for machining and tooling, but a good all-purpose wax is made from a blend of microcrystalline and paraffin wax. It is soft enough to model when warmed, but can also be used for pouring.

SILICONE OR GELFLEX

Both of these materials are used for making flexible master moulds, or just for pouring to capture detail on certain materials. Silcone is a cold compound, and takes excellent impressions, but is relatively expensive. Gelflex is a vinyl compound and needs heating, which can be laborious, but has the advantage that it can be reused.

Safety note: *Always heat Gelflex in a controlled manner, preferably in a special thermostatically controlled melting pot, as it gives off fumes when overheated.*

Glass cutter.

TOOLS AND EQUIPMENT

As we come to look at the equipment needed for kiln-forming, it can feel as though costs are escalating dramatically, especially when looking at the price of purchasing a kiln. A kiln is an essential piece of equipment, but it may be possible to hire or even share kilns with other makers, to keep costs down. We will look at kilns in a separate section towards the end of this chapter.

First we will look at the basic tools and apparatus necessary for kiln-forming techniques, but it may not be essential for you to obtain all of these items to begin with. You may start with what is necessary for creating fused work – for instance a glass cutter, pliers, fusible glass and the use of a kiln – and as you progress through techniques, gradually build up the equipment in your studio.

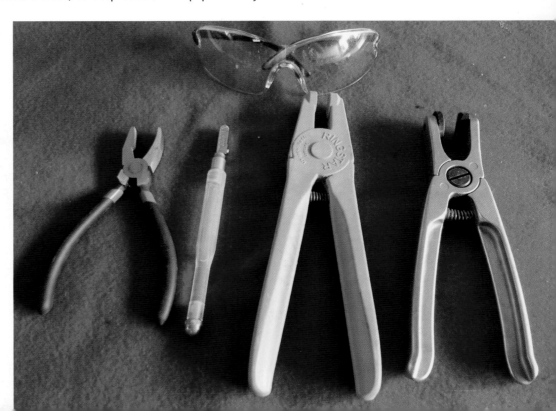

(*above*) Safety glasses; (*left to right*) grozing pliers, glass cutter, two types of cut running pliers.

Glass Fusing and Slumping

GLASS CUTTER

This tool is used to score the glass prior to breaking or 'cutting' into shapes. An oil-filled cutter with a tungsten carbide wheel is the best glass cutter to obtain for cutting glass creatively. More basic cutters without an oil reservoir will prove more difficult to learn with, and require the cutting wheel to be replaced more frequently.

GLASS PLIERS (ALSO KNOWN AS GROZING PLIERS)

These are special pliers whose jaws meet only at the end. They are used for gripping the glass as you snap it along score lines. They can also be used for nibbling, or 'grozing' the glass along its edge to trim it.

CUT RUNNERS

These special pliers are placed at the end of a score line and apply pressure to the back of the glass to snap it apart. They can only be used for straight and slightly curving score lines.

Glass Grinder

This piece of equipment is not essential, but it is used for grinding the edge of glass when score lines have not broken evenly, or to shape a piece of glass after it has been cut.

CUTTING SQUARE

This is basically a large ruler/set square useful for drawing the glasscutter along when scoring your glass.

SAFETY GLASSES

These are essential when cutting glass.

HAIK BRUSH

This is very fine brush used for applying batt wash, as it leaves minimum brush marks.

Glass Casting

The equipment you will need for glass-casting is mainly centred on modelling forms and making refractory moulds.

MODELLING TOOLS

These can include clay modelling tools, and indeed any objects which you find useful for mark making and shaping clay and wax.

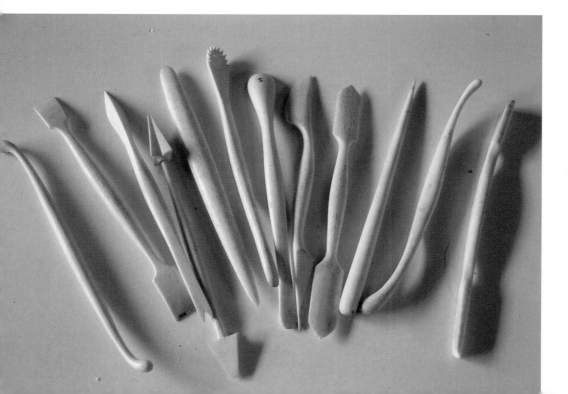

Modelling tools.

A wax melting pot.

BOWLS AND BUCKETS

Flexible plastic bowls and buckets are useful for plaster-making. Silicon bowls are very flexible for breaking plaster out, but they are not necessary for beginners.

LARGE MEASURING JUG

SCALES

These should be able to measure a minimum of 3kg, and preferably be of a type which allows you to reset the weight to zero with the weight still on the scales, so that you can measure weights greater than 3kg.

CONTIBOARD OR COATED CHIPBOARD

This board is cut to form barriers or 'cottles' for retaining mould mix when pouring moulds.

CLAMPS

For holding boards or cottling in place. The type that are a foot long or larger and have a trigger-clamping action are particularly useful.

WALLPAPER STEAMER

Used for steaming out wax.

WAX MELTING POT

You can obtain special thermostatically controlled melting pots for melting wax. These are quite expensive, but an alternative is to use a slow cooker, which will heat the wax slowly and gently.

Safety note: *Always heat wax in a controlled way as it can spontaneously combust if allowed to get too hot.*

KILNS AND CONTROLLERS

There are many kilns which have been designed for kiln-forming glass. These are often available from art glass suppliers, but also from specialist kiln manufacturers. A kiln consists of a metal box, insulated with ceramic material, with electrical elements inside. (Gas kilns cannot be used for kiln-forming glass, since the burners cannot be controlled accurately enough for the firing temperatures required.) The size of the kiln for glass use can vary from something which is a foot square internally up to kilns the size of a double bed.

Kilns used for fusing and slumping will differ slightly from those predominantly used for glass-casting. Fusing kilns are usually flatter rather than taller, so that there is a greater surface area for fusing flatter objects, with elements in the lid; these are often referred to as 'flatbed' kilns. A glass-casting kiln on the other hand is usually simply a ceramic kiln, and is taller rather than flatter, with electrical elements in the side walls. Both types will actually work for all techniques of kiln-forming glass, but the diameter and depth will determine the size of work you can produce. Another major difference will be in the rate at which you heat the glass. Top-heating kilns can be heated approximately 5 per cent per minute faster than the side-heating variety.

Here is a list of the constituent parts of a kiln, so that when they are referred to elsewhere in the book you will have an idea of their function:

KILN TERMS

Elements	High temperature coiled wire; when electricity passes through them, they glow and give off heat.
Thermocouple	A sensor for measuring temperature, which opens as a contact when it reaches a specified temperature; it acts like a temperature switch.
Pyrometer	A probe which reads the actual temperature at a point in the kiln, shown on the controller as the current temperature; usually covered in a ceramic sleeve.
Fire bricks	High temperature insulation used for lining kiln.
Ceramic blanket	High temperature insulation used for lining kiln; also referred to as kiln fibre or ceramic fibreboard.

A pyrometer.

A small flatbed kiln.

A large flatbed kiln.

KILN FIRING RECORDS

Keeping a record of all your firings is an essential part of learning how to kiln-form glass.

A firing log will help you keep track of what conditions you fired the glass under, what glass you used, the firing schedule and the outcomes. As there are so many variables when firing glass, maintaining this record each time helps you to record and assess the different outcomes you may achieve, and why they are happening. Without this record, you will soon forget what you did with different firings, and valuable information will be lost.

Over time as your records build up they will become a valuable resource which will help you with future work and projects.

Example of kiln firing log.

Kiln Used	Date	Glass Used	Colours	Thickness
Laser F6	25th June 2010	Bullseye	Light Orange striker 1025 Fuchsia 1332	3mm 3mm

Start Time	Aims
Friday 5.00 pm	To full fuse two layers of glass, with some areas of copper foil. Will slump in square sagger.

End Time
Saturday 11.30 am

Firing Schedule	°C/hr	to	°C	Hold
	150°C/hr		515°C	
	999°C/hr		760°C	30 mins
	999°C/hr		516°C	30 mins
	75°C/hr		370°C	
	150°C/hr		200°C	
	End			

Kiln Preparation / Position in Kiln
Thin Fire Placed in bottom of kiln on fibreboard

Results
Worked well - Striker fired to nice colour Very small amount/mottling devit around edges

Notes	Drawing/Photo
Devit from glass not sufficiently clean? Try with clear/iridescent next time?	

Controllers

A controller is a computerized device which helps manage the firing of the kiln. It is the second most important piece of equipment after your kiln. The kiln must have the means to accurately check and display the inside temperature; this is usually done with the pyrometer, which gives a precise reading of the temperature in the kiln. This is connected to the controller, which can be pre-programmed to increase or decrease temperature at specified intervals, and is able to control the whole schedule for the firing of your glass.

You must ensure that you obtain a controller that is sophisticated enough to control glass-firing – it is worth investing in a good controller from the beginning, as you can always move it on to another kiln. You will need a controller that can be programmed with multiple ramps, positive or negative, i.e. heating or cooling, and which can also link programmes together. Some controllers come with a variety of pre-programmed firings which are almost always for ceramics, and should not be used. Once you have a regular kiln schedule worked out for a particular firing most controllers allow you to save it in its memory as a user defined program.

Kiln programmer/controller.

Kiln programmer/controller.

HOW TO SET A CONTROLLER

One of the most challenging aspects of running your kiln is programming and setting your controller. This involves setting the heating ramps, the soak, and the annealing and cooling rates.

Many controllers work with different expressions for heating over time, for instance degrees per minute or hour to a set point, i.e. 100°C per hour to 600°C, or by heating to a set point in a certain length of time, i.e. to 600°C in 6 hours or 360 minutes. This can lead to confusion if you have ever worked with one system and then use a controller with another. Here we will look at programming a basic firing for float glass into two types of controller. Both the programs have the same ramps and set points, just expressed in different ways.

CONTROLLER 1

(This controller expresses ramps as set points over a length of time.)

Press the personal program button followed by the arrow button (→) to choose a program number to begin inputting the cycle – Program 1.

Press → and enter the first temperature you want the kiln to reach – 550°C, press ↑ and the time to do this in – 165 mins (2¾ hours).

Press → and enter the second temperature you want the kiln to reach - 820°C, press ↑ and time to do this in – 10 mins (the kiln cannot actually reach temperature in 5 mins, but programming this short time just means that the controller will fire kiln elements continuously).

Press → and enter temperature to soak at – 820°C, press ↑ and enter amount of time for soak – 20 mins.

Press → and enter the first temperature to cool to – 550°C, press ↑ and enter time taken to do this – 5 mins (again, controller will not fire elements at all so will crash cool to annealing temperature).

Press → and enter temperature to soak at for annealing – 550°C, press ↑ and enter amount of time for soak – 10 mins.

Press → and enter the second temperature to cool to – 450°C, press ↑ and enter time taken to do this in – 120 mins (2 hours).

Press → and enter the third temperature to cool to – 150°C, press ↑ and enter time taken to do this in – 120 mins (2 hours).

Press End and then Start, firing begins.

CONTROLLER 2

(This controller expresses ramps as rates of temperature increase to a set point.)

Press the step button followed by the arrow buttons (↑↓) to choose a program number to begin inputting the cycle – Program 1.

Press → and input a delay to the start of the firing (if you want one), otherwise leave at 00.00 to start firing without a delay.

Press the right arrow button (→) and enter (↑↓) the first rate of temperature increase you want, press → again and enter the set point temperature you want kiln to reach – 200°C per hour to 550°C.

Press → and ignore the soak, press → and enter the second rate of temperature increase you want, press → again and enter the set point temperature you want the kiln to reach – FULL (or 999°C per hour) to 820°C.

Press → Enter amount of time to soak at 820°C – 20 mins.

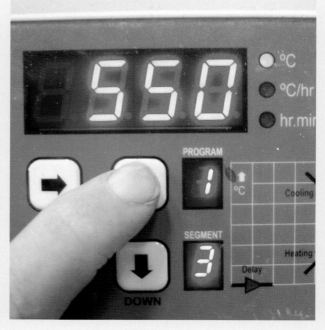

Press → and enter the first rate of temperature decrease you want, press → again and enter the set point temperature you want the kiln to reach – FULL (or 999°C per hour) to 550°C.

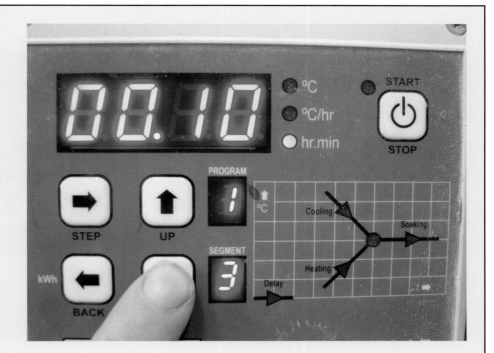

Press → Enter amount of time to soak at 550°C – 10 mins.

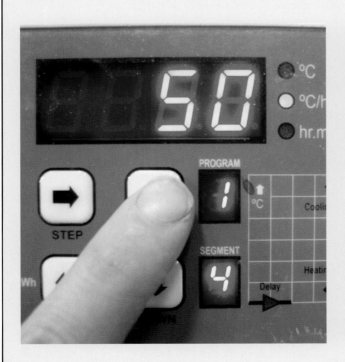

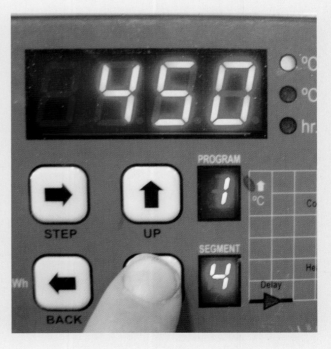

Press → and enter the second rate of temperature decrease you want, press → again and enter the set point temperature you want the kiln to reach – 50°C per hour to 450°C.

Press → and ignore the soak, press → and enter the third rate of temperature decrease you want, press → again and enter the set point temperature you want the kiln to reach – 150°C per hour to 150°C.

Press → and ignore the soak, → so that End is displayed.

Press Start, firing begins.

One option for limiting the cost of buying a kiln is to buy a second-hand one. These are usually ceramic kilns, as it is very difficult to find second-hand glass kilns, which can be used both for fusing or casting without any major concerns. It is sometimes claimed that you cannot fire glass in a ceramics kiln, but this is simply untrue and is probably just sales talk. The position of the elements is also cited as a reason for needing to buy a fusing or flatbed rather than a ceramics kiln, as elements in the top of the kiln help with even firing and greater control over the temperatures inside. This is true to some extent, but not always so – if you find a second-hand ceramics kiln within your budget or you mainly want to cast glass, then it is worth making this sacrifice. The main issue when fusing or slumping with taller ceramic kilns is that you need to assess where your pyrometer, or temperature reader, is positioned in relation to your glass. If it is reading the temperature at the top of your kiln and your fusing is happening near the bottom, the glass will be at a much lower temperature than your pyrometer reading, so you will need to increase your firing temperatures to compensate.

Safety note: *Always make sure you get second-hand kilns checked and installed by a qualified electrician.*

Finishing Equipment

There is a variety of equipment which can be used for finishing your glass pieces, from small to large scale apparatus, which we will look at more closely in Chapter 9.

Now that we have a general overview of the materials and equipment which you will need to begin working with kiln-formed glass, we will look at the possibilities for creating work in a variety of techniques, beginning with the kiln-forming methods of fusing and slumping glass.

Upright/front opening kiln.

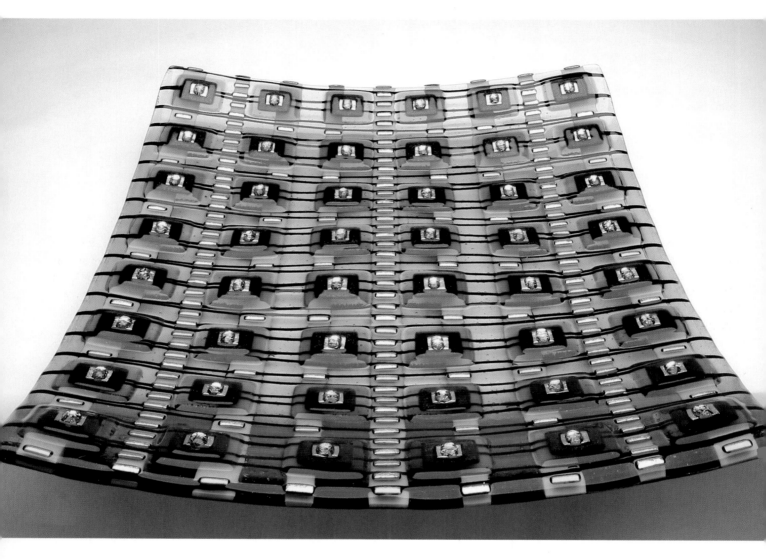

'OP4', Sally Dunnett, fused glass, prefired components, slumped, L: 40cm, W: 30cm, D: 5cm.

FUSING AND SLUMPING

Fusing glass in a kiln can often feel like an alchemic experience, as the kiln door is opened after each firing to witness the magical transformation of sheet glass, powders and metals into a new glass artwork, with striking colours, metallic effects and sometimes a new form. For many, this transformation can become addictive, and is the beginning of a quest to explore the creative possibilities of kiln-formed glass.

Kiln techniques for glass, and in particular, fusing and slumping, have increased in popularity enormously in recent years, mainly because of the accessibility of fusing materials and the relative straightforwardness of the fusing technique. The availability of compatible sheet glasses and production of smaller kilns, specifically made for fusing glass, have made the technique even more accessible.

The techniques of fusing and slumping often go hand in hand, because they both focus principally on sheet or flat glass. Glass pieces made by fusing sheet glass together flat in the kiln are often treated to a second slumping firing. We will now look at an outline of the techniques, followed by guides to creating your first fused and slumped projects.

Fusing is a term used to describe the process of bonding two or more pieces of glass to each other, using the action of heat. In simple terms this means that when glass is heated in the kiln and becomes soft and 'sticky', it bonds to or merges with any other pieces of glass it is in contact with. The technique is most commonly used with sheet glass as a material, although technically other kiln forming methods such as *pâte de verre* embrace the principle of fusing. In the *pâte de verre*

'Waterscape', Karen Lawrence, 2008, kiln-formed glass: fused, etched, textured float glass, gold leaf, L: 5.5m, W: 1.5m, commission for Guy's and St Thomas' Charity, sited at Bereavement Centre, St. Thomas' Hospital, London (Photograph by John Haxby @ The Art Surgery).

'Phosphorous Shell Bowl', Steve Robinson, Kiln fused and slumped glass with enamels, D: approx 42cm.

technique glass powders or frits can be taken to a heat where they just 'stick' to each other, forming a glass structure from the bonds between the grains of glass.

For fusing sheet glass, factors such as the temperature the glass is taken to, the volume of glass used, the colours placed in the assemblage, and the inclusions incorporated into the glass will all affect the outcome. Another key element of fusing sheet glass is cutting and shaping the glass to affect the outcome of the fused piece. For instance, cutting two square pieces of glass that match in size exactly will produce a fused glass tile with a precisely fused edge – mismatching the sizes slightly will produce an irregular 'stepped' edge. We will look at these and many other factors involved in fusing glass shortly.

Slumping is a very descriptive term. It refers to the technique of bending or moving glass to create new shape, form or texture. Slumping involves heating the glass to a temperature where it softens enough to slump into or over moulds. There are various terms used for this method of kiln forming, such as bending, sagging, moulding and draping, but they all refer to the same physical event – the deforming of glass as it is heated, so that it moves or 'slumps', through the action of heat and gravity. The technique is most commonly associated with sheet glass. In industry it is used in many contexts, on a large scale, to create everything from bent glass windows and car windscreens to glass basins and shower screens.

For the glass artist it can be used in a variety of ways to change the shape of glass. For instance, sheet glass can be slumped over a mould to create a bowl or vase. Most often a glass piece which has been previously fused, but is flat, is

'Nest', Paula Rylatt, fused and slumped glass, hanging, L: 66cm.

'Swarm', Lisa Pettibone, enamelled 4mm Artista clear (both sides), slumped on ceramic props, H: 16cm, W: 27cm, D: 25cm.

slumped in this way to create a vessel. Other ways of working with the technique enable us to create more detail on the surface of the glass itself. The glass can be slumped over a mould, or fire resistant material such as sand or kiln paper, to create texture and detail on the back of the glass, as it slumps over the material underneath. Slumping is a very versatile way of adding form to flat glass.

FUSING

We will now look at the principles of fusing and a number of projects which can be achieved with this technique.

Temperatures

One of the most important factors to remember when working with fused glass is that there are various effects which can be achieved by controlling the temperature the glass is taken to. These can be termed the 'tack', 'mid' and 'full' fused stages. Each of these stages is dependent on the top temperature which the fused glass assemblage is fired at. In reality there are an infinite number of these stages, because, as we have seen, glass gradually becomes more fluid and therefore as it softens it loses shape, creating a multitude of effects and forms. However, it is more convenient to classify these effects into generally three categories of heat and fluidity.

The 'tack' fused process involves heating the glass until it becomes tacky but not fluid, to a point at which it bonds together but with the glass retaining well-defined edges and shape. This is achieved at temperatures from around 700° to 750°C, depending on the glass used and the amount of time the glass is held at these temperatures. 'Mid' or soft fusing is the term used when glass is taken to a temperature where individual shapes in the glass can still be retained but with softened edges - this can occur between 750° and 780°C, again depending on the type of glass used. 'Full' fusing refers to the process of heating pieces of glass until they fully merge, so that all the glass flows together forming a flat top surface; edges are fully rounded and any shapes of glass will have lost all their definition. This effect is usually achieved at around 780–820°C. If glass is fired beyond the fully fused stage, it will lose all definition, i.e. edges and form, and start to spread and run as the glass becomes more liquid.

These differing stages in fusing can result in very different effects in the final fired glass, so it is important to experiment with the temperature in your kiln and the effect you desire. Remember that the more layers of glass you use and the higher the temperature you fire the glass at, the larger your fired glass will become, as the glass spreads slightly. This is important, for instance, if you are making a fused panel to fit into a frame. Fully fusing two layers of Bullseye glass, for

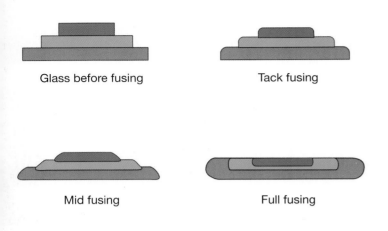

Glass before fusing

Tack fusing

Mid fusing

Full fusing

The stages in glass fusing.

instance, can add 2–4mm of extra area around the glass piece, where the edges round over.

Factors such as the surface tension as the glass melts will affect the final shape as well. For instance, when strips of glass are fused in a lattice type formation, the spaces between the glass will retain a square shape with tack fusing. But when the same lattice arrangement is fully fused the square spaces between the strips will round off, resulting in circular gaps. The volume of glass being fused can also affect the finished form – single layers of glass, with, for instance, shapes fused

Fused float glass.

on top, will contract and draw towards the shapes on top more noticeably than a double layer of glass, because two layers have greater volume and counteract the surface tension.

Therefore understanding the fluidity of glass at many different temperatures will enable you to fully utilize the creative possibilities of the material. Tests and experiments at differing temperatures are essential for developing an intimate understanding of glass and your kiln.

Layering and Encapsulation

Any glass assemblage which is being prepared for fusing involves cutting sheet glass to the appropriate size and shape for the final finished piece. So, a fused glass tile which is square in shape is made from two pieces of sheet glass cut into squares, and layered one on top of the other. These two pieces of glass fuse together and give a fully rounded edge if they are taken to full fusing temperature. If they differ slightly in size then a staggered edge will result, as the two glass edges will not be close enough to flow together. However, you do not have to confine fusing to just two layers of glass – it can involve three or four sheets, or even more – it just depends on the end result required.

A single layer of glass can be fused with shapes of glass laid on top, and can be fired to either the 'mid' or soft fused stage to retain the contour of the overlying pieces, or to the fully fused point to incorporate them fully into the underlying glass – this would obviously be less effective if the underlying sheet glass and the overlying glass pieces were the same colour, as the glass pieces would effectively disappear. Another use of single sheet glass fusing is to fuse powders and frits onto the surface of the glass, rather than trapping between two layers, as this also facilitates the possibility of retaining some surface texture in the powders and frits. In this case the firing temperature would need to be based on the tack or soft fused stages, because if the glass is taken to the full fusing temperature the frits would be fully incorporated into the underlying sheet. Powders and frits can be sprinkled onto the surface of the glass, using a variety of methods to create decorative effects. One disadvantage of firing single sheet fused glass is that unless thicker sheet glass – 4mm or so thick – is used, 2mm or 3mm glass can shrink and contract around the edges when the glass is fired to full fusing temperatures. Also, the resulting fused object can be quite fragile, as it does not have an appropriate thickness of glass to give it resilience.

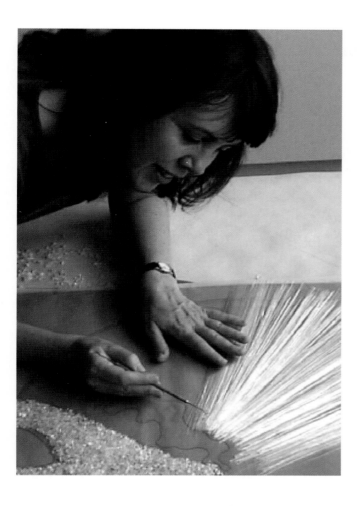

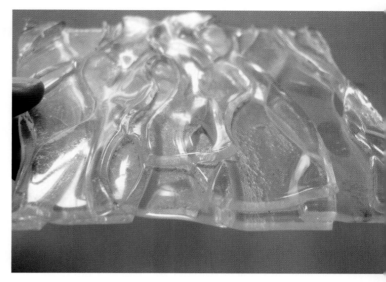

Multiple wavy pieces of glass, mid fused, viewed from edge.

Karen Lawrence assembling glass prior to fusing.

'Flowform', Karen Lawrence, kiln-formed glass: fused, slumped, L: 40cm, W: 40cm, H: 18cm.

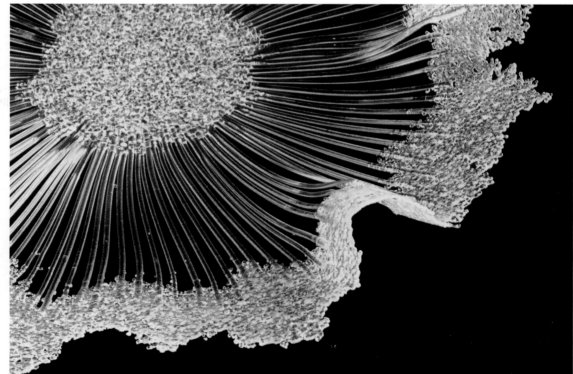

APPLYING POWDERS AND FRITS

Glass-compatible powders and frits are available in a number of grades, from powder form (very fine and easy to sift) through to fine (similar to grains of sugar), medium (compared to coarse sand) and finally coarse (similar to very fine gravel). These can be used in a number of ways to create interesting coloured and textural effects.

SIFTING POWDER

The finest grade of glass powder can be sifted onto the surface of the glass to create an overall 'matte' of colour. This can be worked into sgrafitto style, i.e. by drawing into the glass powder with a pointed tool to create designs and patterns. Stencils, such as paper or card templates, meshes and everyday objects can be used to block certain areas and create patterns and motifs. Combs and serrated card can also be drawn across the powder, forming reeded patterns. Powder can be sifted onto the glass dry, or onto areas of fusing glue, which will hold the powder in place, and any excess can be removed by tipping the powder off onto a sheet of paper.

SPRINKLING FRITS

Fine, medium and coarse grade glass frits are suitable for creating speckled patterns and/or textures on the glass, by sprinkling freehand, or by masking areas with card or objects. These can again be held in place by using fusing glue, spread all over, or painted onto the glass in patterns. Stringers, thin threads of coloured glass, as well as confetti, which are eggshell thin shards of glass, add further decorative effects.

 With skill and practice it is possible to create accomplished visual imagery using powders and frits, and even more so with the use of high temperature enamels in fusing. Artists often work with enamels to depict painterly or near-photographic images which are fired onto or into the glass. Enamels can also be screen-printed on to the glass sheet before fusing.

Safety note: *Always wear a respirator when measuring or mixing dry glass powder.*

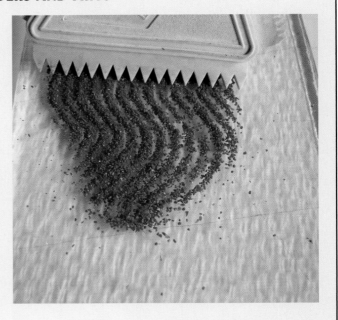

Application of glass powders.

Applying glass powders and copper leaf
(Courtesy Liquid Glass Centre).

'If fish had wings' (Details),
Kylie Yeung, enamelled and
slumped glass, W: 15cm,
H: 10cm (each piece).

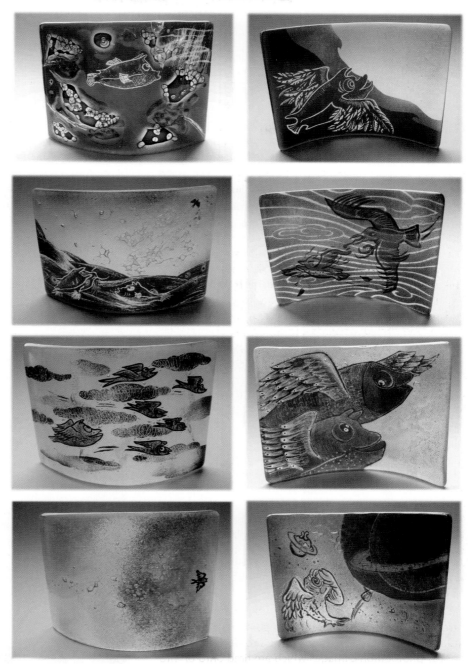

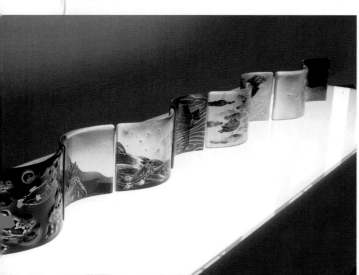

'If fish had wings, Kylie Yeung, enamelled and slumped glass,
L: 128cm, H: 10cm, D: 12cm.

For simplicity's sake two sheets usually provide a suitable thickness in the resulting piece of fused glass, which will be fairly strong and also provide the opportunity for incorporating inclusions into the assemblage. These can consist of glass powders and frits, as we have seen, glass stringers and confetti, as well as other materials which are able to withstand high temperatures. This sandwich of glass and materials is fired in the kiln, where the action of the glass melting together encapsulates the materials inside. Apart from glass powders, frits and enamels, materials suitable for inclusion include metals, micas and certain organic objects. Common sense is the key to deciding what and what cannot be included. Nothing which is overtly flammable, like paper or cardboard, should be used, nor should inorganic compounds such as plastics, which will burn and give off noxious fumes. Organic objects such as plant leaves, thin twigs, small shells and bones can give interesting effects, but they will change when fired. They will carbonize in the firing procedure, resulting in ash

METALS/MINERALS FOR INCLUSIONS AND THEIR EFFECTS

Copper Carbonate	Green to blue bubbles
Copper Powder	Red and dark green, through to blue bubbles
Copper Leaf	Green to blue bubbles
Copper Foil	Dark red, red and dark green/ blue
Copper Wire/Mesh	Dark red to blue
Silver Leaf	Metallic yellow
Silver Foil	Dull silver
Silver Wire	Dull silver
Gold Leaf	Dull gold or yellow, occasionally pink
Aluminium Foil	Silvery black
Aluminium Mesh	Silvery black
Brass Leaf	Brown or dull brass
Brass Foil	Brown or dull brass

Bubbles and more striking colour effects tend to be achieved with higher firing temperatures, of around 800°C or more.

Copper foil fused in glass.

Copper leaf fused in glass.

Mica powder.

Mica fused in glass.

remains sealed in the glass which may retain the form or patterns of the original object. Leaves such as ivy and fern are good for this effect.

Large quantities of metals, such as coins or washers, may cause compatibility problems, as they will not move with the glass as it contracts, but thin or smaller sections of the soft metals, such as aluminium and copper, are very suitable for inclusions. These metals will change colour. Aluminium tends to turn black when fired. Copper on the other hand turns to a variable colour ranging from a reddish-orange to a bluish-green, depending on its position in the glass assemblage, and at what point it is deprived of air as the glass fuses together and encapsulates it. Silver leaf can react with the glass to create a yellow effect. It is advisable to experiment with metals to determine the precise effects achieved in your kiln and with different projects. There should be enough glass around objects or materials for insertions to be sealed inside the glass. Best results are obtained when the object is completely sandwiched between layers of glass. Remember that metals do not melt into the glass when fired, they merely stick to it, and sometimes not very well, so they must be fired between sheets of glass to fully encapsulate them if they are to be permanent. For this reason metals are rarely fired on the surface of the glass.

Mica has become very popular recently as a material for inclusion. It is a mineral from the silicates group, and is found in layers of rock. Its name is derived from the Latin word *micare*, meaning 'to glitter'. It can be used in fusing because it is highly resistant to heat, and unlike metals, does not change colour or appearance when it has been through a firing cycle. It is ground into a powder for use in fusing, and can be sprinkled or mixed with fusing glue to add sparkle and shimmer to the assemblage. As with metals, mica must be encapsulated between fused glass layers, as it does not stick or bond to glass at all, and if fired onto the surface of glass will simply brush away afterwards.

One further substance which needs to be mentioned in the context of encapsulation is air. Creating bubbles in fused glass to order is another area which artists explore as part of their decorative palette. This can be achieved in a number of ways. The first is to use textured glass in the assemblage. Random small bubbles can be realized by laying textured glass with the texture facing inwards in the glass stack, as air is more likely to be trapped between the two layers of glass as they fuse together. More regular bubbles can be achieved by using a certain type of textured glass known as reed glass, which has regular straight lines of texture incorporated into the sheet glass. This can be particularly effective if two layers of reed glass are used, texture facing inwards, with the lines at right angles to each other. A similar method is to use glass stringers laid at angles to each other, sandwiched in between two pieces of glass, which will trap air and create bubbles. Even glass frits, when coarse grades are used, or laid thickly, will trap bubbles.

Bubbles caused by air trapped between pieces of glass frit.

Fused glass with various effects.

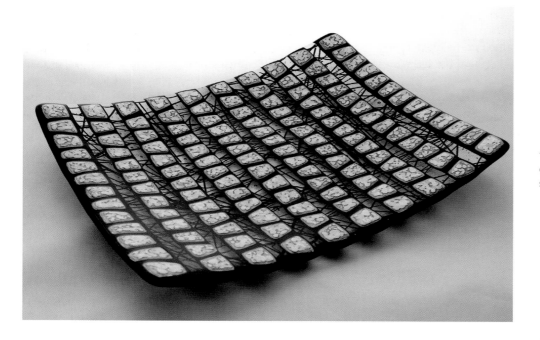

'OP12', Sally Dunnett, fused glass, prefired components, slumped, 30×30cm.

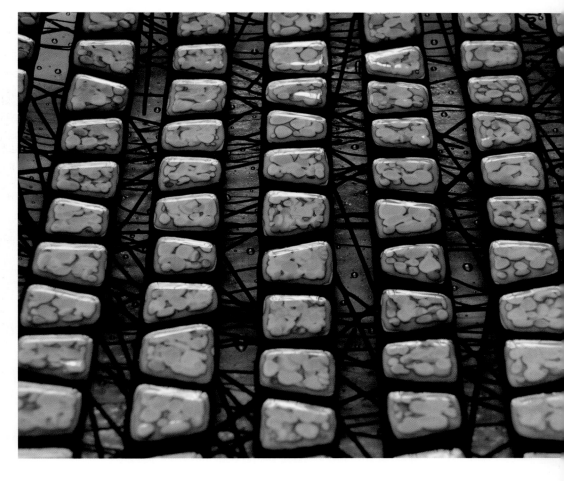

'OP12' (Detail), Sally Dunnett,
fused glass, prefired
components, slumped.

Another method for creating bubbles is to dot very small quantities of a mineral oil, such as sewing machine oil, on the surface of the bottom piece of glass in the stack, and laying the top piece over, thus trapping the oil in between. When fired this should produce small bubbles. Interestingly, baking soda can also create bubbles in glass, since as it burns it produces carbon, which becomes trapped between the glass as it fuses. It can be sprinkled or mixed with water or fusing glue and painted onto the glass. This method is much more unpredictable, and can produce very large bubbles, which may break through the surface of the glass, so it should be used sparingly.

Most of the time you may find you are looking for ways of avoiding bubbles in fused glass, so the techniques outlined above should be borne in mind if you find unwanted trapped air. This usually occurs because of texture or smaller pieces of glass 'locking' the air into the assemblage, and repositioning pieces of glass, or firing sheet glass smooth side inwards, may solve these problems.

It is worth experimenting with powders, frits, inclusions of metal and other materials, and bubbles, to explore your creativity within the technique of glass fusing, achieving your own individual expressions in glass. These materials can be combined in a multitude of effects, for instance coloured powders used with metal leafs, or shapes cut in metal foil added to patterns in frits – the possibilities are endless. Any of these methods and ideas can be also be incorporated onto multiple layers of glass and fired as a stack, creating interesting effects within the glass. We will consider this and other fusing techniques later in this chapter.

Fusing Projects

We will now look at three projects which will enable you to begin to understand the process of fusing glass. These simple ideas can be easily achieved and will develop your skills and knowledge as you work through them.

CUTTING SHEET GLASS

All fusing and slumping work with sheet glass requires you to cut sheet glass into various shapes. The technique is very similar to cutting tiles, in that the surface of the glass is scored with a small and very hard tungsten wheel. The glass is then snapped along this score line, or tapped from below to encourage it to follow the score line as it breaks. Here we will look at the precise cutting technique for sheet glass.

Take a glass cutter and hold it at the edge of the sheet of glass which you would like to score (practise with scrap float glass to begin with). Use your arm and body weight to apply firm but even pressure, as you push the glass cutter forward across the surface of the glass, creating a score line. You should be able to hearing a loud scoring noise as you push the cutter along. Make sure the cutter is lubricating the score line with oil as it moves along. If you hear no noise, you are not pushing down firmly enough. If the glass snaps and jumps apart as you are scoring, you are pushing down too firmly. Practice will enable you to get the right balance. You must always score from one side of the glass to another – you cannot stop a score line mid-way through a sheet of glass, or score an acute angle.

Now you have a score line, you must break the glass along this line. For straight lines it is usually possible to snap the glass along the line, either by holding the two edges of the glass at the bottom edge of the beginning of the score line, and twisting upwards, or by using a pair of cut run pliers. If your score is a curving line, you will usually need to tap the score line underneath with the brass ball on the end of your glass cutter, to draw the score down through the glass by manually 'shocking' it by tapping. This is because glass usually tries to break along the easiest route to the edge, which is a straight line, so in order to achieve a curve we must coax it along by tapping, always underneath. Avoid tapping glass when cutting straight lines, unless you really have to, as it tends to lead to an irregular edge on the glass.

Cutting sheet glass requires practice to achieve certain complex curves and shapes, so keep trying until you have mastered the technique – it will not take long.

Using glass cutter ball end to tap a curving score line.

The glass separates and is 'cut'.

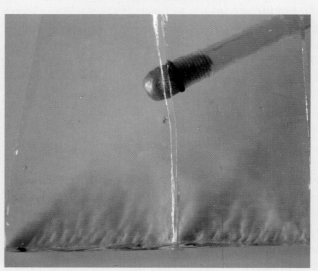

A glass cutter ready to score glass.

PROJECT 1: GLASS SAMPLES

This project is a simple exercise in glass fusing, which will enable you to build up a collection of fused glass samples of various inclusions and effects, for future reference.

1. Cut small squares of 3 or 4mm float or window glass, about 50mm by 50mm square, or any similar size you would like to make, matching pairs of glass pieces in size as precisely as you can. Clean the glass pairs thoroughly with glass cleaner (any proprietary glass cleaner will do). Each pair of squares will form a fused glass sample of a different inclusion.

2. Now lay different samples of glass powders onto the bottom sheet of glass. Use effects such as stencilling, painting, sprinkling etc. Use different metals and micas, experiment with inclusions.

3. Lay the other square over the top of the first, using fusing glue to secure if necessary. You may find that with chunky wires, coarser frits etc. you will need to use glue to stop the top piece of glass from sliding off, but avoid using excessive amounts.

4. Place in the kiln on a kiln shelf treated with batt or kiln wash, or covered with kiln paper, and fire using **Firing Schedule 1**.

5. Remove from kiln when cool, clean off fired kiln paper or batt wash wearing a respirator, or by vacuuming residues.

6. Cut more squares and you can make many more than the ten samples if you wish, helping build up a repertoire of different effects.

Glass samples (Courtesy Liquid Glass Centre).

APPLYING BATT OR KILN WASH

Batt wash, also known as kiln wash, is a coating which prevents glass from sticking to kiln shelves and ceramic and metal moulds. It is made from zircon, alumina and China clay. It is worth making an effort when applying batt wash to get it as smooth as possible, since any marks and brush strokes in the surface will be translated into the same textures on the back of your glass. It is also possible to spray batt wash to give a smoother application.

Safety note: *Wear a respirator when applying and removing batt wash.*

1. Mix a portion of the batt wash with water to a milky consistency.
2. Apply with a soft brush (hake or badger brushes are good) a coat of kiln wash to the kiln shelf or mould being used.
3. The batt wash will appear to be translucent at first, but as it dries it will become opaque and powdery.
4. Apply up to two more coats of batt wash, each at right angles to the previous, allowing to dry before applying the next.
5. Let batt wash dry thoroughly before using shelf or mould.

You should be able to use your shelves and moulds for many firings if you follow these instructions. At some point the batt wash will start to crack off – when this happens, scrape it off and reapply. Many kiln workers use kiln paper for ease of use, especially thin fire, but batt wash is more economical in the long run.

Safety note: *Wear a respirator when mixing dry batt wash powder, and when scraping fired kiln shelves.*

Applying batt wash.

PROJECT 2: FUSED GLASS TILE

The next project will enable you to make a small fused glass tile, which could be used as a coaster, for fixing to the wall as a wall tile or splashback, or simply for decorative pleasure. Fused glass tiles are not recommended for floor tiles, as the glass can be very slippery when wet.

1. Cut two glass squares, 100mm by 100mm square, in 3mm compatible glass, one coloured for the base of the assemblage, and the other clear for the top. Make sure both are very clean after cutting.
2. Decorate the surface of the bottom glass piece with coloured shapes of glass, glass powders, frits, stringers, metals etc, or any other combination of inclusions which you have tested.
3. Place the clear piece of glass on top, using fusing glue if necessary.
4. Carefully place in the kiln on a kiln shelf treated with batt or kiln wash, or covered with kiln paper, and fire using **Firing Schedule 2**, adjusting the top firing temperature and annealing temperature according to the compatible glass you have used.
5. Remove from kiln when cool, clean off fired kiln paper or batt wash wearing a respirator, or by vacuuming residues.

ABOVE LEFT:
Powders applied to glass tile with stencils.

ABOVE RIGHT:
Metals as inclusions in glass tile.

LEFT:
Glass frits in fused tile.

BELOW LEFT:
A tile with powders and clear frits.

BELOW RIGHT:
Tile with stringers and frits.

STRINGERS AND RODS

Glass stringers and rods can be used to create lines of colour in a fused glass assemblage. They are made from compatible glass – stringers are drawn into a very thin spaghetti like strip, about 1–2mm thick, rods are thicker at about 4–6mm. They can be laid on the glass to form pattern and detail which will be fused onto the glass. As they are round, they tend to slide around the surface of the sheet glass as you are using them, so they often need to be held in place using fusing glue. Because stringers are so thin they can also be heated and bent into shapes before they are fused onto the surface of the glass or into the stack. Wearing heatproof gloves, and with a kiln shelf or heatproof tray underneath, take a stringer and hold it above the flame of a candle or in the flame of a gas torch for a few seconds, until it starts to glow. The stringer will soften at the point where it is being heated, and can be bent into shapes by softening at various points along the length. The bent shapes can then be incorporated into a fusing assemblage as normal.

Joining and bending glass stringers/rods using a candle.

Bent/manipulated glass stringers/rods for incorporating into fused glass panel (Courtesy Liquid Glass Centre).

You can also make your own glass stringers from rods or small pieces of sheet glass. Rods can also be bent into shapes, but you will need a gas torch for the extra heat needed to melt the thickness of glass. Hold and heat a compatible glass rod or a small strip of sheet glass in a gas torch flame. When it is glowing and molten pull the two ends apart to form a string of glass, or manipulate into shapes using tweezers or pliers. Leave to cool on a kiln shelf.

Safety note: *Be very careful when working with a gas torch – take appropriate precautions.*

Heating glass rod in flame (Courtesy Liquid Glass Centre).

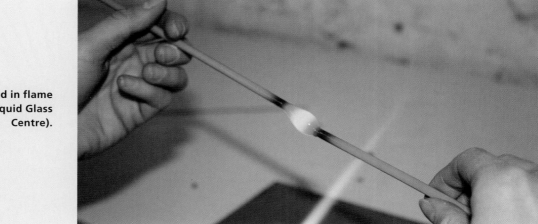

The rod becomes molten and softens (Courtesy Liquid Glass Centre).

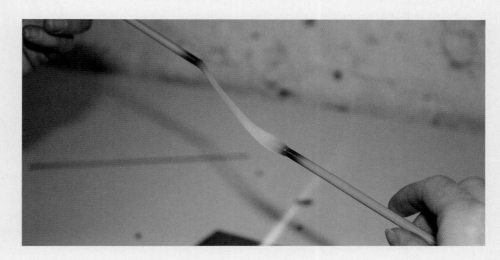

The glass can be pulled to form a stringer or shape (Courtesy Liquid Glass Centre).

PROJECT 3: AUTONOMOUS PANEL

This project will allow you to bring the effects you have learned in Projects 1 and 2 to full fruition, as you will create a fused glass panel for hanging in a window or against a wall, or for fixing in a frame with a backlight. We will be using three layers of glass to create more depth and options for different effects in the layers.

1. Cut three pieces of glass, 300mm by 150mm in compatible glass, one coloured for the base of the assemblage, and the other two clear for the upper layers. Make sure all are very clean after cutting.
2. Decorate the surface of the bottom glass piece with glass powders, frits, stringers, metals etc, or any other combination of inclusions which you have tested. Bear in mind that you will be creating effects on the next layer as well.
3. Make two copper wire hangers by bending wire into a 'U' shape, and insert between the bottom and middle layer of glass, either side along the top edge.
4. Decorate the next layer of sheet glass with glass powders, frits, stringers, metals etc.
5. Place the final clear piece of glass on top, using fusing glue if necessary.
6. Carefully place in the kiln on a kiln shelf treated with batt or kiln wash, or covered with kiln paper, and fire using **Firing Schedule 3**, adjusting the top firing temperature and annealing temperature according to the compatible glass you have used.
7. Remove from kiln when cool, clean off fired kiln paper or batt wash wearing a respirator, or by vacuuming residues.

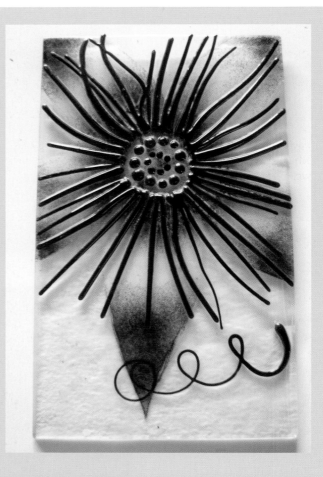

Autonomous panel fired, with manipulated glass rod inclusions (Courtesy Kim Atherton, Liquid Glass Centre).

Assembling autonomous panel (Courtesy Liquid Glass Centre).

GLASS JEWELLERY

Fused glass jewellery has become an extremely popular way of working with small pieces of glass to create highly individual coloured pieces of adornment. The technique is a good way of using up scrap pieces of sheet glass, but has also become a popular method of working in its own right. The decorative possibilities of fused glass jewellery have been greatly extended by the use of dichroic glass, which is very expensive but lends itself to the work very well, with its highly coloured, iridescent sheen.

As dichroic glass is essentially a coating on one side of a piece of glass, you will need to consider the effects which will result after it has been fired. First of all, you need to assess which side of the glass has the coating. This is easy with black base glass, but with clear glass you can hold a pointed object against the surface of the glass. If the reflection in the glass meets the point of the actual object, you are pointing at the coated side. If there is a gap between the object and its reflection, the coated side is opposite.

The test for coated side – point touches its image.

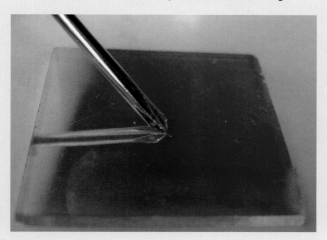

The uncoated side – a gap between point and its image.

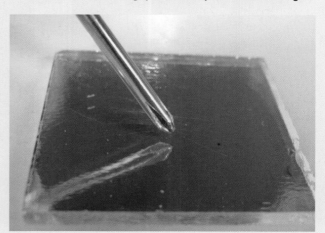

Pieces of glass are cut and stacked, one to three pieces thick, in the kiln. Small pieces of dichroic glass can be incorporated into the assemblage. Where the dichroic glass is placed in the stack will affect the end result – when dichroic glass is fused without a glass covering, i.e. with the coating uppermost, the result is a slightly matt metallic foil effect. With a glass covering, i.e. with the coating laid face down when using clear base dichroic glass, or with a top sheet of clear glass in the stack for clear black bases, the result is a glossy lustrous effect.

Experiment with shapes and layering for jewellery making, because as the pieces of glass are quite small and fired quite hot, squares and corners will often round off.

Fixings can be achieved either by manually gluing metal bails to the fused glass 'cabochons' once they have been fired, by drilling holes in the pieces, or alternatively by incorporating a hanging device into the glass piece before it is fired.

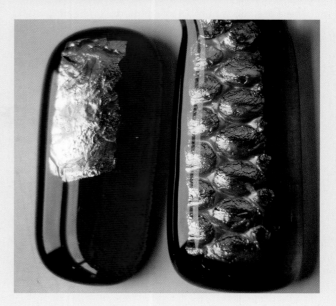

Different effects in fused dichroic glass.

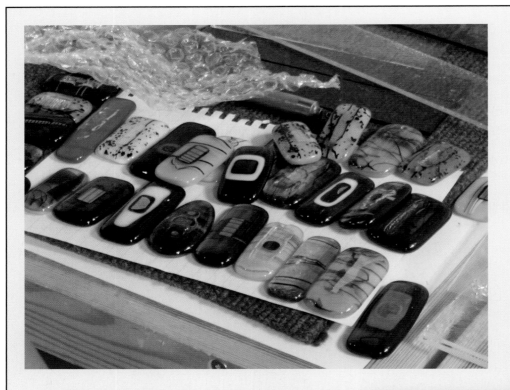

Fused glass jewellery pieces
(Courtesy Liquid Glass
Centre).

Metal hooks made from copper or nichrome wire and bent into a 'U' or other shape can be fired between the pieces of glass, protruding from the edge, to make a hanging device.

There are also a number of methods for creating voids in the fused glass jewellery piece to enable it to hang. The glass pieces can be pre-drilled before firing to create a hole which will take a jump ring. The holes will need to line up as the glass is stacked, and must be at least 3mm in diameter to stop them closing as the glass flows when fused.

Another method is to use a thick ceramic paper cut into thin strips, or to wet a small piece of kiln paper – perhaps 10mm square – and roll it between your fingers to form a small roll of ceramic fibres. These can be placed between two layers of glass in the jewellery piece, lying across the top but allowing glass to protrude above it and with the roll projecting from the edges, before it is fired. As the glass fuses it is held apart along the length of the ceramic roll, creating a channel in the glass piece through which cord or chain can be fed.

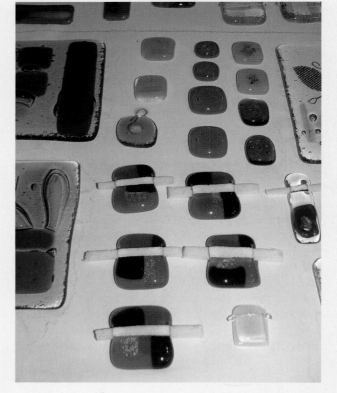

Glass jewellery pieces in kiln (Courtesy Liquid
Glass Centre).

'Weightless', Lisa Pettibone, H: 15cm, W: 30cm, D: 65cm. 6mm float glass slumped on ceramic props. Lisa makes all her own slip-cast ceramic and plaster props for slumping her glasswork.

SLUMPING

Once you have mastered the principle of fusing glass, the next stage in creating form and structure in glass is to look at the slumping technique.

Techniques and Temperatures

As we have seen, slumping glass allows you to bend, shape and manipulate a flat piece of sheet or fused glass using heat and gravity, so that it either slumps or sags *into* the form of a mould which it is placed over, or drapes *over* a mould it is placed on. Slumping always forms the second stage of the two-stage fusing and slumping process, since it is performed using a cooler firing, and the technique needs to be applied to glass after all the effects desired by fusing have been achieved. This means that firing sheet glass flat at a hot firing such as a full fuse, will allow any glass pieces to melt and fully combine. When cooled, the flat fused glass is placed in a mould, and fired at anything from 650° to 750°C, depending on the glass and the mould, to achieve its shape. If we tried to create the same effect from one hotter firing, the glass would fuse but also flow down into the mould, creating a completely different, and more irregular, effect. However, it can be possible to tack fuse and slump in single firings.

It is also possible to suspend flat glass with nichrome wire from a frame in the kiln, using fixed points or holes drilled along the edge of the glass, so that it sags or drapes into free

'Tenya', Lisa Pettibone, fused spectrum (black and clear layers, separate enamelled section cut in), carved, enamelled on several layers and slumped on plaster prop in a steel mould, H: 38cm, W: 25cm, D: 17cm.

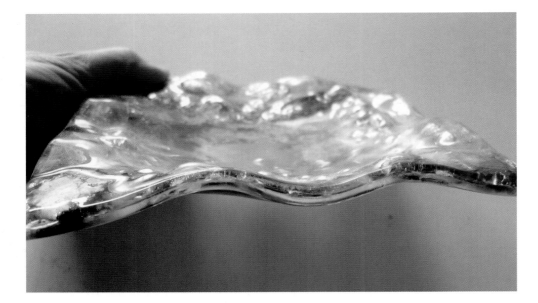

Fused glass panel which has been slumped.

Fused glass panels loaded in a kiln ready for slump firing (Courtesy Liquid Glass Centre).

air. This 'free' slumping is also achieved using the 'drop-out' technique – a metal or ceramic circular ring with a large round or square (or other shaped) hole in the middle is placed in the kiln, supported some distance above the kiln shelf using kiln bricks or props. Sheet or fused glass is laid on the drop-out mould, and as the kiln reaches top temperature, the glass slumps or drops through the opening into the space

underneath. The kiln is held at this temperature until enough glass has passed through to make a cavity of the size you want – this can be as shallow or deep as you need, and is dependent on the height of your props. The deeper the drop-out the thicker the fused glass you start with needs to be – at least two or three layers of sheet glass.

The trick to drop-out and other draping types of slumping is

A dropout slump in the kiln.

Proprietary mould.

knowing exactly how long to hold the kiln at top temperature, as the glass is slumping – too long and the glass will stretch too far and end up as a mass on the kiln shelf. The timing is also important for firing in sagging moulds (or moulds which you slump glass into), as holding top temperature for too long means the glass will start to flow down into the mould, causing edges around the perimeter to become uneven, and variation in the thickness of the glass from the top of the piece to the bottom. This is why it is crucial to understand the exact temperature in your kiln at the height where the glass is being fired – i.e. is it near the pyrometer, or far below it? – as well as watching any slump firings to time exactly how long it takes at a certain temperature to slump a certain distance. There are many variables, and testing is the key.

Proprietary ceramic moulds are manufactured exclusively for the glass artist now, and are universally sold by art glass suppliers, as they form the backbone of the equipment needed for creating all manner of fused and slumped glass objects, from glass bowls and vases to lampshades and sconces. They are made from bisque-fired clay, and are light-weight and durable, lasting for many years if looked after. Occasionally they will chip on the edge if they are knocked, so you will need to be careful when loading them into the kiln or stacking them. The only preparation they need before firing is a coating of batt or kiln wash. Any ceramic forms can be used for slumping, as long as they are batt washed or kiln paper is used, and much creativity can be triggered when slumping in the kiln by using unusual shapes and forms.

Various ceramic moulds/forms which can be used for slumping.

Other fire resistant materials and forms can be used for slumping in the kiln, including stainless steel, thick ceramic papers and blanket, vermiculite board, and other ceramic forms, such as kitchen tableware and even roof tiles! Any metal or ceramic materials always need to be coated with batt or kiln wash. With ceramic objects which have already been

Amanda Lawrence has made a series of glass pieces based on part-skeletal leaves, some enamelled and some sand-blasted. The slumping process was interesting because she wanted a recurve on the edges of the leaf shape and had to work out how to force the glass to curve back on itself.

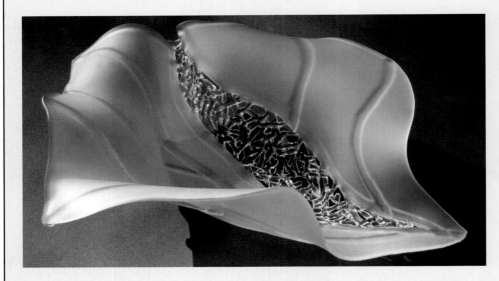

'Fall of the Leaf', Amanda Lawrence, fused, slumped and part-sandblasted float glass, W: 35cm, L: 38cm.

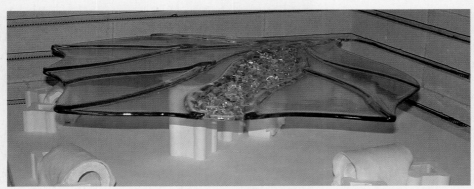

'Fall of the Leaf' ready to slump. This shows the kiln setup for slumping the 'Fall of the Leaf' piece over two tall kiln posts, using a hardened ceramic fibre 'foot' to define the base of the piece and three round posts on their sides to force the corners of the piece to roll upwards during the slump.

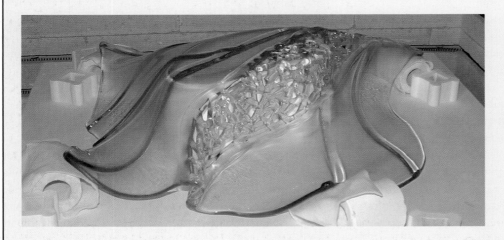

'Fall of the Leaf' after slumping.

glazed, and some stainless steel, it can be difficult to apply batt wash as it will not take to the shiny surface. One way around this is to spray the surface of the object to be coated with hairspray, to make it sticky. The kiln wash should then adhere and coat the surface as it is applied.

Texture

Some materials can be used specifically to create texture on the back of glass. This is a form of slumping, as the glass is softening and flowing around a material placed underneath it, creating an indented pattern or texture, which when applied to sheet or fused glass is often referred to as kiln-carving. The materials which can be used to apply this technique include ceramic paper, sand, whiting or chalk, and plaster.

Kiln or ceramic paper is one of the simplest ways of creating texture. It comes in a variety of thicknesses, from 1mm to 6mm, which give different degrees of depth to the indentation. The paper can be cut into shapes or torn and then placed on a kiln shelf. A sheet of glass, unfired assemblage, or previously fused project is then laid over the paper and fired to a full fuse firing to obtain the maximum kiln-carved effect. You may need to pre-fire the ceramic paper to burn off the binder. The advantage of using ceramic paper is that you can achieve a very neat effect, with well defined edges,

Kiln paper laid into a slumping mould.

as the paper can be cut precisely. You can, for instance, cut letters from ceramic paper and kiln-carve words into the back of the glass.

Sand, whiting or loose plaster can be placed directly onto the kiln shelf and patterns or textures drawn into them, for instance a serrated comb drawn through sand. Glass does not stick to these materials at fusing temperatures, so they are an

Fused glass with kiln carved detail.

'Clarity's Nest', Kim Bramley, shallow kiln-formed bowl, using a deep ceramic kiln paper kiln-carving technique, Dia: 40cm, 12mm thick.

ideal way of working quickly. Again glass is placed on top, being careful not to dislodge the loose material too much, and fired to a full fuse temperature. This can be an immediate and spontaneous way of working with texture which involves little preparation. The disadvantage however is that the detail is very organic, as it is difficult to control the loose materials precisely, and it is also easy to dislodge the materials underneath as the glass is placed on top. But with practice it is possible to obtain interesting surface detail on the back of the glass.

All of the firings in kiln-carving are best performed at quite a hot temperature, such as a full fuse firing, as the glass has to 'move' or flow a considerable amount in order to pick up the detail of the material underneath.

For creatively controlling the surface the sheet or fused glass is being slumped or kiln-carved on, another possibility is to create your own mould, using a plaster refractory mould mix. This effectively means that you can create an individual mould, with unique texture or form, using a plaster and silica mix which will withstand one, or possibly more, firings. It is possible, using a flat tablet of clay as a modelling material, to experiment with creating surface marks, impressions and

detail. The plaster refractory mix which is then poured over the tablet picks up all the detail you have created in the clay. This can then be used as a mould to fire your glass on, and all the detail will be transferred to the surface of the glass. We will look more closely at mould-making techniques in the following chapters, but it is worth bearing in mind that you can create your own moulds for slumping in this way.

Sand for slumping glass.

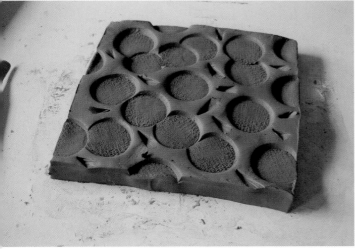

Clay tablet.

Plaster refractory mix.

'To Know the Road Ahead, Ask Those Coming Back', Rachel Elliot, lost-wax kiln-cast lead crystal glass and kiln-formed float glass, H: 85cm, W: 25cm, D: 25cm (Photograph by Sarah Rose Cameron).

Making 'To Know the Road Ahead, Ask Those Coming Back'. For this piece float glass with black tracing enamel was cut into roads and overfired to create two road hills.

Here Rachel Elliot has used kiln bricks and props, set up in the kiln, to create considerable height for slumping her glass 'roads'. This piece shows the fluidity of the glass as it stretches and then folds into ripples as it reaches the kiln shelf.

Slumping Projects

We will now look at some projects which will help you explore the slumping technique, enable you to make finished, high quality vessels and wares using slumping moulds, and explore texture and form.

'Devil's Moss', Steve Robinson, kiln-fused and slumped glass with enamels, D: approx 42cm. Steve makes his own moulds for slumping.

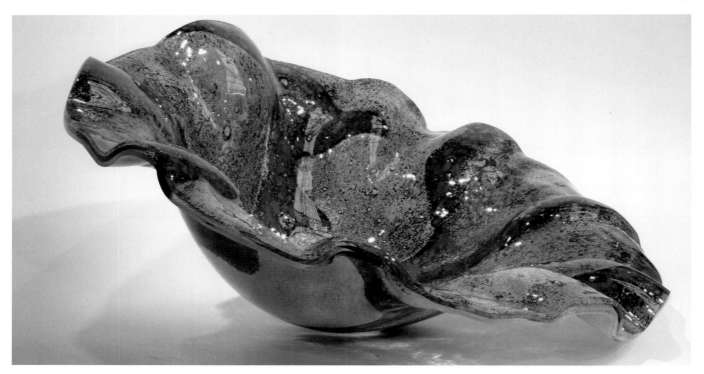

PROJECT 4: SLUMPED GLASS BOWL

This is the simplest piece to make using the slumping technique, as you are merely bending the fused glass into a sagging mould, allowing it to deform under its own weight using the heat in the kiln, until it meets the mould underneath. You can use any shape of fused glass, with the correct sized mould, although these examples use a square. Remember that the fused glass must not be bigger than the mould underneath (although it can happily be smaller), as the glass will slump over the edge of the mould and may become permanently trapped on it.

1. You will need to prepare a square fused glass piece, using two layers of glass, cut to 200mm x 200mm square, and fire using **Firing Schedule 2**, adjusting the top firing temperature and annealing temperature according to the compatible glass you have used.

Fused and slumped glass bowls ready to slump in kiln (Courtesy Liquid Glass Centre).

2. Remove from kiln when cool, clean off fired kiln paper or batt wash wearing a respirator, or by vacuuming residues.
3. Apply batt wash to a 220mm x 220mm square slumping mould, and allow to dry.
4. Place the fused glass piece on the mould.

5. Carefully place in the kiln, and fire using **Firing Schedule 4**, adjusting the top firing temperature and annealing temperature according to the compatible glass you have used.
6. Remove from kiln when cool; clean off batt wash.

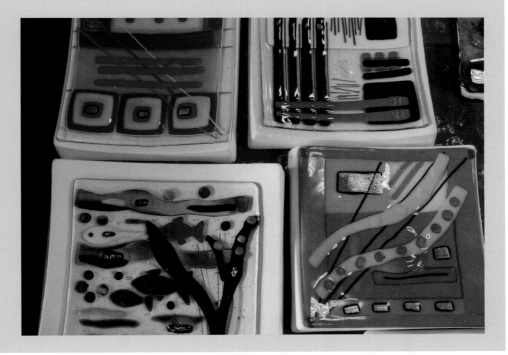

Slumped bowls after firing (Courtesy Liquid Glass Centre).

PROJECT 5: KILN-CARVED GLASS PLATTER

In this project we will fuse oval-shaped sheet glass with stringers and glass pieces, and kiln-carve the underside using kiln paper. This will then be fired into a slumping mould to give a gently curving oval platter with details kiln-carved onto the back.

1. Prepare two pieces of oval sized glass, by drawing a template around a long oval sagging mould, and cutting the sheet glass 2mm or so to the inside of the line. Clean the glass.
2. Decorate the bottom layer of glass, using fusing glue where necessary, and lay the second piece of glass on top.
3. Cut shapes in 3mm ceramic paper, wearing gloves if necessary as it can be a skin irritant, and place on the kiln shelf, arranging the position according to the size of your oval glass assemblage.
4. Fire using **Firing Schedule 2**, adjusting the top firing temperature and annealing temperature according to the compatible glass you have used.
5. Remove from kiln when cool, but **do not** remove the kiln paper shapes from the back. If any shapes fall out when you pick up the fused glass piece, then reposition them and keep in place using fusing glue.
6. Apply batt wash to your slumping mould, and allow to dry. Place the fused glass piece on the mould.
7. Carefully place in the kiln, and fire using **Firing Schedule 4**, adjusting the top firing temperature and annealing temperature according to the compatible glass you have used.
8. Remove from kiln when cool, clean off batt wash.

Kiln-carved glass platter.

Kiln-carved glass platter showing impression of kiln paper.

PROJECT 6: LATTICE BOWL

Fused and slumped glass pieces do not have to be made from solid sheet glass. As we have noted, glass will fuse wherever it touches another piece of glass. In this project we will look at creating a fused lattice from strips of glass, which will then be slumped into a bowl shaped mould.

1. Cut a quantity of strips of 3mm float or window glass 300mm long x 10mm wide (you will need about 24).
2. Arrange 12 of these on a kiln shelf treated with batt wash or lined with kiln paper, with 10mm gaps between the strips. Arrange the other 12 by laying them over and at right angles to the first 12, using fusing glue on the points where they cross over to hold in place if necessary, to form a lattice.
3. Place in the kiln and fire using **Firing Schedule 1**.
4. Remove from kiln when cool, clean off fired kiln paper or batt wash wearing a respirator or by vacuuming residues.
5. Apply batt wash to a 300mm square slumping mould, and allow to dry. Place the fused glass lattice on the mould.

6. Carefully place in the kiln, and fire using **Firing Schedule 5.** Remove from kiln when cool, clean off batt wash.

Lattice bowl in kiln ready for slumping.

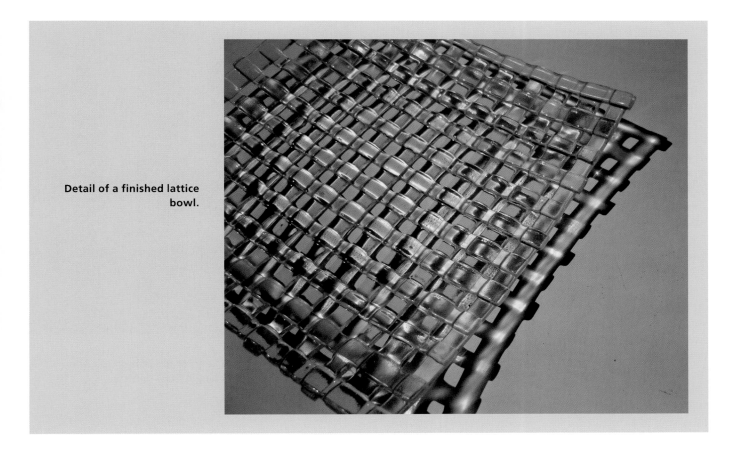

Detail of a finished lattice bowl.

OTHER FUSING AND SLUMPING TECHNIQUES

There are many more ways of working with sheet glass, but the projects outlined in this chapter will give you a basic grounding in fusing and slumping techniques. We will finish by looking briefly at more advanced techniques such as deep fusing and pot melting, which will give you a taste of some further methods for extending your repertoire. See the section Firing Schedules at the end of the book for details on firing.

Glass ready to fire in kiln (Courtesy Liquid Glass Centre).

Fire Polishing

Fire polishing involves re-firing glass to a temperature which re-melts the surface of the glass and gives it a polished, shiny appearance. Depending on the type of glass, fire polishing temperatures can range from 700°C to 760°C.

Fire polishing is typically used for glass which has already been fused and cut, for instance a jewellery piece with ground or sawn edges from drilling. It will restore the glossy surface and round over the cut edges. It can be used on larger pieces of glass, but it may not always give consistent results over the entire piece. It will not change the appearance of glass which has devitrified, or has blemishes.

It is usually only used on flat fused objects, as the temperature at which fire polishing usually takes place will distort any slumped or cast work, so it is best stay at the polish temperature for a short time only. It is possible with great diligence and practice, to fire polish a three-dimensional object, but you should only undertake this with extreme caution and meticulousness, as if you do not get the temperature and soak time right your piece will deform. The temperatures at which fire polishing takes place are hot enough to start to distort the glass shape, if not watched carefully.

Fire polishing can never replace cold polishing, which will reveal the high polished, mirror smooth surface of the glass, but does have the advantage of not removing detail. See the Firing Schedules section for a typical fire polishing kiln firing for a small fused piece.

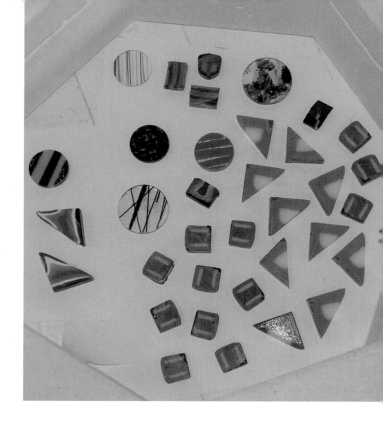

Jewellery pieces ready for fire polishing in kiln (Courtesy Liquid Glass Centre).

Drilled edge and fired polished edge of glass pieces (Courtesy Liquid Glass Centre).

Deep Fusing

Deep fusing refers to a technique where multiple layers, perhaps ten or so, of glass are stacked, with decoration in between, in the kiln and fired so that they all fuse together. The term 'deep' refers to the fact that this technique creates a considerably thick piece of fused glass, which because of the decoration on the multiple layers, creates a sense of depth in the imagery. The technique is in some ways a form of glass casting, in that you are creating a thicker slab of glass and supporting it around the edge to retain it, effectively creating a mould. It is best to use coloured pieces of glass towards the bottom of the stack, and clear or faintly tinted glass in the upper layers, as this keeps the imagery clear. The imagery in between the sheets can be created out of smaller coloured pieces of glass, frits, powders and stringers, metals and any other inclusions as discussed before.

The multiple layers of glass must be retained whilst being

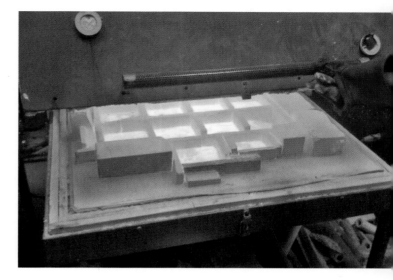

Deep fusing firing in kiln.

'Untitled', Adam Hussain, deep fused glass, H: 20cm, W: 20cm, D: 5cm (Courtesy Liquid Glass Centre).

fired, otherwise the stack would spread out onto the kiln shelf, creating a larger shallow mass. This is achieved by creating 'walls' of vermiculite or ceramic fibreboard around the stack, lined with kiln paper and supported by kiln furniture, to stop them moving. This effectively 'dams' the glass all the way round, helping to form the final block. The technique was pioneered by Bullseye glass, and detailed instructions for undertaking deep fusing can be found on their website.

Pot Melting

Pot melting involves taking the techniques of fusing and slumping to their extreme – it is in fact a version of glass casting, and is also referred to as an aperture melt. Coloured pieces of glass are stacked into a ceramic flowerpot which is placed in a kiln, suspended on kiln props above a kiln shelf, and taken to a high enough temperature for the glass to melt and pour through the hole in the bottom of the flowerpot, around 850–900°C held for a period of time. You may need to open up the hole at the bottom depending upon the amount of glass flow you require – this can be done by drilling a larger hole with a glass drill. The glass accumulates on a batt washed kiln shelf below, creating a mass of glass incorporating swirling patterns, achieved as the different colours combine and mingle as they pass through the aperture. Metal or ceramic rings or walls, lined with batt wash or kiln paper, can be placed underneath to contain the glass that melts through.

The main objective of this technique is to create billets of glass with interesting patterns which can be drilled or cut and re-fused into new fused glass projects as interesting details. It is also useful for using up scrap pieces of compatible glass. It works best with holes of around 10–20mm in diameter, and it is possible to experiment with more than one aperture to get interesting effects, by drilling extra holes into the base of the flowerpot.

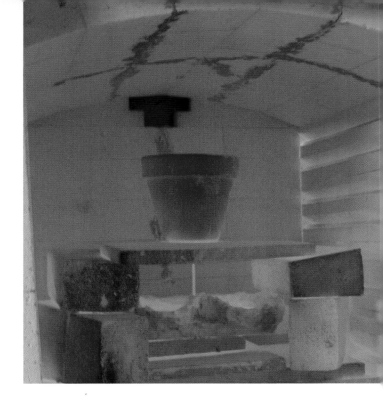

Pot melting, glass pouring through aperture in pot (Courtesy Liquid Glass Centre).

A pot-melted glass piece showing colour flow.

Pattern Bar

Creating a pattern bar is another technique which you might like to try in order to make details which can be incorporated into other fused glass pieces. Pattern bars are related to the technique of murrine and mosaic cane making, where multiple colours of glass are contained in a long bar or rod, similar to a stick of rock, and cut into sections for further use.

Strips of coloured sheet glass, of varying widths and as long as you require, are cut and stacked on top of each other, either wrapped in kiln paper and held with wire, or contained by ceramic fibre board, so that they fuse together. It is also possible to obtain stainless steel moulds which will hold the strips, lined with kiln paper. The stack is fired to a tack or soft-fused temperature and cooled. Using a diamond saw it can then be cut into slices which can be re-fused, on end, to make interesting highly detailed patterns.

Cut up after firing (Courtesy Liquid Glass Centre).

Pattern bar glass strips assembled (Courtesy Liquid Glass Centre).

Microwaving Glass

A technique for fusing glass has recently become popular using a household microwave oven. In normal circumstances, microwaves pass through glass. A very small 'micro-kiln' is available which is placed in a domestic microwave oven and heats up as the oven is on. The container has a lining of silicon carbide which absorbs the microwaves, enabling the interior to heat up to fusing temperatures. Concentrated heat is built up inside the container which can reach up to 850°C, enough to melt and fuse small pieces of glass.

To use a micro-kiln, line the small chamber with some thin fire paper and load with a small compatible glass jewellery sized assemblage. Gently place the kiln bottom in the microwave, and cover with the lid. Turn the microwave onto full power and set the timer for about 3–4 minutes to melt the glass. Allow to cool completely before opening the chamber. As the pieces are so small, the glass will be annealed during the 40–50 minute cool down. Do not remove the lid during the cooling stage or this may result in your glass cracking.

Safety note*: Glass remains hot for a long time and should only be handled when cool.*

The drawbacks of the technique are that the space available for fusing glass inside the container is very limited – currently about 100mm diameter. The main use for this item seems to be for making small items such as fused glass jewellery and cabochons. However, the glass can heat unevenly and can be hard to control, resulting in irregular results, and possible mismatching of items which you might like to pair up. At best the micro-kiln will enable you to get an idea of the principle of fusing, but after this its use may be limited. If you make many small pieces of fused glass to incorporate into larger fused glass pieces in the kiln, then it may be of some use.

The techniques discussed in this chapter are merely the beginning of exploration and experimentation as you learn more about the properties and characteristics of glass when it is heated in the kiln. As you complete more and more firings you will gain the confidence to work on more complex projects, and on a larger scale if you wish.

Re-fired into a fused glass tile (Courtesy Liquid Glass Centre).

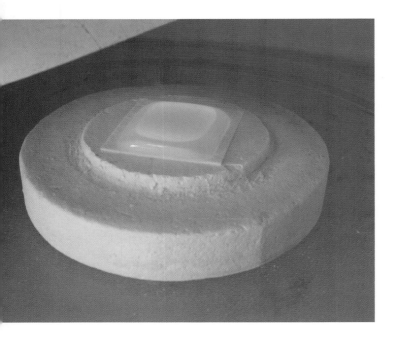

Firing in a microwave kiln.

'Orb', Kim Atherton, hot-formed, fused and slumped glass vessel, D: 38cm. Here hot and warm glass techniques combine. Kim makes her own glass cane, using hot glass which is cut into sections, fused in the kiln and then slumped in a further firing.

BEGINNING KILN-CASTING

**'Rainbow Ray', Sabrina Cant,
kiln-cast glass, L: 70cm,
W: 50cm, H: 10cm.**

Kiln-casting involves melting glass to a temperature where the glass is molten enough to fully flow into a mould. Using moulds specifically made for firing in a kiln, it allows the glass artist to capture and replicate three-dimensional objects, such as forms, figures, patterns and textures, which have been modelled in clay or wax, and translate them into glass. Kiln-casting is one of the most versatile of glass techniques. This form of glass working has a rich history, due in part to the fact that the technique allows for replication and repetition.

One of the drawbacks is that the process can seem complicated, and the model and mould-making aspects can sometimes feel as if they are distancing the glass artist from a more

**OPPOSITE PAGE:
'Orange Red Wedge', Crispian Heath, cast glass,
H: 42cm, W: 17cm, D: 10cm.**

'Shell', Tlws Johnson, kiln-cast glass, W: 48cm, H: 47cm, D: 13cm.

forms in simple open moulds, and box-casting, through to lost-wax mould-making and casting, as well as mould-making for larger work, and other allied techniques such as *pâte de verre*.

Kiln-casting has been practised for thousands of years. Over this time many methods have been discovered, forgotten again, and re-discovered. Of all the glass techniques, there is more mystery and intrigue surrounding kiln-casting than any other. This is because it is really a hybrid of other techniques – it encompasses modelling, mould-making, casting techniques borrowed from metal and ceramic working, master mould-making, and many other procedures which all add to the end result.

Casting models are typically made from clay or wax and then 'invested' (covered completely) with a fireable mould material, to make a refractory mould. The model is removed directly, or by the lost-wax technique, and the empty mould is cleaned and then fired in a kiln in such a way that a specific amount of glass will melt into the mould's empty spaces. The goal is achieving a piece of kiln-cast glass by working through all these steps, as well as annealing correctly, and this is often not an easy route to follow. Creating and working with open face, lost-wax and multiple part moulds, and understanding positives and negatives, are all part of the process.

Making cast glass is a slow process requiring skill and patience. Experience and knowledge is needed to avoid bubbles, cloudiness, and cracking during annealing. However, with practice and perseverance the end results can be amazing.

The techniques and materials involved in kiln-casting glass are based on several components of the process, as we have discussed – modelling and mould-making, as well as firing

direct approach to making work. However, for those that want to fully exploit the molten properties of glass using a kiln, and create intriguing and stimulating three-dimensional work, it is an important method to master.

Over the next few chapters we will look at the principle techniques of working with kiln-cast glass, from creating

Glass melts and fills open shallow mould

Glass melts and flows from reservoir into cavity in mould

Illustration of two different moulds for glass casting.

the glass itself. We will be using clay, wax and other materials to model. Mould-making will look at the process of making a refractory mould from plaster and silica. Specific projects will lead us through the processes in order to obtain successful results. We will discover how to fire the mould and cool the glass successfully. Many cast glass sculptures can be solid and quite large, and so require careful control in the annealing cycle. Even a small piece of cast glass needs controlled cooling to ensure it does not crack. Finally we will look at removing the mould, usually by breaking it to release the glass. Further work on the glass, such as cutting or polishing, is then undertaken.

MODELLING

It is essential to make a model from which the mould can be taken. It is possible to work with different materials to create the model, and even to take moulds directly from objects, as we shall see shortly, but if there is any undercutting in the form then it must be made from a flexible material like clay or wax.

For the modelling process the simplest material to work with is clay, since it is malleable and ductile, and easy to remove from the mould. Clay can only be used in relatively open moulds and when there is minimal undercutting, such as small undercuts in textural marks, or shallow swellings in the form, as the clay must be removed using hands or tools. More severe undercuts, where it is impossible to reach, necessitate the use of wax as the model material, usually in conjunction with a master mould, or modelled by hand. Another material which can be used for hand modelling and open moulds is plasticine, although this is more useful when used in small quantities to touch up other models or materials.

The most important point to bear in mind when working directly on a positive form, i.e. making a model directly in clay, or even modelling directly in wax, is that what you make in clay or wax is what you will get in glass. The mould poured around the clay or wax becomes the negative. The glass cast back into the mould returns to the positive again. So your clay or wax positive and your glass piece will match.

We will look at lost-wax casting in the next chapter. To help ensure that all areas inside the mould will be filled with glass during the firing process without trapping air bubbles, sprue channels and vents need to be added to some wax forms.

UNDERCUTTING

One of the more difficult aspects of working with models and mould-making is determining factors such as the best way to approach different forms, and elements such as undercutting.

An undercut is a part of the model or sculpture which has been cut away from the material leaving a portion overhanging. It is therefore any part of the surface which extends below or beneath another part of the same surface. Undercutting traps the refractory mould mix in the 'cut under' section, meaning that it is impossible to release or remove the mould without breaking off either the mould or the object.

Clay can be removed from small undercuts because it is relatively ductile. Using wax which can be steamed out (hence the term 'lost-wax') is one of the solutions to the problem of undercutting.

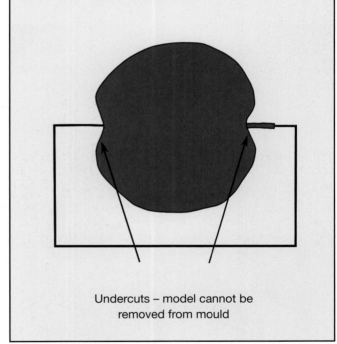

Undercuts – model cannot be removed from mould

These are channels which allow air to escape as a mould fills with glass – they become the exit routes for venting the displaced air. Cups or reservoirs are also needed to create a reservoir in which the glass is held.

Other materials which can be used for creating the primary form, from which the mould is taken, include sand, polystyrene, cardboard, and even ice! Secondary forms and

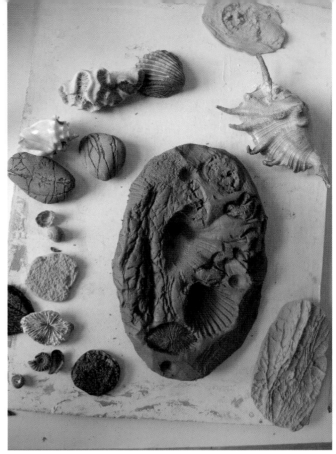

TOP RIGHT:
Clay modelling (Courtesy Liquid Glass Centre).

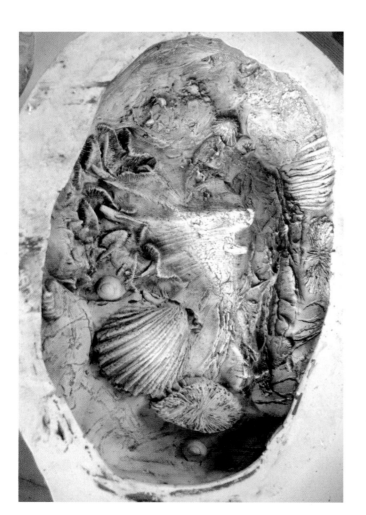

BELOW:
Negative refractory mould taken from clay positive
(Courtesy Liquid Glass Centre).

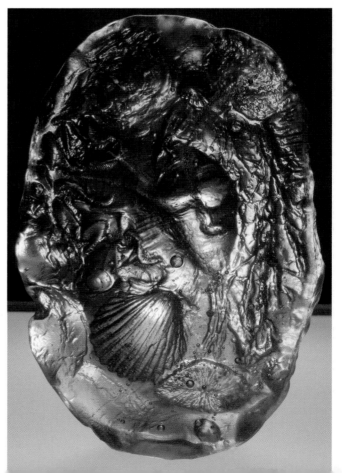

BOTTOM RIGHT:
Final glass cast (Courtesy Liquid Glass Centre).

impressions can be taken from almost any found object. For instance clay can be used and objects pushed in to make impressions, or silicone can be applied to objects to get an impression into which wax is poured, with the wax then made into a model, or incorporated into other wax or clay elements. Sand is very useful for kiln-forming, as glass can be slumped or cast directly onto it, without sticking to the sand (depending on the temperature), and so can be useful for creating quick and simple textures and forms. The possibilities are endless, and are only restricted by your imagination.

A mould taken from sand as a modelling material (Courtesy Liquid Glass Centre).

STAGES OF KILN-CASTING

Here we see a kiln-cast piece by glass artist Fiaz Elson in various stages, from mould-making to completion.

Pouring the mould mix over the boxed-in model.

Marking out the model form in polystyrene ready to shape.

LEFT:
Removing the polystyrene and washing moulds ready to place in the kiln.

RIGHT:
Using water displacement to determine quantity of glass.

LEFT:
Placing the glass in moulds.

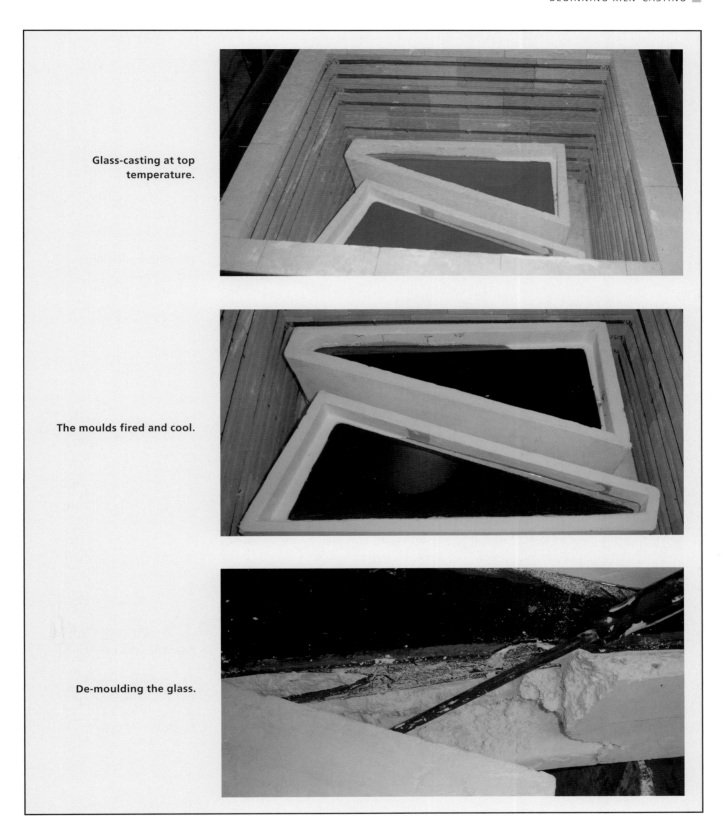

Glass-casting at top temperature.

The moulds fired and cool.

De-moulding the glass.

Grinding the flat facets.

Polishing with an airtool.

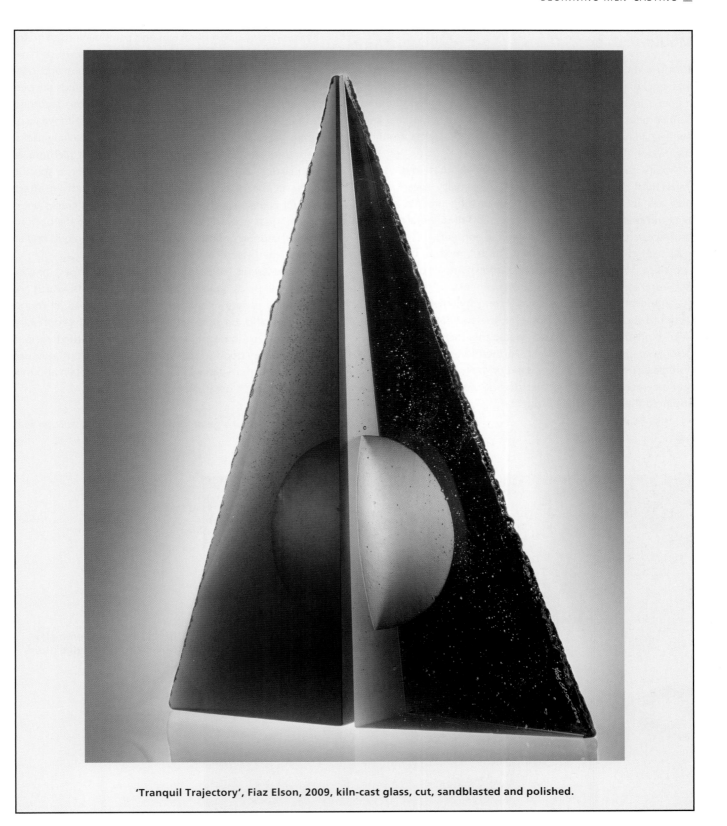

'Tranquil Trajectory', Fiaz Elson, 2009, kiln-cast glass, cut, sandblasted and polished.

Mould-making

Taking a mould from the model, or 'investing' it in mould material, is the next step in the glass-casting process. The model is invested in mould material either by pouring into a containment form – a mould box or cottle – or sometimes by hand-building the mould to build up multiple layers around the model.

Moulds made for glass-casting are usually referred to as 'refractory' or waste moulds, which essentially means that they are able to withstand the high heating process in the kiln, and that they are finished with after firing and are often broken apart or 'wasted' to remove the contents.

As we have seen, they are made from a mixture of plaster and silica. Normally moulds made from plaster alone would not be able to withstand the firing process, as they would crack and break. Plaster is not a strong material when subjected to such high heats. However, the addition of the silica helps bind and fuse the plaster mould together, so that it can hold its shape without cracking. Furthermore, the addition of fibreglass strands, vermiculite, sand or grog, or other forms of reinforcement, provides further strength to prevent breaking and hold the plaster mould together.

There are many different recipes and combinations of materials used to make moulds for glass-casting, all of which have been carefully devised to suit specific techniques and outcomes. For instance, there are old recipes for moulds devised by the kiln glass masters such as Argy-Rousseau, recorded meticulously in his notes, which were developed after years of research. There are mould mixes which are particularly useful for very intricate work, or very large casts, or a plethora of other qualities, all of which are aimed at creating a specific outcome in the glass – a successful casting with an intact mould. Of course, if the mould is too weak and cracks open in the kiln, glass pours through the crack and into the bottom of the kiln, causing at best a difficult mess to clean out, and at worst damaged electrical elements and brickwork.

There are useful 'all-purpose' mould mix recipes, one of which we will be using in the kiln-casting projects, which are suitable for a variety of purposes, and give good all round results. It is also possible to buy ready-mixed proprietary mould formulas, some made from closely guarded recipes which give a very good surface on the cast glass. But most are simply made from materials which are easy to obtain and mix yourself, and cost a great deal less.

Safety note: Wear a respiratory mask when mixing working with plaster or silica.

Refractory mould with glass cullet (Courtesy Liquid Glass Centre).

SOME INTERESTING FACTS ABOUT PLASTER

- Plaster of Paris is one of the most versatile of materials for sculptors.
- Plaster is made from gypsum, which is a mineral derived from calcium sulphate. The word gypsum is derived from the Greek word *gypsos* or 'chalk'. Plaster is made by heating gypsum to 150°C, at which point its water of crystallization, about 75% of the water content, is released, and it is transformed into plaster.
- It is then ground to a dry white powder. Grinding does not seem to affect its setting properties, as when the powder is mixed with water it recovers the one and a half parts of water it lost previously, and it sets.
- There is still more water left in the plaster, known as 'free water', because in order to make the plaster mix pourable we need to mix it with more water than it recovers in crystallization. This is why plaster moulds still feel damp when they have set. This water is forced out by firing wet in the kiln, or drying in an appropriate place.

- Plaster must be stored away from moisture, as if it absorbs any dampness it will set more rapidly than protected or dry-stored plaster.
- The balance of plaster to water can affect setting time – a mix with a maximum quantity of plaster to a minimum of water will set quickly, but the mould will be weaker than normal.
- A small quantity of set plaster, which has been ground and added to a fresh mix, will accelerate the set of the new mix.
- About 1 teaspoon of salt added to a litre of water used in the mould mix will also speed up setting.
- Sugar will retard the setting time.
- Shortly after the plaster has begun to set, warmth will be felt on its surface. The reaction is exothermic and gives off heat. This is called the 'heat of crystallization', and is roughly equivalent to the heat that was required to decompose the original gypsum into plaster.

Plaster as used for mould-making.

Mould mix in use as it is setting
(Courtesy Liquid Glass Centre).

Cast-glass surface from plaster refractory mould.

Health and safety procedures should be followed strictly when working with mould-making materials, as some can be hazardous to health (read the Health and Safety section thoroughly before beginning).

Mould-making is a messy process, and a suitable space must be found to undertake the activity. Mould mix should not be poured down the sink, as this will inevitably block the pipes. It is possible to mix moulds in a bag lining a bucket, and then discard the bag afterwards, with excess mould mix inside, leaving the bucket clean and the unwanted mix easily disposed of. Otherwise, excess mixture can be left to go off or harden, and then cracked off from the inside of buckets. Other equipment such as plaster files, knives, modelling tools etc. will all become clogged with plaster, and should be cleaned after each use.

Cottling

When preparing a model for investment in a mould, before pouring the mix, you will need to build some cottling (sometimes referred to as coddling or dams) or a mould box around the model to contain the fluid mould mix once it is poured and before it sets. Which you use is best determined by the form of the model. For instance, if you were investing a round model in a square mould box, there would be excessive quantities of mould mix in the corners, which is wasteful, and also can affect the annealing of the glass and mould.

Cottling is generally the term used for a flexible form that holds the mix, mostly for round or oval moulds. It can be a thick clay slab positioned around the model, or simply a piece of lino or sheet metal flashing. If the model is best contained by a square or rectangular shaped mould, boards can be used. These must be sealed or waterproofed so that mould mix does not soak into them – plasticized chipboard (formica) is a good option. They are clamped or fixed together, and by combining boards of different lengths, any sized square or rectangular box form can be made to contain the wet mould mix. Four clamped mould boards are referred to as a mould box.

The model must be fixed to a board. A clay model is naturally heavy and wet, and tends to stay in position when the mould mix is poured. Wax generally needs to be held in place as it is fairly buoyant (we will look more closely at this in the next chapter). If using clay, to give you an easier release you can choose to spray your form with a releasing agent such as WD 40 or a vegetable oil. The cottling or mould box must be

One of the chief points to be remembered when working with glass cast into a plaster refractory mould is that where the glass is melted against the mould, the surface of the glass which is lying against the mould will always be affected to some extent by this contact. This can also depend on the mould mix used. When casting, glass has a tendency to fuse with the calcium content of the plaster, which can give a matt effect to the glass. Sometimes even the fibreglass strands used in the mix are picked up by the glass from the mould surface. Only the parts of the glass which are open to the air, and not in contact with the mould, will retain a shiny, fire polished surface. Face coats are sometimes applied to the model before the bulk of the mould material is applied or poured; these pre-coats can include talc in a plaster base, to help the mould material come away from the glass surface more easily after the firing is completed, and improve the surface quality.

Mould box clamped.

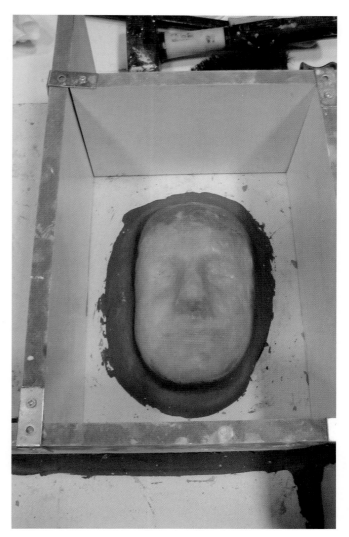

**Mould box with brackets to hold together
(Courtesy Liquid Glass Centre).**

positioned about 30mm away from the model, to give the optimum thickness of mould wall around it. Any closer and the mould will be too thin – and farther away and it will be too thick. Thin and thick mould walls will affect factors such as cracking of the mould and annealing. It is best to mark the level the mould mix should be poured to on the inside of the board or cottle, about 30–40mm above the highest point on your model, as you will not be able to judge the depth of mix once the model is submerged. Finally the cottling or mould box must be sealed with wet clay around the outside on any joins, i.e. where boards lie against each other, to waterproof it

and stop any mould mix pouring out. The mould mix is made and poured, and left to set – usually within 5–20 minutes.

Mould Recipes

You will need to first calculate how much mould mix to make. As we have mentioned, there are many different recipes for mould mixes, but the easiest and simplest for all-purpose use is made from a simple mix of one part water, one part plaster, and one part silica, together with some fibreglass strands.

CALCULATING THE QUANTITY OF MOULD MIX

Before you make your mould mix, you will need to calculate the volume needed to fill your cottle or mould box, with the model inside. As you make more mould mixes you will probably get used to judging this by eye, but there is a method for calculating the amount needed.

1. First you will need to find the volume of the entire cottle or mould box.
 For a circular cottle, i.e. a cylindrical mould box, this is *pi* (3.14) x height (cm) x radius (distance from centre to edge of cylinder or half of circumference in cm) x radius again = volume in millilitres (litres).
 For example: 3.14 x (H) 25cm x (R) 5cm x (R) 5cm = 1962ml (about 2 litres)
 For a mould box this is length (cm) x height (cm) x depth (cm) = volume in millilitres (litres)
 For example: (H) 20cm x (L) 20cm x (D) 5cm = 2000ml (2 litres)

2. Next subtract the volume of your model; this can be an estimate, or you can determine the volume by displacement of water, or weight of wax used.
3. If we had a 2000ml (2 litre) mould box and a model with a volume of 1000ml (1 litre)
 For example: 2000ml (2 litres) minus 1000ml (1 litre) = 1000ml (1 litre) quantity of mould mix needed
4. This total volume of mould mix needed is roughly equivalent to the quantity of dry materials you add to the water:
 So, to make 1 litre of mould mix, you need 1kg of dry materials = ½kg of silica and ½kg plaster, added to ½ litre of water using the ratio outlined below.

It may be safer to make a little more than you need, as a contingency, as it is better to have slightly too much rather than too little.

To make the mould mix, water is measured in volume and dry ingredients in weight, as usefully, 1 litre of water weighs 1kg. So, for instance, if you used 1 litre by volume of water, you would use 1kg by weight of dry plaster, and 1kg by weight of silica. Warm water speeds up the plaster setting process, cold water slows it down. The best plasters to use for the mix are Potter's Plaster or Fine Casting Plaster, as they give the best results.

For the silica element of the recipe, it is possible to use either quartz, which is a dry ground silica, or flint, which is a slightly damp form of the material. Flint is preferable, as it is damp and less dusty or airborne when making the mould mix.

Fibreglass strands are added towards the end of the mix, and only a relatively small quantity. The best fibreglass to use is in the form of 'soft loose strands', which need to be 10mm or longer to give the mould good strength.

Always add the dry ingredients to water, never water to the dry ingredients. And don't fill your receptacle over half full with water, as the dry ingredients will nearly double the volume, so use a bigger container if you need to.

It is best to mix the ingredients by hand, as you will need to be able to judge the consistency of the mix and can do so more accurately by feeling as you agitate the mixture. You can wear gloves, although many kiln casters prefer to mix without to feel the mixture properly. If you have sensitive skin it is best to wear gloves.

The mould mix is made as follows (read the Health and Safety section and make sure you wear a respiratory mask):

Remember: 1 part water + 1 part plaster + 1 part silica
i.e. 1 litre water + 1 kg dry plaster + 1 kg silica
plus 1 tablespoon of fibreglass strands per litre of water used

1. Take one part of lukewarm water and pour into a bowl or bucket.
2. Add one part flint or quartz to the water, and stir until dissolved. There may be small granules of the flint left undissolved, but these can be left.
3. Nothing will set at this stage, so this mixture can be left for a short time (re-agitate before adding plaster) but once you have added the plaster you will need to pay the mould mix your full attention.
4. Add one part plaster and mix by agitating your hand at the bottom of the container. Feel around the mix for lumps and squeeze to dissolve. Avoid stirring vigorously as this can introduce air to the mix.
5. Add the fibreglass strands; they are fairly soft and will not catch your skin when mixing into the wet mix.
6. When the mixture feels creamy and coats your hand without watery streaks, it is ready to pour.

Volume of Mould Mix needed	Water	Silica	Plaster	Fibreglass strands
½ litre	250 ml	250g	250g	¼ tbsp
1 litre	500 ml	500g	500g	½ tbsp
1½ litres	750 ml	750g	750g	¾ tbsp
2 litres	1 litre	1 kg	1 kg	1 tbsp
2½ litres	1¼ litres	1¼ kg	1¼ kg	1¼ tbsp
3 litres	1½ litres	1½ kg	1½ kg	1½ tbsp
3½ litres	1¾ litres	1¾ kg	1¾ kg	1¾ tbsp
4 litres	2 litres	2 kg	2 kg	2 tbsp
4½ litres	2¼ litres	2¼ kg	2¼ kg	2¼ tbsp
5 litres	2½ litres	2½ kg	2½ kg	2½ tbsp
5½ litres	2¾ litres	2¾ kg	2¾ kg	2¾ tbsp
6 litres	3 litres	3 kg	3 kg	3 tbsp

Chart showing quantities of mould-making materials needed.

Judging the correct moment to pour is a knack which you will get used to. It is best to pour just as the mix is about to go off. This is because if you pour when the mixture is a long way from going off, the water can separate from the other materials, which can cause a weak mould. If you pour too late, and the mix is quickly setting, you will find it difficult to get all the mould mix into the mould box, or you may not pick up all the detail on your form. The mixture should be about the consistency of single to double cream when you pour, coating your hand without separating or looking watery. It is then ready – pour the mix either directly from the bowl or bucket, or using a jug. If the mixture is setting quickly, time is of the essence, and it is quicker to pour directly from the bucket. You should try to pour the mix slowly along a surface, preferably the inside of the mould box or cottle, or onto your hand held just above the model, allowing the level to slowly ride inside, as this minimizes splashing and air trapping. Fill to the line you have previously marked. The form should be covered, plus about 30–40mm of mix above the highest point on your model. Then jog or tap the board *very gently* to release any trapped air bubbles, which you should see when they have risen to the surface of the mould mix. Leave to set.

Mixing the materials for the mould.

Pouring the mould mix into the mould box
(Courtesy Liquid Glass Centre).

Mould mix poured into moulds with clay cottling.

Cleaning and Filling

All moulds need to have the modelling material removed and the mould cleaned prior to loading with glass and firing. As we have discussed, the model will need to be removed directly if it is an object or a material like clay or sand. Clay must be dug out, but very carefully. Initially use your fingers rather than tools to remove the bulk of the clay, as you will not be able to feel the plaster surface beneath the clay if you use tools, and you may damage the mould. Use a plugging action with a sticky block of clay pushed onto the clay in the mould, lifting up sharply, to 'pull' the clay out of the mould. The aim is to remove as much of the clay in one piece as possible. Any further clay debris can be removed with tools

if necessary. If wax was used then this will be removed by steaming out (*see* Chapter 6).

The empty mould is rinsed and then loaded into a kiln. An appropriate amount of glass, in the form of glass frits or casting billets is either piled directly into the mould, in the case of a more open mould, or suspended in a crucible. This can be either built into the model and hence form part of the mould, or can be a separate container made from ceramic or mould mix materials, placed over the top of the mould so that the glass will melt and pour into the cavity during the firing.

The glass you will use will depend on the effect you want in the finished piece. Frits and powders will cast giving a more opaque quality to the finished piece. Casting cullet can trap some amount of air as the glass casts, giving a glass with some bubbles in the finished piece. Larger casting billets will cast to give a relatively clear glass. Many of the finest glass casts, in terms of the sheer quality of the glass, are cast from large blocks of optical quality glass.

Glass artist Fiaz Elson with optical glass blocks.

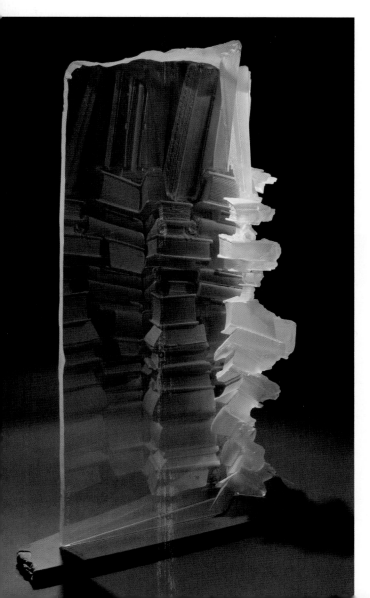

'Untitled Still Life with Books', Colin Reid, 2008, cast optical glass with slate, H: 66cm, W: 40cm, D: 10cm.

CALCULATING THE QUANTITY OF GLASS FOR FILLING A MOULD

You can determine the quantity of glass required to fill a mould by two methods. The first method measures the actual quantity of glass needed, by using the glass cullet itself to displace the quantity of water needed to fill the mould. The second involves measuring the volume of space in the mould and using a formula to determine the weight of glass needed. Depending on the type of glass used this weight will vary, as different glasses have different weights.

Here are the steps you will need to follow.

METHOD 1

Once you have made and cleaned out your mould you can determine the *physical quantity* of glass you will need to fill the mould by the displacement method. This is the simplest method, and useful if you already have the glass you are casting with.

1. Take a container, preferably tall rather than shallow, and fill it with water. It should be able to hold at least twice the quantity of water it takes to fill the cavity in your mould. It doesn't matter which level the water is filled to, but the container should be nearly full.
2. Mark a line with a permanent marker where the water comes to, and then pour some of the water into your empty mould. Fill the mould with this water to the level you would like the glass to come to after it has been cast.

3. Discard the water in the mould. Be careful not to discard any of the water in the container.
4. Fill the container, which has the remainder of the water in it, with the glass cullet to be used for casting, until the water level returns to the line you marked originally.

The volume of water which filled your mould has now been replaced with glass, giving roughly the amount of glass you will need to fill the mould.

METHOD 2

With this method you can use either the weight of the microcrystalline wax required to fill the space inside your mould, or the volume of the space itself, determined by water volume, to determine the amount of glass needed by *weight*. This method is useful if you have already made the mould but want to know how much glass to obtain.

1. You can determine the amount of wax you used to make the original model, by weighing a block before and after making the model, and determining the weight of wax that was used.
2. Or you can measure the volume of water used to fill the mould cavity.
3. Calculate the weight of glass needed according to the following formula:

 1kg of wax or 1 litre of water
 = 2.5kg of soda-lime glass (Bullseye, Spectrum, float)
 = 3.7kg of Gaffer casting glass

Measuring the quantity of glass required to fill a mould.

**Mould loaded with glass for firing
(Courtesy Liquid Glass Centre).**

into certain areas of the reservoir, or create different layers, which will flow into a mould and give marked results.

Directly applying coloured glass powder or frit to create patterns, or to restrict the colour to a specific area of the mould, for instance in an impression of indentation in the mould, is a technique which is often used in *pâte de verre*. It works particularly well as the nature of this technique means that the glass does not flow very much, as it is fired to a degree which fuses the glass frit, as opposed to casting, therefore the colour does not flow and tends to stay in the area to which it was applied. Metal foils, wires, meshes and leaves, as well as mica, can all be used, either placed with the glass to cast, or laid directly into the mould and becoming encapsulated in the glass.

Again, you should ensure your glass is clean – wash any cullet or coarser frit before you load your mould. Remember that the finer the particles of glass, the more air they will trap as they cast, causing a cast of a more opaque glass quality. The larger the chunks of glass used, the less air is trapped and the clearer the final cast glass is. Coloured glass powder or frit can be used in addition to cullet, to add colour to the main body of glass. Where the glass frit or powder is placed, the quantity used and many other factors will affect the outcome in the cast glass.

Safety note: *Remember to wear a respiratory mask when using glass powders or frits.*

Glass powder laid directly into a mould, if the interior is accessible, will move less than colour placed in a reservoir, which will flow with the main body of glass down into the mould, creating swirls and streaks. It is quite difficult to control colour in this way, and it is more a case of working with the flow of the glass and enjoying the outcome. However, with practice it is possible to lay coloured powder, frits or cullet

**'Dream Boat', Tlws Johnson, kiln-cast glass, H: 132 mm,
W: 240mm, D: 85 mm (Photograph by John Credland).
Tlws Johnson used dichroic glass as an experimental inclusion
to highlight the shells at the base.**

Firing

Firing your mould and glass is the one of the most important factors in the whole of the kiln-casting process. The kiln must be programmed with a very carefully controlled firing schedule that takes into account the type of glass being used, the thickness and complexity of the glass and mould, as well as the number of moulds loaded into the kiln. This will ensure that the proper heating, annealing and cooling phases will take place without cracking the mould or the glass piece. Many kiln-cast pieces are solid and relatively large compared to, for, instance, fused-glass pieces made from two or so sheets of glass, and consequently need considerably more annealing. Even a small piece of kiln-cast glass 100mm thick can take many hours of carefully controlled cooling to ensure it does not crack, and at 200mm thick the time required to cool could be measured in days rather than hours.

Firing for kiln-casting follows the same basic principles as we have seen in a previous chapter – a gentle initial heating, more rapid heating-up to casting temperature, rapid cooling to near the annealing point, soaking or holding at annealing temperature, and slow cooling-down through the transformation range to the strain point, and then to room temperature. Casting usually takes place at a hotter temperature than fusing glass, at around 820–850°C, and sometimes up to 900°C depending on the glass used. As with all kiln-forming, the correct annealing temperature, and time soaking, is crucial to the outcome of kiln-cast glass. Refer to the tables in the Resources section for an idea of the kiln firing schedule you will need to use for different sized kiln casts.

The mould is placed in the kiln on a bed of sand or vermiculite or even loose plaster to allow it to be levelled, so that the glass will cast evenly – this is particularly important in large shallow open moulds. The base of the mould, which is the top surface of the mould mix when you pour it over your model, can be uneven, so use a spirit level on the top of the mould when it is sitting in the kiln and adjust the sand or vermiculite underneath the mould until it is level. The other benefit of having these materials under the mould is that they allow heat to circulate around the base of the mould, ensuring an even firing.

Moulds levelled in kiln before firing (Courtesy Liquid Glass Centre).

There has been some discussion over the firing of wet moulds, i.e. refractory moulds which have not been dried prior to loading in the kiln, and still contain a lot of water in the body of the mould itself. On the one hand firing wet moulds can cause your kiln to corrode or rust more quickly, including the elements, as steam is forced from the mould rapidly as the kiln heats up, accumulating inside the kiln. For this reason you should always leave the bung out when firing wet moulds on the heating section of the firing, to allow the steam to escape. Some feel that drying moulds can minimize cracking and breaking during the firing. Many artists do not want to compromise their kiln and choose to dry out their moulds before firing. This can be achieved by placing in a special drying cabinet, or putting in a warm place like an airing cupboard, for a few days. When the mould stops feeling cool to the touch it is dry.

On the other hand, firing wet moulds speeds up the kiln-casting process, as you can fire the mould straight after you have made it and loaded it with glass. Some glass artists fire their moulds wet as they believe that this results in a cleaner surface on the glass after firing (although others claim this about dry moulds!). It has also been suggested that a wet mould conducts heat into its core faster than a dry mould. It is true that kilns do corrode more quickly if they are used for firing wet moulds, but it can still take many years to cause any significant damage, which may necessitate a change of elements, or wire brushing and treating any corroded bodywork.

De-moulding

Once the glass has cast and the kiln cooled down, the mould and glass can be removed from the kiln. Remember that glass or moulds should never be removed from the kiln until they are comfortable to handle, i.e. 50°C or less, and preferably should be left until they have cooled to room temperature.

The next task is to remove the glass from the mould. This is called de-moulding, or sometimes 'divesting'. Once refractory plaster moulds have been fired they become very soft, and can be broken quite easily. They should be taken from the kiln carefully to avoid crumbling or breaking, and then the mould can be removed.

Safety note: *A respiratory mask should always be worn when de-moulding, as the silica in the mould mix can become readily airborne as you break the mould open.*

Use your hands, or a levering action with a blunt tool pushed a short distance into the mould, to break sections of the mould away. If there are extremities or fine detail you should take special care – they can easily be knocked off or damaged whilst removing the mould.

Safety note: *Always take extreme care when de-moulding, as the glass coming from the mould can have very sharp edges or points – you can cut yourself very easily.*

If there are any remaining parts of the mould you can use water to remove them. Do not soak the whole mould in water to soften it as this causes the mould to expand and can put pressure on small sections of the cast glass and break them. Rather, soak the glass cast once you have removed the vast majority of the mould, so that no undue pressure is applied to it. Running water and a stiff brush will scrub off residual mould remnants left on the surface of the glass. For deep cavities or rough surfaces you may need to pick out the mould mix with a fine tool. On the final piece you may then need to remove any surface irregularities, glass left in the reservoir, or marks where vents were attached, and in general it may need cold-working or polishing to finish.

De-moulding the cast glass.

OPEN FACE CASTS – A DIFFERENT VIEWPOINT

One of the interesting aspects of making open-face casts is that they can have a nice, open, fire-polished surface where the glass is not in contact with the mould. This can provide interesting viewpoints when looking at the final glass cast.

When looking at the glass from the fire-polished surface, impressions made *into* the clay, so pushed or marked into the surface when making the model, in other words 'intaglio', and which are the same in the final cast glass, will look as if they are in positive, or 'relief' when viewed from the fire-polished side. You can exploit this to great effect when making open-face casts.

Conversely, if you create relief in the clay, which you will also have in your final glass piece, then this will appear to be in negative when viewed from the fire-polished side.

Glass cast into open mould (Courtesy Kim Atherton, Liquid Glass Centre).

Detail viewed from fire-polished side of glass (Courtesy Kim Atherton, Liquid Glass Centre).

Deborah Timperley, glass salver with square black glass base and 23.5ct gold centre, kiln-cast glass, D: 24cm. Deborah makes a composition with fabric, looking for 'interesting events in the surface'. She makes a mould in refractory mix of the fabric composition. This is then fired in the kiln with 23ct gold and glass. Once cooled the mould is broken away and the glass is fired again to slump into a shallow bowl. Finally the bowl is polished on a linisher.

Kiln-Casting Projects

As we have seen, kiln-cast glass comes in many guises, all variants on the theme of using moulds to capture and define the fluid glass into a three-dimensional form. As a starting point, we will look at the field of creating open moulds for casting glass.

PROJECT 7: OPEN-FACE CAST

This involves creating a mould from a model which has an 'open' face, i.e. the area at the top of the mould which is open to the air. Apart from creating a form which tends to be flatter and more slab-like, one of the major advantages of and reasons for working with open moulds is that it is relatively easy to remove the modelling material or objects. This technique is also sometimes called 'box casting', taken from the idea of using a mould box to contain the mix. Because the area at the top of the mould is quite open, it means we can reach in and manually remove it with ease. This technique also has the advantage of producing a fire-polished surface on the glass where the mould is open and the glass is not in contact with the mould. For this project we will take a mould directly from clay.

1. Take some smooth buff clay and roll out into a board. Hand sculpt or model a low relief slab using modelling tools, make marks and impressions, use found objects to create textures etc. The clay slab should be about 250mm square. Do not make the slab more than 40mm thick. You can work freely on your model – slight undercuts will not cause problems. Remember to make the form look the way you want the final piece to look – the finished glass surface will be exactly like your clay surface.

2. When you have finished working on the clay, you must prepare a mould for glass-casting. Choose a cottle (round) or mould box (square) depending on your model. These can be either rolled up lino, taped with gaffer tape, or four boards clamped together with trigger clamps. Make their position 30mm away from the perimeter of the model. Seal the bottom and side edges of the cottle or box with clay on the inside (if possible) and always on the outside so that the mould mix will not seep under or through. Make sure the height of the cottle or mould box allows for the mix at the top of the mould, as you will need to pour mould mix to 30–40mm higher than the top of your model. Mark this line on the inside.

3. Calculate the amount of mould mix you need to make according to the information included in Mould Recipes in this chapter. Make up the mould mix, allowing a little extra to be sure you have enough. For instance, if you need 2 litres of mould mix, you will need 2kgs of dry materials = 1kg of flint, 1kg of plaster, and 2 litres of water.

Safety Note: Be sure you wear a respiratory mask.

4. Make up as follows. Pour 2 litres of warm water into a bucket. Weigh out 1kg of flint, pour into the bucket and stir to dissolve. Weigh out 1kg of plaster and add to bucket, agitating to mix. Add 2 tablespoons of fibreglass strands.

5. When the mixture is smooth and has a consistency of single to double cream, pour mix into the mould. Avoid pouring directly over your artwork – pour on the side to avoid trapping air in the piece. Very gently tap the board below or the side of the mould to help release any air that has been trapped in the mould mix. Put your finger into the top of the mould mix whilst still liquid and agitate it gently to smooth the top of the mould, which will later become the base of the mould.

6. The mould mix is set when it has warmed up and then cooled again. Plaster is exothermic, which means it gives off heat as it is setting. If you feel the surface of the mould after you have poured the mould mix, you should be able to detect this heat which, once it has dissipated, will indicate that the mould mix has set. This should take around half an hour.

7. Let it set until completely cold, and then remove the original clay model. You should try to remove the clay in one piece as far as possible. To do this expose the plaster refractory mould underneath the clay in one corner by using another plug of clay to push against the clay tablet and pull up quickly. This should pull or lift some of the clay away from the mould. Keep doing this until you are able to 'lift' the whole slab of clay out of the mould. Areas with undercuts and texture may still have trapped clay, which you will need to clean out with tools. Clean the inside of the mould very carefully with water and a soft brush, so that you do not remove detail. Never scrub the inside of the mould with a coarse brush or scourer – you will destroy the delicate detail. Be careful not to chip the mould. Smooth the top edges with a damp sponge.

8. Gather the glass you would like to use for casting in the mould – either frit or billets of glass. Use Method 1 for calculating the amount of glass needed to fill the mould. If you are using billets, stack the clean glass in the mould cavity with larger pieces towards the centre and smaller ones towards the outside. Add any colour or inclusions, trapped between pieces of billet. Avoid having pieces overlapping or touching the wall of the mould. If using frit then pile in the mould, with any colour mixed into the frit or laid directly into the mould itself. Again, avoid frit overlapping the edge of the cavity.

9. Position a kiln shelf or batt in the kiln, ideally raised about 30–40mm from the kiln floor with kiln props. This improves heat circulation in the kiln. Place a layer of vermiculite or sand on the shelf and position your mould on this. Use a spirit level to make sure the mould is level in all directions, adjusting by pushing it into the vermiculite or sand as needed. Sometimes, if the kiln is difficult to load with a mould, you may want to place glass in the mould after it has been put into the kiln and levelled.

10. Fire using **Firing Schedule 6**.

11. When the kiln is at 50°C crack the door (leave open slightly) until it reaches room temperature. The glass in the mould will still be hotter than the temperature in the kiln, as it will retain heat for longer. When the glass is comfortable to touch, the mould can be removed from the kiln. Remove the mould by breaking it away from the glass. Be extremely careful removing the mould – the glass may have sharp edges. Use a stiff brush to remove any mould material stuck in crevices, with water if necessary.

If you have any sharp edges these may need grinding with a diamond pad or on a linisher, if you have one. Now you have completed your first piece of kiln-cast glass, you should be able to appreciate the qualities of the process and the unique effects which can be achieved. You will have also gained valuable experience in modelling and mould-making.

Glass billets ready to fire in open-face mould (Courtesy Liquid Glass Centre).

Example of open-face cast mould (Courtesy Kim Atherton, Liquid Glass Centre).

Another example of an open-face mould (Courtesy Liquid Glass Centre).

**Glass in an open-face mould
(Courtesy Liquid Glass Centre).**

**Glass in an open-face mould
(Courtesy Liquid Glass Centre).**

Three-Dimensional Casting

As models increase in size, so the volume of glass in a cast piece grows exponentially, and therefore annealing time will increase. We will now look at the possibility of creating a small, more three-dimensional, cast form.

PROJECT 8: SIMPLE 3-D CAST

For this project we will still be working with an open mould, but we will create a model which is taller and fuller than the previous open-face cast. Again we will use clay so that we can model the material directly to create a positive, with the negative mould taken from the clay. You will need to be careful not to create areas which are severely undercut, as you will not be able to remove the clay.

1. Take some smooth buff clay and hand-sculpt a three-dimensional form about 100mm high maximum (so you can reach in to remove clay), 100mm wide, 50mm deep, using modelling tools. The form you decide on must be removable from the mould, so the base (which will become the opening at the top of the mould) should be large enough to allow you access to remove clay. Remember to make the form look the way you want the final glass piece to appear.

2. When you have finished working on the clay, you must prepare a mould for glass-casting. Choose a cottle (round) or mould box (square) depending on your model. Position the cottling 30mm away from the perimeter of the model. Seal the bottom and side edges of the cottle or box. Mark a pouring line on the inside of the cottling, 30mm from the highest point of the model.

3. Calculate the amount of mould mix you need to make according to the information included in Mould Recipes in this chapter. Make up the mould mix, allowing a little extra to be sure you have enough.

 Safety note*: Make sure you wear a respiratory mask.*

4. Pour required quantity of warm water into a bucket. Weigh out flint, pour into the bucket and stir to dissolve. Weigh plaster and add to bucket, agitating to mix. Add fibreglass strands.

5. When the mixture is smooth and has a consistency of single to double cream, pour mix into the mould. Tap the board below or the side of the mould very gently. Put your finger into the top of the mould mix whilst still liquid and agitate it gently to smooth the top of the mould, which will become the base of the mould when set.

6. The mould mix is set when it has warmed up and then cooled again. This should take around half an hour.

7. Leave the mould until completely cold, and remove the original clay model. This time you may have to dig out most of the clay, and use tools to clean out any areas with small undercuts and texture. Clean the inside of the mould with water and a soft brush very carefully, so that you do not remove detail. Smooth the top edges with a damp sponge.

8. Gather the glass you would like to use for casting in the mould – either frit or billets of glass. Use Method 1 for calculating the amount of glass needed to fill the mould.

9. Position your mould on a kiln shelf with vermiculite or sand as before. Level the mould. This time you may need a reservoir to hold the glass above the mould, as you will have a more enclosed mould which is not easy to stack glass in. Use a terracotta plant pot with a hole in the bottom, and fill with any excess glass which cannot fit into the mould itself. Using kiln props and/or strips cut from kiln shelves, position your plant pot reservoir on the props or kiln shelf over the top of the mould, so that the glass will pour through the aperture into your mould when casting.

10. Fire using **Firing Schedule 7**.

11. When cool remove mould from kiln. Remove the glass from the mould by breaking away the mould. Remember the glass may have sharp edges. Clean, and grind any sharp edges.

ABOVE: **Modelling a more three-dimensional clay model (Courtesy Liquid Glass Centre).**

BELOW: **Removing clay from a deeper mould (Courtesy Liquid Glass Centre).**

The projects in kiln-casting which you have now completed have introduced you to this wonderful technique, enabling you to work more interactively with glass as you consider shape and form, colour and light. The possibilities of sculpting the glass will grow as you become more confident in modelling and mould-making. In the next chapter, we will concentrate on the technique of lost-wax casting, so that you can create glass with complex forms.

'Chocbox', Tlws Johnson, cast glass, W: 30cm, H: 22cm, D: 4cm. Tlws used plaster to make a mould of a flimsy plastic chocolate box tray. 'I loved the pockets that once contained mouth-watering sweets and the pattern of regimented containers'. The mould was filled with recycled crystal glass, fired in the kiln, and afterwards the top surface polished.

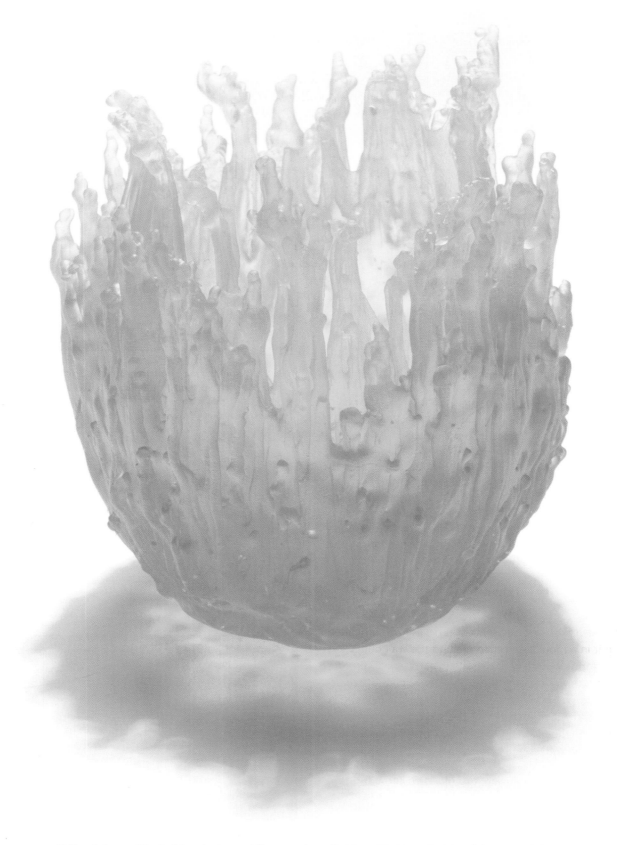

'Downpour – Yellow', James Maclachlan, lost-wax kiln-cast glass, H: 16cm, W: 14cm, D: 14cm (Photograph by Tas Kyprianou).

LOST-WAX CASTING

Lost-wax casting allows anything that can be modelled in wax to be replicated in another material, in our case glass, but also more commonly metal. It is utilized as a technique to produce complex objects, usually cast in bronze or brass. The lost-wax process, sometimes referred to by the French term *cire perdue,* is an ancient technique stretching back through thousands of years, with the first known examples of the process occurring in India around 3500BC.

The technique has been associated with glass from very early periods, and certainly was in use during the Roman period. However, it was not until the nineteenth century that its potential for casting glass was fully explored by the foremost exponents of Art Nouveau glass, such as Henri Cros, Argy-Rousseau, Décorchment and most particularly, Frederick Carder. The technique has seen a revival in recent years, beginning with the Czech mastery of the method, through to the studio glass movement of the 1960s and 1970s and it has become popular again, due to the general revived interest in kiln-forming, and in creating increasingly more complex and larger artworks in cast glass.

The lost-wax casting method involves making a wax model, investing it in a mould, and then melting the wax out of the mould to form a cavity into which a glass version can be cast. Hence the origin of the term 'lost', as the wax (or more importantly the *form* of the wax) is lost or destroyed when it is removed from the mould. The wax can be reclaimed many times for the model-making process – it is melted out and reused. In the past other materials have been used for the 'lost' process, such as tallow, or resin, but wax has become the most useful and versatile material.

Working with the lost-wax technique allows the glass artist to cast objects which would otherwise be impossible or more difficult to create in glass. The technique allows us to remove the model, which must be made from wax, from the

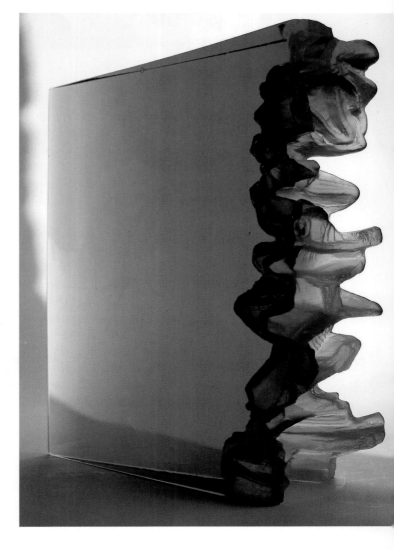

'Blue Wedge', Crispian Heath, cast glass, H: 27 cm, W: 23.5 cm, D: 9 cm.

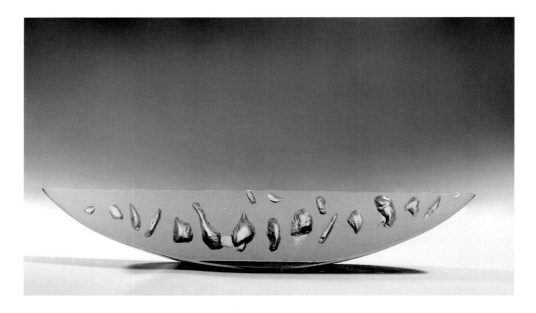

'Stepping Stones', Joanne Mitchell, 2008, kiln-cast glass, W: 40cm, H: 9cm, D: 4cm.

refractory mould without breaking it or having to make very complex multi-part moulds. Glass is then cast into the cavity inside the refractory mould. After casting, the glass object is trapped in the mould. Since refractory moulds for glass do not last, as they are based on plaster and become very soft after firing, in glass-casting the refractory mould is almost always lost, so that the mould is broken away from the glass to reveal the cast glass.

In sculptural casting it is possible to work on making multi-part moulds (known as piece moulds), where multiple sections come apart so that the original object can be removed and the mould reused, but the lost-wax technique circumvents the need to make these complex moulds with multiple parts. Of course many forms would be impossible to make even if the mould were separated into many parts – the shapes, textures and undercuts are far too complex. As a refractory mould for glass casting, multi-part moulds are mainly used for glass pieces where access to the interior of the mould is needed, for instance, when preparing a *pâte de verre* mould by packing two halves of the mould with crushed glass, laying in colour. In short, the lost-wax technique neatly gets around the problem of undercuts and multiple parts.

By modelling or forming a wax version, also known as a 'pattern', of a complex, undercut shape or structure we are able to make a refractory mould of that object by pouring a mould mix around the wax. The use of wax means that we can remove the model material from the refractory mould by

steaming it out, rather than digging it out, like clay, which would otherwise be trapped inside the mould, and then cast glass into the cavity left behind. As wax melts to a liquid, this also means that we only need to have a very small opening in the mould, to allow the wax to drip out and the glass to flow in, as opposed to a largely open mould. This enables us to cast forms almost entirely 'in the round' and have control of virtually all the exterior surface apart from the small opening area. It is possible to create wax patterns by modelling by hand, as well as casting them in a master mould, so that multiple copies may be made even though each wax pattern is lost in the refractory mould-making process.

Example of wax model (Courtesy Liquid Glass Centre).

STAGES IN THE PROCESS

To make the process of lost-wax casting for glass more accessible, it may be useful to look at the various stages in the production of a glass piece by this technique.

The first step in the process is to create the wax model. This can be done either by modelling the wax by hand, either using a special type of modelling wax which is soft, or cutting into blocks of harder wax; or by creating a master mould, into which wax is poured, facilitating the reproduction of multiple waxes.

Example of wax model.

Stages in refractory and master-mould making.

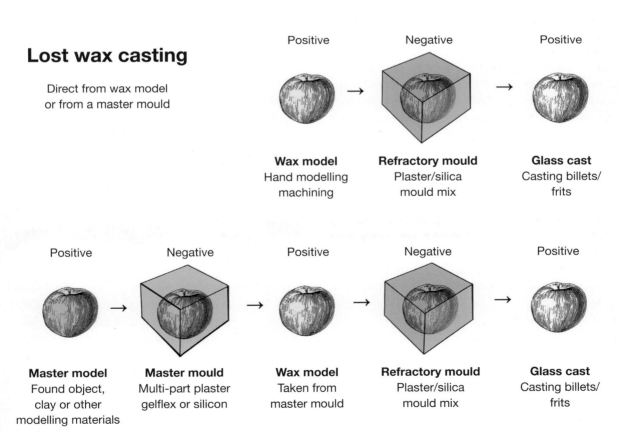

Lost wax casting

Direct from wax model
or from a master mould

Positive	Negative	Positive
Wax model	**Refractory mould**	**Glass cast**
Hand modelling machining	Plaster/silica mould mix	Casting billets/ frits

Positive	Negative	Positive	Negative	Positive
Master model	**Master mould**	**Wax model**	**Refractory mould**	**Glass cast**
Found object, clay or other modelling materials	Multi-part plaster gelflex or silicon	Taken from master mould	Plaster/silica mould mix	Casting billets/ frits

Casting Directly from One-off Wax Model

As you can see from the diagram on page 141, in the top section we can see the stages in making a cast piece directly from a wax model. This would involve modelling wax directly (the positive) to make the form you wish to make in glass – it is important to remember that what you make in wax you get in glass. You would then make a refractory mould (the negative), fire to cast with glass, and you have created the same form in glass (the positive again).

Casting from a Wax Copy

The lower section of the diagram shows the stages involved in making a cast piece using a wax copy of the original object made in a master mould. This technique is used to replicate the same wax again and again, so that you can make many glass casts. It is also the only option when you want to take a cast from an object itself or a model in another material, like clay, which cannot be removed from the mould (the positive). This would involve creating either a mould which comes apart or away from the original in sections – a multi-part mould – or one which is flexible, so that the original object can be removed from the master mould.

The master mould (the negative) can be made from plaster, or flexible materials such as Gelflex or silicone, depending on the model. Wax is then poured into the cavity left in the master mould, which gives a wax (the positive) from which we can proceed onto the refractory mould-making stage.

We now join the same stage as modelling the wax directly – we would make a refractory mould (the negative), fire with glass, and create the form in glass (the positive again).

Although these stages seem somewhat confusing at first, it will not be long before you find you are able to 'think' in terms of positives and negatives, and you will be able to confidently assess the best way to go about preparing a model for the lost-wax casting procedure. We will now look at these stages in more depth.

THE MODEL OR PATTERN

As we have discussed, a wax model or pattern (i.e. wax copy) must be made in order to invest it in a refractory-mould mix. For lost-wax glass casting we can make a one-off wax model,

Pouring molten wax (Courtesy Liquid Glass Centre).

which will be steamed out and lost, or we can make a master mould so that we have the ability to replicate many waxes, or patterns, each steamed out and lost. Wax is an interesting material to work with – it has its own qualities and can take some time to get used to, but it is indispensible when it comes to model-making because of its versatility.

Wax for Modelling

There are numerous recipes used for wax modelling and pattern-making in the lost-wax process, many having been used for metal casting for hundreds and thousands of years. In the past beeswax would have formed the major component of most blends for lost-wax casting, often modified with other substances such as rosin, which is a tree resin, to make a particular recipe, which would be closely guarded by metal-casters for its properties. With the advent of petroleum-based waxes, derived from oil, a completely consistent, refined wax was available which to some extent standardized the materials used for modelling.

WORKING WITH WAX

Wax should be treated with care and caution.

Microcrystalline wax melts at about 71°C. It should be heated in a controlled manner, preferably in a wax-melting pot with a thermostat, made specifically for the job. These can be obtained from sculpture suppliers, although they are quite expensive.

More cost-effective methods for safe melting would be to use a double pan with the inner wax container sitting in a water bath. You can use an old saucepan and a suitable sized larger pan with a raised mesh inside it so that there is no direct contact between the wax container and the heat source.

Another good safe alternative is to melt your wax in a slow cooker. Melt wax on the high setting and then switch to medium or low to keep the wax fluid. Melting wax this way can take extra time as the thermostat is set to only a little above the melting temperature for wax, but it is very safe. If you can, find one with quite a large pot so that you can melt plenty of wax in one go to allow you to keep working.

SAFETY POINTS FOR MELTING WAX

- Never leave melting wax unattended.
- Always have a lid available for the container you are melting in – it can be used to smother a smoking pot or fire.
- Never use water to extinguish a wax fire.
- The flash point of wax (i.e. the point at which it spontaneously turns into flames) can be anything above 150°C, so it is safest not to heat it above 100°C, and never directly over a hotplate.
- Do not let a double boiler run dry – it can quickly get too hot.
- Use an electric heat source if possible – fires are less likely if you do not use naked flame as a heat source.
- Work with ventilation fans if possible.

Wax slab.

Microcrystalline wax can be used unmodified for pouring into master moulds. For other uses it can be mixed with other waxes to make a suitable blend for the purpose needed. It commonly has petroleum jelly added to soften it slightly for hand modelling. The natural translucency of wax can cause real problems when modelling and detailing, because it is difficult to see the surface of the form properly.

For this reason, when modelling wax for sculpture colour or dye is often added to block the translucency of the wax and allow the artist to visualize the form of the sculpture as it is progressing. Interestingly, this may or may not be relevant for the glass artist, as the form is turned back to translucency when cast in glass. Oil soluble dyes can be obtained from wax manufacturers and candle makers shops in most colours.

Which wax to use will come down to personal preference, experimentation with different blends, and ultimately how you will be shaping the wax. Some suppliers have readymade blends suitable for lost-wax glass casting, for instance their own blend of modelling wax, suitable for hand modelling. These can be more convenient to use, but it is also fairly easy to make your own blend. Some common waxes for various uses include:

Pouring	Microcrystalline (soft or hard)
Hand Modelling	Microcrystalline (soft)
	Microcrystalline with 5–10% petroleum jelly added to soften
Cutting/Tooling	Microcrystalline with approximately 5% paraffin wax or rosin added (but quantity to add depends on hardness required)

Most waxes or blends used today for lost-wax casting are based on a type referred to as microcrystalline wax. Microcrystalline waxes consist of a matrix of extremely small crystals. They are sometimes referred to as amorphous wax. The wax is petroleum based, like paraffin wax, but because of its fine grained crystalline structure, it is finer and more flexible. It is non-toxic, almost odourless and very fluid when melted. It comes in several grades, from a harder through to a softer wax.

HOW TO MAKE A SLAB MOULD

A slab mould can be a handy addition to your wax equipment, as it allows you to make wax sheets and blocks which are useful for modelling or recycling your wax. Slab moulds can be made from either a flexible material such as Gelflex or silicone, or from plaster.

To make a plaster slab mould, take a large flat object, such as a board or plastic tray, about 400mm by 300mm, but this purely depends on the size of the wax slabs/sheets you want to make. The mould needs to be about 50mm deep, so build a wall of clay around the tray so that you have the form of a block shape – taper the clay outwards towards the bottom.

Build a cottle around this, 30mm from the bottom tapered edge of the clay, and 30mm taller, and make up a mix of plaster using the ratio of 1 litre of water to 1.4kg of plaster. Pour the plaster over the tray and fill up the cottle. Leave to set; when ready remove the clay and tray. Clean the slab mould ready for use. If the mould is dry it must always be soaked in water for half an hour before pouring wax into it.

You can also make a slab mould using Gelflex or silicone, which will be more resilient than plaster, but you must make sure that whatever you use for creating the flat surface (the tray, for the plaster slab mould) can withstand the temperature if using Gelflex, which is poured hot.

The slab mould can be used to make blocks of wax as well as varying thicknesses of sheets. Thin sheets of wax are very useful, as if they are thin enough they can be warmed quickly in warm water. This means they can be brought to a workable softness very quickly, and by warming several a whole mass can be softened in a much shorter time than soaking blocks of wax in warm water.

Diagram of a wax slab mould.

Microcrystalline wax generally comes in slabs, from ½kg up to 5kg in size. The larger 5kg slab can be broken up for melting by hitting hard with a hammer, whereupon it will break up into chunks. The wax must be cold in order to break, as if it is warm it will merely bend when you hit it, so keep your wax in a cool place, or chill the block in the fridge or freezer for a while. Break up the wax on the floor but on a mat or plastic sheet to keep the pieces clean.

It is a good idea to make up a rubber or plaster slab mould to help you form sheets or slabs of wax yourself when forming or re-melting wax. This can be a simple one-piece mould made from plaster, of any flat smooth object, such as a plastic cutting board. Soak any plaster moulds thoroughly in water before pouring melted wax into them; this will keep the wax from soaking in and sticking. Thinner sheets of wax may be obtained by tilting the mould so that the wax flows over the whole surface – thicker ones by filling the mould and letting it set.

HAND MODELLING

One of the easiest ways to begin lost-wax casting glass is to work directly in wax so that the process is simplified to just

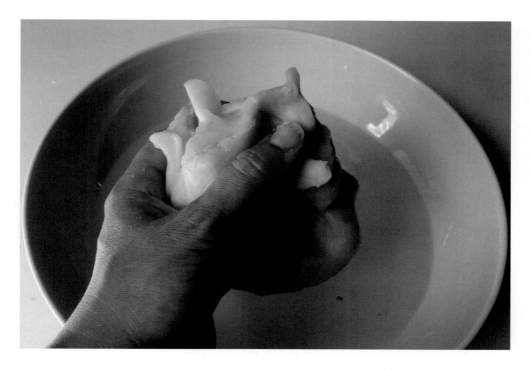

Warmed wax becomes soft and malleable.

modelling and taking a refractory mould from the wax. The stages involved in producing a master mould are at this point left out, and this often helps the glass caster to understand and perfect the use of wax as a modelling material, before going on to look at master moulds. The disadvantage is that you will only have one copy of your model, as the wax you work on will be lost. if you wanted to make another glass cast, or if anything went wrong in any of the following stages you would need to make it again from scratch. However, working in wax directly can be a great tool for enabling creative spontaneity.

The wax must be warm in order to shape it by hand – you will not be able to sculpt it if it is cold. In order to warm the wax, fill a bucket with warm water, a little hotter than bath temperature, say about 45°C, and soak the wax for at least half an hour, depending on the size of the block of wax. You will need to regularly top up with hotter water to keep the temperature warm enough. The wax will then become plastic enough for you to be able to mould, press and shape the wax with your fingers, a little like clay. The natural heat in your hands when modelling the wax helps to keep it soft.

It is also useful to keep an electric hot plate nearby, on which you can heat up basic metal modelling tools to help shape, cut and smooth the wax as you are working. Hot tools can be used to carve into the wax, can be held between pieces of wax which are brought together quickly to join

them together, or can be experimented with in a number of ways to work the wax.

Safety note: Always heat just the tip of the tool on the hot plate. Make sure you pick up the cool end of the tool. Never leave tools on the hot plate for a prolonged period.

A metal dish or metal plate with a flat bottom can be placed on the hot plate to warm up intermittently, and sections of the wax model can be held against this plate for a few seconds to liquefy a larger, flat area of the wax, enabling it to be joined to other wax pieces.

Safety note: The dish or plate must never be left on the hot plate, as it will smoke.

The pieces to be joined have to be held completely still for a few seconds while the wax sets. Once the joint is stable it can be completed by using a hot knife to run wax into any gaps left.

Wax is quite unlike any other modelling material to work with by hand, and it often feels difficult and awkward to work with at first, but you will soon get the hang of it.

Cutting into the wax when cold with sharper metal tools is also an option when modelling by hand. With this method you can achieve clean and precise cuts and marks in the

Building a wax model (Courtesy Liquid Glass Centre).

wax. You can also try this in combination with modelling when warm. Keep a bucket of cold water to hand as well as the warm, so that you can cool waxes quickly if you want to create different effects by cutting into the cold wax. Wax can also be sawn, as well as cut on a lathe with a chisel.

You might consider the option of adding to or building a wax model with smaller wax pieces. Proprietary silicone moulds in various shapes are relatively common now, for shaping everything from baking cakes to soap and candle-making. All of these can be used for making smaller decorative wax elements which can be joined to make larger composite wax sculptures.

For a simple mould you can also use clay to make small waxes of found objects without undercuts – simply take a found object, push it into wet clay to give an impression, and pour wax into the impression. Leave for a short while to set, and then clean and use this element to join to other pieces of wax or a larger wax sculpture. Often a stickier wax is used as a sort of wax glue – it has a lower melting point and can be heated and used to hold material or pieces in position, or for repairing wax models, or for joining wax pieces. It comes in a stick form, the end of which can be melted briefly in a flame and used for any of these purposes.

Wax is an invaluable material when it comes to mould-making for glass. It can be a very creative medium, and the more you work with it the more you will begin to realize its potential. When you have something you like, you will be ready to go on to the stage of preparing your wax for the refractory mould-making procedure.

Making wax components in clay (Courtesy Liquid Glass Centre).

RECYCLING AND CLEANING WAX

One of the great advantages of wax is that it can be re-used again and again. As the wax goes through its cycle of use – melting to make a model, steaming out, re-melting for re-use – it will begin to accumulate debris, such as particles of plaster and clay. Gradually it will become very contaminated – this will affect the quality of your models and can cause burning and smoking when re-heating your wax. There may also be water trapped in the wax.

You can re-use wax a few times by simply reheating the wax in your melting pot, checking first that there is no water at the bottom of the pot. If there is, then make a hole in the wax and pour the water away. When the wax is molten pour it carefully into your slab or mould, stopping when you see any debris or more water, which will be towards the bottom of the pot. Discard any of the contaminated wax which is left.

VERY DIRTY WAX

Take used wax from the steaming-out process and put into your wax melting pot. Heat the wax until it has melted, and then switch off so that the wax cools down again. This first heating separates the wax, water and debris into layers in the pot – most of the debris will sink to the bottom of the pot, together with any water.

When the wax has completely cooled, heat the wax for a few minutes, just to liquefy the wax block where it touches the sides of the melting pot, and pull out the whole block of wax and put on a board or some newspaper (be careful to let the block cool a little before you handle it).

Discard the water, and clean the debris from the pot and the bottom of the block, by scraping away if necessary.

Re-melt the wax and use to pour into your mould or slab mould.

Recycling and cleaning wax.

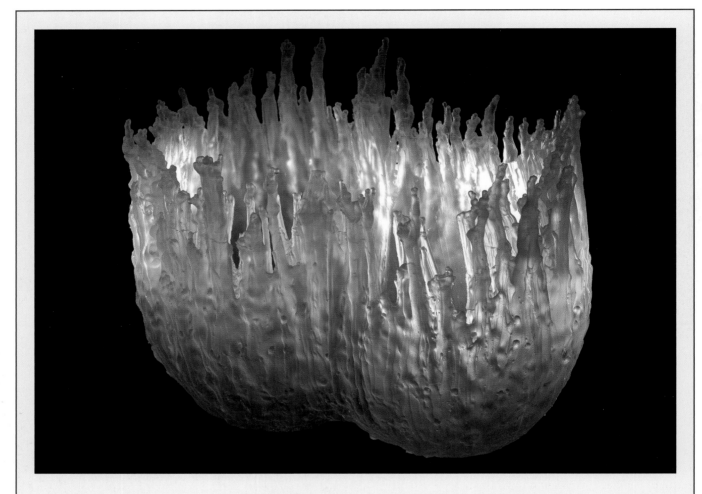

'Freeze 2', James Maclachlan, lost-wax kiln-cast glass, H: 30cm, W: 40cm, D: 24cm. James's glasswork captures a moment when molten liquid solidifies, creating objects where structure and decoration are one.

PREPARING FOR THE REFRACTORY MOULD

All waxes, whether made using hand modelling or in a master mould, need to be prepared for mould-making and glass-casting. The most important consideration is that the wax should be exactly as you envisage the final glass cast to be – any surface imperfections and marks will be translated to the final glass cast, so it is worth spending some time making sure that you have the wax model exactly as you want it.

We shall now look at other considerations such as creating a reservoir for holding the glass and ways of encouraging glass to flow into the mould.

Reservoirs

A reservoir consists of a space in your refractory mould, above the cavity which contains the negative space of your model, where glass can be held ready to melt into the cavity. A reservoir is essential for any mould which is partially or almost completely enclosed, indeed for all but the most open of moulds. This is because it is often not possible to get the glass pieces into the cavity as they are too large to fit through the opening to the mould. Even if the glass cullet used did fit through the opening, it is also not possible to fill the interior of the mould with enough glass to fill the cavity, as the cullet used takes up much more space before it is melted than afterwards, due

Reservoir built into a mould.

to the irregular shapes of the cullet. Therefore extra space is needed to hold the excess glass. Even if quite fine glass frit is used to fill up the cavity and melt into the mould, you will still need extra glass to fill the mould completely, as it will settle when melted, and there will still be some space left after melting. For this reason, amongst others, a reservoir needs to be created. A reservoir is very different to a pouring cup used in moulds for metal casting, which is simply an enlarged opening and pouring space, and does not need to hold the whole quantity of material which will fill the mould, as the metal is poured instantly whilst molten.

A reservoir for glass casting is most frequently built into the mould, so that it is made as part of the refractory mould itself. This is because there is less likelihood of problems arising than with a separate reservoir, such as the reservoir moving, tipping over or breaking open. If they are made as one structure it adds strength and stability to the whole reservoir and mould construction.

The reservoir is often funnel-shaped, tapering towards the opening of the mould, to encourage the molten glass to flow in readily. It can be created in one of three ways. In the first two, the reservoir area is created when the model is being prepared, so that when mould mix is poured around it, it becomes a space in the top of the mould to load glass.

(1) CLAY RESERVOIR

This reservoir area can be made from clay. There are many advantages to this method, as it provides great flexibility and simplicity in construction. The reservoir is made using a block of clay which mirrors the approximate shape of your model, with a slightly increased volume. For instance, if the model is roughly round and, for instance, 100mm high by 100mm diameter, then the reservoir will need to be a similar shape and a little bigger in volume, say 100mm round and 150mm high.

It is often the height of the reservoir which is increased, so that the outer dimensions or shape can be kept closely matching the model. The reason for the reservoir mirroring the shape of the model is that it provides a similar thickness of mould wall in the reservoir and model areas of the mould. This ensures that there are no very thick areas of mould material in the mould, which would affect its heating and cooling in the kiln. This principle cannot always be practicably applied,

Small wax model with clay reservoir.

however, as it would be unworkable to have a very tall mould, in the case of a tall model, so there are some occasions when the reservoir can be made wider and shorter.

A clay reservoir is achieved by modelling some clay on a board into a mound, tapering towards the top to meet your model. The model is placed on top of the clay mound. The point at which the clay and the wax model meet becomes the opening where glass will enter the mould. In metal-casting this is known as the gate.

You will need to consider the size of opening you require for your model, and the best place to position the opening, remembering that this is where, after casting, there may be excess glass to cut off and/or a surface which may need finishing or polishing work. For this reason the opening point for most models is the bottom or underneath of the model, if it has one, or a place on the model which the maker considers to be the most inconspicuous. Because of the viscosity of glass, most openings to the mould need to be at least 15mm in diameter, preferably larger. Therefore the clay mound would need to taper to a point no smaller than 15mm in diameter, with the wax model pushed onto this point.

In some cases you may need to support the wax model where it meets the clay reservoir, as it may be liable to topple over, or the wax may rise and separate from the clay when mould mix is poured over both. This can be achieved by pushing a cocktail or barbecue skewer into the clay, which the wax model can in turn be pressed onto, or you could use screws or other similar metal pins to help anchor the model to the clay.

(2) WAX RESERVOIR

The second method is to make a reservoir in wax, which will melt out when the rest of your wax model melts away. This would be made separately and attached to your wax model, if hand modelling a wax, but can also be made as part of the model itself, by incorporating a reservoir area into a master mould (see Chapter 7), which is perhaps the great advantage of a wax reservoir. If you are making multiple waxes this can greatly speed up the process of preparing your models. The reservoir would be formed together with the model each time in the master mould, and is particularly useful if making hollow models. To make a separate wax reservoir, you again need to think about the volume and shape of your model, and replicate the approximate size and shape in the reservoir.

Wax reservoirs can be made by pouring the molten wax into a heat resistant flexible container, such as a silicone bowl,

and agitating or swilling the wax so that it coats the inside of the bowl, creating a large 'cup' which can be attached to your wax model. Whilst still soft the shape of the wax reservoir can be manipulated by hand to mirror your model, and when cool cut to the correct size. Softened or sticky wax can be used to attach the reservoir to the model using heated tools.

Another technique for creating a wax reservoir is to fill a balloon with cold water to an appropriate size, and dip into the wax repeatedly to form a 'cup'. When the wax is thick enough (4mm or so) burst the balloon, trim off the top edge with a knife, and you have a wax reservoir ready for attaching.

(3) SEPARATE RESERVOIR

It is also possible to use a separate reservoir for certain situations in lost-wax casting. This third method of providing a reservoir uses a separate container to hold the glass, which must be heat-resistant up to kiln temperatures, as well as fairly rigid and strong. A separate reservoir can be useful when casting very large moulds, or when time is at a premium for mould-making, or if there has been some failure in the mould-making process and the reservoir area has become damaged or deficient.

Flowerpots are most commonly used, as they are strong and can easily withstand firing temperatures. They also come in a variety of sizes, have a hole in the bottom for the glass to cast through, and can be reusable if you use the same compatibility glass (after the first firing there will be a coating of glass on the inside of the flowerpot). You may need to open up the hole at the bottom depending upon the amount of glass flow you require – this can be done by drilling a larger hole with a glass drill.

The pot needs to be positioned so that it is suspended directly above the space in the refractory mould, and not sitting on the top of the mould itself, as the weight can weaken the mould, and melted glass can sometimes bond the flowerpot to the top of the cast glass. It can be suspended by propping it on kiln bricks or kiln furniture around and above the mould in the kiln, ready for the glass to flow out of the hole at the bottom and into the mould when the top temperature is reached.

Flowerpots do have the disadvantage of allowing glass to flow out and over the top of the mould, and consequently over the bed of the kiln, if you overfill them with glass, so measure glass quantity carefully. Other forms of separate reservoirs can be made by casting from refractory material itself, or by wiring pieces of ceramic fibreboard together.

Casting with flowerpots.

Large mould with separate refractory reservoir.

Air Vents

After a reservoir has been attached to the wax model considerations must be made about the likelihood of air becoming trapped in the mould whilst the glass is casting. Whenever glass enters a mould it must displace air trapped within the cavity. Air vents or small channels through the mould provide a means for trapped air to escape from the inside of the mould to the outside. This movement of air encourages the glass to flow into the mould, and prevents an air blockage.

The most common sign of a blockage is when the kiln is opened and the reservoir in the mould is still full of glass.

Air trapped within the mould has prevented the glass from flowing down into the cavity. Because glass flows slowly though the opening into the mould, giving air some time to displace, it is not always necessary to provide air vents, especially when the opening to the mould is larger and it is more likely that air can flow out, but there are certain situations where you will always need one or more.

If we look at the form or structure of some models, they may have areas which rise up into the mould above the main body of the cavity. If the figure of a person, for instance, were being cast through an opening at the base of its feet, an outstretched arm would constitute a problem area for the

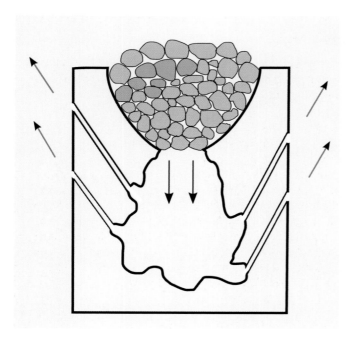

Mould with vents to allow air and glass to fully flow.

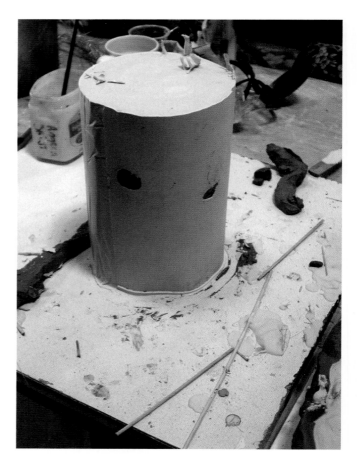

Clay plug for vents in sides of mould – the clay is removed and the skewers pulled out.

displaced air. When the figure is cast glass would flow into the cavity of the torso and legs, but as the glass starts to flow into the arms, air would become trapped without any means of escaping. To alleviate this problem, a vent is added to the end of each arm, so that the air can escape, and the glass can continue to flow through to the end. Whenever there is the likelihood of air getting trapped in an area of the mould, it is necessary to add a vent to avoid the failure of the casting.

Vents are relatively simple to add to the model. They usually run from the points which may trap air to the top or sides of the mould. They can be made from wooden barbecue skewers, coated in a little petroleum jelly, or drinking straws for larger vents. These are attached to the model using clay, softened sticky wax, or even, if using the wooden skewers, simply pushed a little into the wax model. They run to the edges of the mould, or down to the board on which you are assembling your reservoir and model, near the reservoir area itself, but never into the reservoir – if the vents are connected to the reservoir then they will simply fill with the glass in the reservoir as it melts, preventing the air from escaping. At the boards they are again fixed with clay or wax. These skewers or straws also serve the dual purpose of helping to support an unsteady model if this is necessary. When the mould has been poured, and turned right way up, the skewers or straws will

need to be removed from the mould by cleaning away the wax or clay, and pulling the end of the straw or skewer with a pair of pliers – they should slide out easily. You now have a vent for air to flow out of the mould freely.

Cottling

The mould will then need to be prepared with cottling. To set up the cottling, refer to the Cottling section in Chapter 5. Again the cottling or mould box must be positioned about 30mm away from the model, to give the optimum thickness of mould wall around it. Make doubly sure that all edges are sealed with clay to avoid leaks. If necessary reinforce cottling or mould boxes with clamps, tape, heavy blocks (such as bricks) as appropriate, to avoid lino or boards being forced apart with the weight of mould mix.

CLEARING UP PLASTER

WHAT TO DO IF YOU HAVE A PLASTER SPILL

Plaster spills happen to everyone at some point, and can range from a small leak through to a major spill. It is wise to consider how you are going to deal with any spills should they occur.

When making smaller moulds you will need quick access to water and paper towels or cheap absorbent cloths to clean up after small leaks. You may be able to plug the leak with a small amount of wet clay, or failing that some loose plaster sprinkled over the point where plaster is emerging.

If a major spill occurs from a rupture in the cottling, have a bucket ready nearby to collect liquid plaster which will flood your worktop and pour over the edge. If the mould mix is near setting, and the cottling is intact or repaired sufficiently, you may be able to reuse the plaster by pouring it back into the mould, but you should be sure that the cottling will hold.

For bigger moulds have a large bin nearby, which has an open top and a bin liner inside. Use this to collect any flooding plaster.

CLEANING UP TOOLS, SURFACES AND HANDS

Avoid washing cloths out at a normal sink as the plaster solution will eventually block your drain pipe. The same goes for tools and hands.

Keep a large bin nearby, which has an open top and a bin liner inside, for disposing of plaster-soaked paper towels or cloths.

Plaster is easily removed from tools while it is still wet – just wipe it off with a paper towel and drop it in the bin.

Clean your hands by wiping the plaster on a rag or paper towels, and then rinse in a bucket of water (leave the water to stand and any plaster residues should sink to the bottom of the bucket). Any plaster that is left in buckets and bins can be cracked off by flexing them after the plaster has dried.

SINK PLASTER TRAP

To avoid the possibility of blocked drains, you could make your own plaster trap and install under your sink. To do this, remove your usual trap waste pipe and replace with a length of flexible waste pipe. This will be used to drain water into a receptacle – you could use a standard cistern tank. Cut a hole near the top of this tank, and fit a pipe into this hole. Seal with silicone. This can either connect to your usual drain pipe, or drain into a secondary plaster trap for extra caution. It is also possible to buy a readymade plaster trap from sculpture suppliers.

A plaster trap.

To drain

REFRACTORY MOULD-MAKING

You will now need to assess the amount of mould mix to make, again refer to the Mould Recipes section in Chapter 5. Make up the appropriate amount and pour into the cottling and over your model.

If you are attempting to make a larger mould, say 250–300mm diameter and upwards, you may consider reinforcing the mould with a sort of 'scrim'. Because the refractory mould will be fired in the kiln, this will need to withstand high temperatures – the most common reinforcement in this case is chicken wire. To use reinforcement, when you have set up your model and cottling, before pouring your mould mix, cut a length of chicken wire with tin snips to an appropriate length to form a casing around your model. Secure the chicken wire casing by twisting the wire at the point where the two ends meet, so that it cannot spring open. This should then be placed in the space between the model

and the cottling, but must not touch either, so that it will be completely embedded in the mould mix. Mould mix is then poured into the mould, filling up the space and trapping the chicken wire inside the mould where it will serve to add strength to the mould when fired. There are also further variations in application of and recipes for mould mix which we will look at in the next chapter.

De-Waxing

Once your mould mix has been poured and set around your wax model, it is necessary to remove the wax. This is the part of the lost-wax technique which gives its name to the process. The wax must be removed, or 'lost', in order to empty the cavity inside the mould, making it ready to receive cast glass. This is achieved by heating the wax until it liquefies and so runs out of the mould, which has been positioned upside down to allow the wax to flow out. In metal casting, wax is often 'burned' out of a mould by heating it in a kiln which has been especially adapted with a hole in the floor for the wax to run out of the kiln.

Never attempt to burn out wax in a normal kiln. Heating a mould in this manner is not considered to be suitable for glass-casting. This is because there is a strong likelihood that wax will seep into the mould wall, which is quite absorbent when it is heated. There is also a possibility that wax particles will be left in the mould, or coat the inner surface of the mould, which will cause contamination of the glass when it is cast into the mould. Wax left in the mould will burn and leave black marks and defects in the final cast piece, creating undesirable blemishes. There is also a significant health and safety risk associated with wax fumes being released, as well as the possibility of fire being caused by wax reaching its flash point.

Because of this, wax is usually steamed out of a refractory mould for glass casting. This method is clean and efficient, keeping the mould surface wet and hot as the steam melts out the wax model. It is also a very clean technique, as very little trace of wax is left in the mould, as the mould walls are steam cleaned.

To steam out a wax, the best equipment to use is a wallpaper steamer. Set up the steaming station using a large, deep plastic tray (a photographic developing tray is good), a metal grid or oven shelf to support the mould, and the wallpaper steamer. The tray, which should be rigid and able to hold significant weight, should be placed underneath the metal

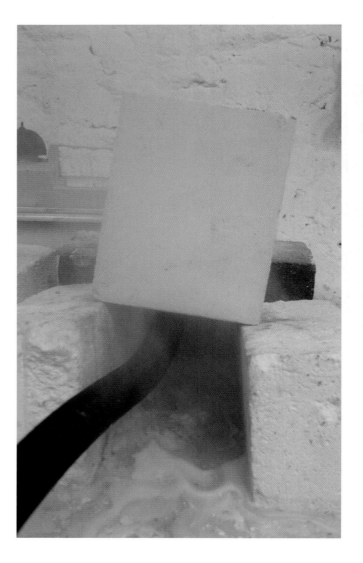

Steaming wax from a mould.

shelf to catch all the wax and water which will flow from the mould. The shelf itself can be supported on bricks or other sturdy blocks. The mould is placed upside down (mould opening and reservoir at bottom) on top of the shelf and the pipe from the steamer fixed with a wire tie to the metal shelf with a short length passing through the shelf and up into the mould. This will direct steam up into the cavity of the mould, melting wax as it meets it, which will flow down into the tray below. The place where the wax was will now become a void.

You can check visually for the amount of wax left in the mould, if you can see into the cavity to some degree.

A wallpaper stripper used as a wax steamer.

Clean mould for casting.

Safety Note: Be very careful when handling the mould. Turn the steamer off for a minute or more, making sure all steam has dissipated, before turning the mould upright to visually check for wax. It is advisable to wear heat-resistant gloves when handling the mould as it stays very hot for some time.

To check towards the end of the steaming, all the wax will have steamed out when an implement such as a spoon held under the tray to catch a drip from the mould shows no waxy content. In some wider moulds you may also need to move the end of the steam pipe into a different area of the mould to help melt leftover wax.

When you have determined that all the wax has been successfully steamed out, there is one final check you can implement to make sure. Boil a kettle of water and pour this into the mould cavity, up to the top of the mould opening or reservoir. If large globules of wax, about 10mm in diameter, rise to the surface, then there is still a significant amount of wax left in the mould. If, on the other hand, you see a waxy film with very small globules of wax about 1–2mm in size, then all the wax has been steamed from the mould. The boiling water is simply melting the last particles of wax left on the cavity walls of the mould. Pour away the boiling water, being very careful to avoid scalds, and refill the mould with another one or two kettles of water to finish flushing out all the wax. The mould is now ready to be set up for casting the glass.

Firing, Casting and De-moulding

Refer to the sections in the previous chapter for information on determining the quantity of glass you will need to fill the mould, firing and de-moulding. The glass will be placed in the reservoir built into your mould, or in a separate reservoir if you have chosen to use one, ready to cast during the kiln firing. As discussed in the previous chapter, you will need to think about colour dispersion if you use powders or frits sprinkled into the glass in the reservoir.

Again, the correct annealing temperature, and time kept soaking, is crucial to the outcome of the final piece. Remember that exposed areas of glass, such as those in open moulds or in reservoirs which have filled with excess glass, may need insulation as the kiln cools down, so they do not cool too rapidly in the final stages of the firing, causing strain. Refer to the tables in the Firing Schedules for an idea of the manufacturers' kiln-firing schedule you will need to use for different-sized kiln casts.

There may be marks left on the cast where vents were attached to the model – these may be in the form of small lumps or blobs of glass, where glass can often start to flow down the vent. It rarely travels very far, as the vent is usually too narrow for the viscosity of the glass. You will also find a mark and possibly a certain amount of glass at the opening to the mould, possibly filling the reservoir, depending on how accurately you have determined the quantity of glass. These areas will need to be cut and cold-worked to remove their traces (*see* Chapter 9 to learn more).

OTHER LOST MATERIALS

To some degree, it is possible to use the principles of the lost-wax process with any material that can burn or melt to leave a mould cavity. Some car manufacturers, for instance, use a lost-foam technique to make engine blocks when casting metal.

In principle there are two methods of achieving a lost-wax type of displacement of the model. The first involves burning the object out of the mould *in* the kiln. There are, however, important considerations to be made concerning health and safety, as well as, for glass casting, the effect of the residues left in the glass from this process. The other technique is to use a material for the model which can be removed from the mould *before* firing in the kiln.

If anything is to be burnt directly from the mould in the kiln, it should be an organic object and fairly small. Never burn any large objects in a mould, such as a large piece of wood, as they may cause a fire in your kiln. Never burn inorganic objects such as plastics.

Direct burning of combustible objects has been practised for some glass-cast objects, but the results can be mixed.

Small objects, such as plants, small bones, shells, vegetables, rope or materials will burn from the mould, but they will also leave an ash residue. This may form black marks in the mould that subsequently cast into the glass. The other danger is that the object, which may have a lot of water trapped in it, will cause problems on the inner surface of the mould as it burns away. A vegetable, for instance, will start to cook inside the mould as the heat in the kiln increases, and the resulting cooked remnants accumulate in the bottom of the mould, where they will start to degrade the refractory mould surface. Admittedly as the heat increases the vegetable will eventually turn to ash, but it may cause damage to the inner mould surface before it does so. The remnants may also create bubbles in the glass. It is wise to consider if the technique is ultimately effective. A wax model of the object made from a master mould will enable you to replicate the object cleanly and without contamination.

Removing other lost materials from the mould *prior* to firing is a more interesting area of mould-making for glass-casting. Polystyrene foam can be used to create larger forms, which are then invested in a refractory mix, and the foam afterwards dug out. The mould must have a fairly open face in order to gain access to the foam. (There is a practice of burning out foam for metal casting, but this is not recommended for glass casting moulds, and gives off toxic fumes). Another way of working is to look at materials which can be modelled and melt or dissolve, thereby allowing you to remove them from the mould. The most interesting material which you could use in this category is ice, which can be moulded, carved, melted etc before being used as the positive model for a refractory mould. The ice will begin to melt very quickly after a mould mix has been poured around it, and can be left upside down for the water from the ice model to melt out. This technique can create fascinating new ways of creating glass forms.

Glass artist Joseph Harrington uses ice as a modelling material for his glass sculptures.

Ice ready for mould pouring.

The mould after the ice has melted.

'Implement', Joseph Harrington, lost-ice process, kiln-cast glass, H: 23cm, W: 28cm, D: 4cm.

PROJECT 9: HAND MODELLED LOST-WAX SCULPTURE

For this project we will make a simple lost-wax sculpture. We will use a readymade modelling wax, or microcrystalline wax which has been modified with 5% petroleum jelly. We will model the material directly to create a positive wax model, with the negative mould taken from the wax. You will be able to create undercuts and textures, as this is the primary benefit of working in the lost-wax technique.

1. Take a block of modelling wax about 150mm high, 100mm wide and 50mm deep and soak in warm water, about 45°C, for at least half an hour. Keep the water at the right temperature by topping up with hotter water. Hand-sculpt a three-dimensional form from the block of wax. Keep the wax warm when you are not handling it by immersing in the water again. You can use tools to carve into the wax, either when warm, or chill the wax in the fridge to give sharper, cut lines when carving. Remember to make the form look the way you want the final glass piece to look. Polish the wax with a heat gun if desired.

2. When you have finished working on the wax, prepare a mould for glass casting. Create a reservoir in clay, a little larger than your wax model, with a similar outer contour, tapering to a flattened point. Choose an entry point for the glass on your model (usually the base) and anchor your model to the reservoir by pushing it onto a barbecue skewer (cut to length) protruding from the flattened point in the reservoir. Choose a cottle (round) or mould box (square) depending on your model. Position the cottling 30mm away from the perimeter of the model. Seal the bottom and side edges of the cottle or box. Mark a pouring line on the inside of the cottling, 30–40mm from the highest point of the model.

3. Calculate the amount of mould mix you need to make according to the information included in Mould Recipes in the previous chapter. Make up the mould mix, allowing a little extra to be sure you have enough.

Safety Note: Make sure you wear a respiratory mask.

4. Pour required quantity of warm water into a bucket. Weigh out flint, pour into the bucket and stir to dissolve. Weigh plaster and add to bucket, agitating to mix. Add fibreglass strands.

5. When the mixture is smooth and has a consistency of single to double cream, pour mix into the mould. Tap the board below or the side of the mould very gently. Put your finger into the top of the mould mix whilst still liquid and agitate it gently to smooth the top of the mould, which will become the base of the mould.

6. The mould mix is set when it has warmed up and cooled again. This should take around half an hour.

7. Leave the mould until completely cold. Set up a steamer, and position the mould upside down over a tray, with the steaming pipe position in the opening of the mould. Steam out all the wax. When you believe all the wax has been removed, boil a kettle and check for wax residues. Clean with one or two more flushes of boiled water. Smooth the top edges of the mould with a damp sponge.

8. Gather the glass you would like to use for casting in the mould – either frit or billets of glass. Use Method 1 for calculating the amount of glass needed to fill the mould. If you have a reservoir built into your mould, remember to only pour the water into the mould to the level you want the glass to come to, not to the top of the reservoir.

9. Position your mould on a kiln shelf with vermiculite or sand. Level the mould. Fill the reservoir with the measured glass and any colour or metals.

10. Fire using **Firing Schedule 7**.

11. When cool remove mould from kiln. Remove the mould by breaking it away from the glass. Remember the glass may have sharp edges. Clean, and grind any sharp edges.

Hand-modelled wax (Courtesy Liquid Glass Centre).

Now that you have completed a glass piece in the lost-wax technique, you will understand the fundamentals of this unique process. You will now have some useful experience in modelling and mould-making. Working in the lost-wax technique brings endless creative possibilities to the artist using glass as a medium. In the next chapter we will look at master mould-making techniques to extend your repertoire.

159

MASTER MOULD-MAKING

'See Past the Future', Bruno Romanelli, lost-wax cast, W: 60cm, D: 6cm, H: 13cm (Photograph by Alan Tabor).

We will now look at one further technique associated with lost-wax casting, namely master mould making. Understanding how to make a master mould will enable you to make a copy of any artwork or found object you want to make in glass, as

OPPOSITE PAGE:
'Illusionary Space Series', Margareth Troli, glass and granite, lost-wax casting technique, Dia: 30cm, D: 25cm (Photograph by Simon Bruntnell).

well as allowing you to make multiple waxes, so that you can repeat the process again and again. This will also ultimately enable you to refine your mould-making and glass-casting skills, as you will be able to work through any problems you may encounter in the techniques without losing your original artwork. Although master mould making may at first seem a complex and lengthy process, it is invaluable for those seeking to fully explore the lost-wax technique, and once mastered the processes become second nature.

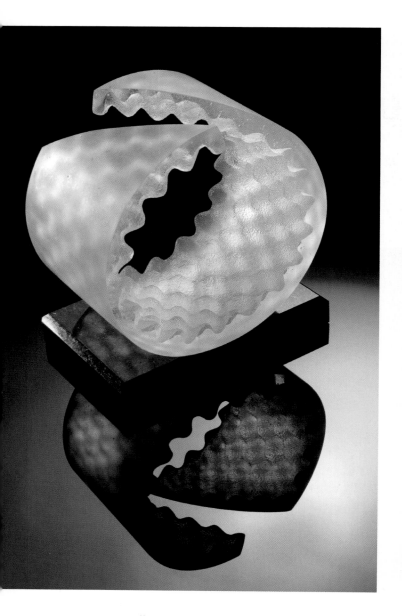 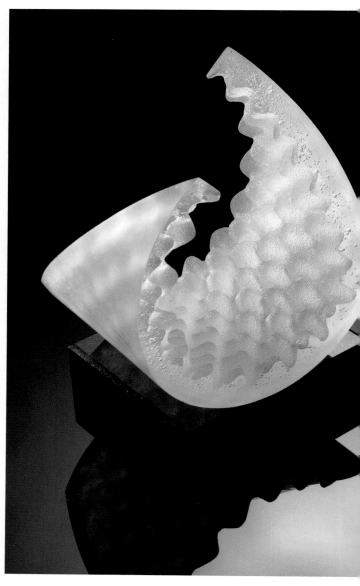

'Illusionary Space Series', Margareth Troli, glass and granite, lost-wax casting technique, Dia: 30cm (Photograph by Simon Bruntnell).

As we have seen in the previous chapter, the use of wax in mould making for glass enables great versatility in the form and design of models. The purpose of a master mould for glass-casting is simply to enable one or more wax versions of an object to be made.

Master moulds have been used for centuries to create forms for all types of industries, from ice cream moulds to metal tools. Master moulds were made from metal, stone, plaster, sulphur or even wood. Most often they were used for making simple objects with few undercuts, such as casting metal vessels. One popular use of master moulds in the nineteenth and twentieth century was for casting objects in pewter. Scores of pewter objects could be cast from a single master mould in a day. The use of a master mould is also a mainstay of the bronze-casting process, to create waxes for multiple editions of work. For glass-casting, the use of a master mould enables us to create multiple waxes, from which many refractory moulds, and therefore glass casts, can be made. Making a

A master mould.

master mould may also be a necessity, to transform an under-cut model in another material into a wax from which we can make a refractory mould.

There are therefore many reasons for making a master mould when casting in glass, an important one being that it preserves the original model. A master mould will give you the potential for making multiple waxes, or wax patterns, which means that you will be able to make as many refractory moulds, and therefore as many glass casts (one wax=one refractory mould=one glass cast). You may want to make many moulds of the same object so that you can make an edition of glass casts, or to perfect the firing schedule, or so that you can experiment with the colour you are casting with, or effects in the glass; or simply as a failsafe against problems in annealing. A master mould can be kept for many years if necessary, and will not only enable you to repeat your wax at any point in the future, but is also good way of keeping a physical record of your waxes and work. In any case, there is no doubt that working from a master mould will give you many more options than a hand-modelled wax. Many glass artists automatically work from master moulds, or make master moulds of their one-off models.

Of course it is usually necessary to make a master mould if you like working in clay or other materials, or found objects, and your form is undercut, as you need to 'convert' the form into wax to make a refractory mould, and therefore you have no choice but to make a master mould. But it is also important to remember that if you like modelling directly in wax, there is no reason why you cannot use a cold-curing flexible mould material such as silicone to take an impression of your hand-modelled wax, effectively creating a master mould, so that you can then make more of the same. There are several materials to work in when making a master mould, and we will look at the various reasons for using them, as well as the methods to be adopted.

The materials you will use for the master mould will depend on the type of objects you wish to capture and the materials they are made of. Plaster makes a rigid master mould, which is used for objects which will release from the mould easily and have few undercuts. Flexible mould materials such as vinyl (also known as Gelflex), silicone and alginate are useful for multiple undercuts and highly textured surfaces, as the master mould itself can flex and enable the object to be released.

If we look at the materials objects may be made from, we can discuss specific master mould materials or methods which might be appropriate.

MATERIALS FOR OBJECTS

Plastic

Plastic objects are good for taking master moulds from because they are smooth and release easily from a rigid master mould, as often they can flex and bend. The smoother the surface, the easier it is to remove them from the master mould. They can only be used with cold-setting master mould materials however, such as plaster, silicone and alginate.

Wood

An important factor when creating a master mould with wood is water proofing it before casting over it.

Exposed wood will absorb water from a plaster master mould, making the mould weak, and will cause bubbles if there is a lot of end grain or texture in the surface when using flexible mould materials. Therefore wood needs to be completely sealed against this using varnish such as a gloss marine type, which will create a good seal.

Clay

Again, clay is one of the most versatile and useful modelling materials. It can be used to fashion any model, and will release well from plaster, hot or cold flexible master mould materials such as Gelflex or silicone. A coating of soft soap helps ensure a clean surface when used to make a plaster master mould.

Found objects.

Styrofoam or Polystyrene Objects

For large or simple forms in master moulds, styrofoam or polystyrene can be an option. There are many different densities of styrofoam available, so care must be taken in determining which kind will work the best for your application. Foam tends to float very readily when mould mix is poured over it, so make sure it is anchored down very well. It cannot be used with hot flexible mould materials.

Found Objects

In general you can make a master mould from any object, or elements of an object, as long as you consider the material it is made from. Plastics will melt if you pour Gelflex around them, painted objects may have their surfaces affected by plaster or hot flexible mould materials – it is worth studying your object well before you decide on the best master mould material to use. Complex form or detailed textures and undercuts require flexible mould materials, smooth and simple forms can be captured using a rigid mould material such as plaster.

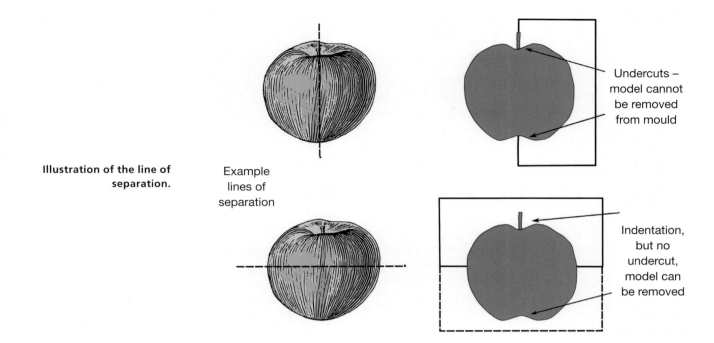

Illustration of the line of separation.

Example lines of separation

Undercuts – model cannot be removed from mould

Indentation, but no undercut, model can be removed

PLASTER MOULDS

A plaster master mould is usually utilized when you need to make a master mould of a fairly simple form, with limited undercuts. The technique produces a rigid mould which will need to come apart to remove the original model and any waxes poured into it. These are also called multi-part moulds, as the master mould is constructed so that various sections of it fit together around and into any undercuts, to make up the entire outer surface. Each undercut area will need one or more parts. For this reason master moulds are often referred to by the number of parts needed to make them up – for instance, a two-part master mould would have two parts that fit together, and a three-part would have three. In commercial applications master moulds can have dozens of parts. Multi-part master moulds are not suitable for textured undercuts or multifaceted models – a flexible rubber mould would be more suitable for such purposes.

It can be difficult to determine how many parts a model will need, but an analysis of the form should help you work this out. If we look at the example of an apple, this would need a two-part master mould. The 'line of separation', or the dividing line for the two parts, also known as the parting line, would be around the widest point of the apple, so that one part of the mould encompasses the top part of the apple

above the dividing line, and the other part of the mould the bottom below the dividing line. It can be seen that there is no undercut as we look down on the object from above the line and below the line upwards. You may be inclined to think that the area where the apple dips in around the stalk might be undercut, but it is not so when viewed from above, unless the cavity cuts back under itself. So, if we made two parts which fitted together and came apart at the line of separation, we would be able to remove the apple from the two parts of the mould. This is a simple example of a two-part mould, but for some objects three or four parts may be needed to separate the mould pieces.

The best way to determine the number of parts you would need for a model is to hold up your model and imagine how many pieces you would have to build around it to encompass the entire form, and how many interfaces you would need so that you could separate them from each other and remove the object from the middle without it being trapped. It is a bit like imagining three-dimensional jigsaw pieces built around your model, and you are trying to keep the jigsaw as simple as possible. You must then work out the best lines of separation for these parts. It is often useful to draw a sketch of the object to determine the best ways of separating the outer space. You would then need to go on to prepare the model for making these separate parts in plaster.

PROBLEMS WITH UNDERCUTS

There is one tricky part of the apple as a model – the stalk. Strictly this is an undercut, in that most stalks are wider at the top and taper inwards. This presents a problem as it will probably get trapped in the plaster master mould that will be poured around it.

The problem of the stalk serves to show that not all objects are straightforward. Some creative ways of amending or approaching the model are needed when preparing for a master mould.

In this case the stalk could be removed and a small wax stalk hand modelled for each wax you make in the master mould. Another possibility is to thicken by hand the lower part of the stalk with a small amount of wax, so that it is no longer undercut and will pull out of the plaster master mould. However, even then it will be very thin and delicate, and the wax may keep breaking here, so it may be better to hand-fashion the stalk each time.

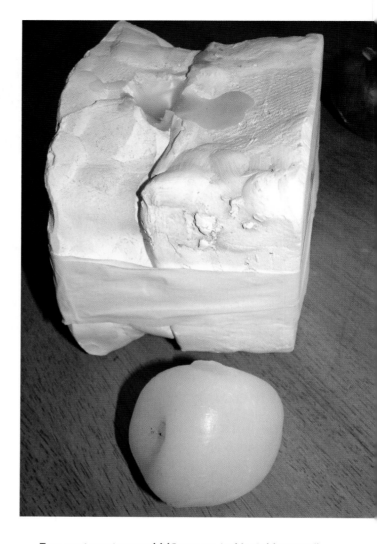

Two-part master mould (Courtesy Jackie Calderwood).

How to Make a Two-Part Plaster Master Mould

You will need to mount your model on a tapered funnel of clay which in negative will be an opening to the interior of the master mould through which you can pour the wax. The funnel will usually be positioned somewhere along your line of separation, and needs to be wide enough to allow wax to be poured in – at least 10mm in diameter.

Decide on your line of separation and cover half of your model with cling film to protect the surface (particularly if the model is made from clay or other soft material). Lay the model, funnel attached, with the line of separation horizontal and support underneath with clay. Place a board upright against the flat bottom of the funnel, and support with clay or a heavy weight, and seal along the bottom edge with more clay.

Then build up a block of clay around the sides of the model so that you have a level area of clay surrounding the model up to your line of separation, about 20–30mm wide. The clay must follow the line of separation exactly, otherwise an undercut will result.

You can now build a clay wall as a cottle around the model and clay block, to contain the plaster. It needs to be 20–30mm higher than the top of your model, and 20mm thick, standing on edge, running from the board around the clay block and meeting the board again. You can apply a release agent such as soft soap or petroleum jelly to the model to help removal from the plaster mould.

You will now need to prepare some plaster to make the first part of your master mould. Remember, this will just be a plain plaster mix, not a refractory mould mix – this mould is just for pouring waxes. Estimate the amount of plaster mix needed – as in Chapter 5, the volume of your mould box minus the volume of the model. The mix ratio for the plaster should be 1 litre of water to 1.4kg of plaster. The volume this makes will be about three-fifths larger than the original amount of water, i.e.

Examples of registration marks. The hollow must not be deeper than the halfway mark, or you will not be able to get the other part out.

Aperture for pouring wax

Registration marks

1 litre water at beginning

1 divided by 5 and multiplied by 3 = 0.6 litres

Add to original litre = 1.6 litres mould mix

Working backwards, to get, for instance, 1.6 litres of mould mix, you would divide by 8 and multiply by 5 to give you the amount of water to start off with.

1.6 litres mould mix needed

1.6 divided by 8 and multiplied by 5 = 1

Use 1 litre water to make 1.6 litres mould mix

Water goes in the bucket or bowl first, followed by the plaster, gently strewing it into the water. Agitate the plaster gently using your hand until it is evenly mixed.

It can now be poured over the top half of the model, to a height of 20–30 mm above your model (the top of the clay wall). Leave to set – this should take 5–15 minutes, and can be determined when the plaster has heated up and is cool again.

Remove the wall and board, turn the model over and remove the supporting block of clay. Be careful to leave the clay funnel intact and the model still embedded in the plaster.

Before you repeat the process for the other half of the master mould you must make some registration marks in the surface of the plaster on the first part of the mould. These are indentations or notches which help you put the two parts of the mould back together in the right place – the two halves of the marks fit into each other, aligning the moulds perfectly.

To make the marks, use either a round-ended modelling tool or a small coin to carve a circular hollow into the horizontal face of the mould. This can be achieved by rotating the tool or coin around until it cuts into the plaster. Be careful not to make a hollow too deep, or undercut, as this will cause problems. Sometimes there is not enough room in the face of the plaster for a circular hollow, in which case you can cut v-shaped notches into the edge of the mould.

Now make the other half of the master mould. Apply petroleum jelly or soft soap to the face of the first part of the master mould. Make a similar amount of mould mix for the second part and pour over the first part. Leave to set. When the second part has set, gently prise the two parts of plaster apart. Be very careful as it is easy to damage the mould at this stage. Do not force the plaster parts too much, but lever gently using the funnel area if necessary until they come apart. If they do not want to come apart, you may have an undercut which is trapping one of the plaster parts. In that case, one or more of the parts may need to be re-made.

Once the plaster master mould has been made, the parts can be simply tied securely together with string, strapped up with tape, or if larger held together with clamps. All the registration marks should be aligned with no gaps visible. The master mould must be positioned with the hole for the pouring funnel at the top – prop up the mould and make sure it is stable if it does not have a flat bottom. It is now time to pour the wax – we will look at the technique of pouring wax shortly.

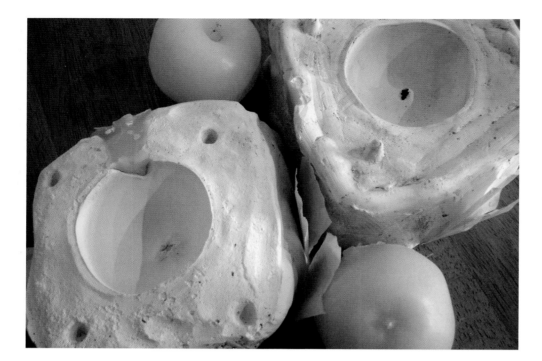

Waxes from mould (Courtesy Jackie Calderwood).

FLEXIBLE MOULDS

Essentially a flexible master mould is a simple one-piece mould. Modern synthetic rubbers have been developed which capture very fine detail and can flex to release under-cut areas of a model, greatly reducing the number of mould parts necessary, often to a single-part flexible master mould. Flexible mould materials can essentially be divided into two classes – hot- and cold-setting compounds. All of these flexible mould materials are suitable for pouring wax into to form the model.

Silicone

Silicone rubbers are some of the most versatile of flexible mould materials. They come in a wide range of viscosities, strengths, and properties, making them useful in a number of different mould making situations. Room Temperature Vulcanizing (RTV) silicone rubbers are cold-setting, making them useful for pouring on model materials which cannot withstand the temperatures of vinyl hot-melting compounds. The variation in viscosities and setting times of different silicones also make them useful for a variety of applications such as taking impressions of objects on a vertical surface or more detailed

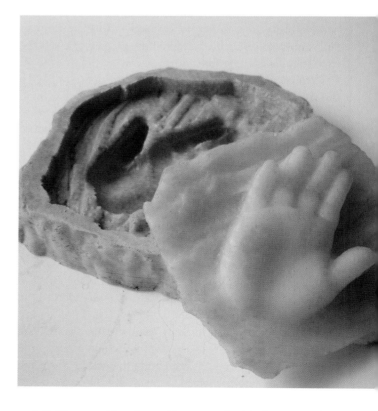

A Gelflex mould and wax (Courtesy Liquid Glass Centre).

Qualities	Silicone	Gelflex	Rubber/Latex	Alginate
Number of components	Two	One	One	One + water
Time and effort required	Very little	Very little	Very much	Very little
Linear shrinkage	Very little	Some	Very much	Very little
Curing	Reaction of two components – no heat produced	When cool	When dry	When solidified – very quick
Price	High	Medium	Low	Low
Attributes when cured				
Self-releasing	Yes	Yes	No	No
Service life of the mould	Medium to long	Long	Short	Very short

Attributes of flexible mould materials.

reproductions. The disadvantage of silicone is that it can only be used once, and is comparatively expensive.

Vinyl or Gelflex

Vinyl hot-melting compounds are used by melting down and pouring over the original model. They melt at around 150°C, and should be poured when they have cooled slightly. They can be re-melted many times, and so are a very economical way of making a flexible master mould, as old master moulds can be chopped up and re-melted when no longer needed. The disadvantages are that (1) they cannot be used on any material that cannot withstand the temperature of the compound when hot, and (2) dry objects need to be sealed to prevent the heat causing trapped air to expand, creating bubbles in the mould.

Safety note: *Avoid breathing the fumes given off by Gelflex and wear skin and eye protection.*

Latex Rubber

Latex comes as a liquid which air dries. It is a very economical and durable material. Moulds are made either by dipping, or by painting on layers of latex, allowing each layer to dry before proceeding to the next layer. The advantage of latex moulds is that they are very elastic and can therefore be used to cast models with significant undercuts. The disadvantage is that the material is so elastic that it can deform very easily

when wax is poured into it. For this reason it may be more suitable for taking flat, textural impressions or moulds from which wax elements can be created.

Alginate

Alginate is a gum which is found in algae. It usually comes in powdered form, which is mixed with water and is cold-setting. It sets very quickly – between 2 and 6 minutes depending on the compound. It is suitable for taking quick and detailed impressions or moulds from almost any material. As it is free of chemicals and so fast-setting, it is especially suited for taking moulds directly from the skin – it is used extensively as a mould-making material in dentistry and life casting. Its disadvantages are that it can be very flexible when thin in section, so may need to be used with a mother mould, and it is not particularly hardy and will tear easily, so master moulds may deteriorate after a short time.

Safety note: *Plaster should never be used for taking casts of body parts directly – use alginate and then use the alginate mould to create a plaster if necessary.*

Because of the relative merits of the different flexible mould making materials, some are more suitable for making master moulds, such as silicone and vinyl compounds, and others for taking impressions of objects or textures, such as latex and alginate. For this reason we will now look at the process of making a flexible master mould from silicone or vinyl, as these will be the materials most often used for the process.

How to Make a Vinyl or Silicone Master Mould

A flexible master mould from silicone or Gelflex (vinyl) is made in a number of ways, depending on the object or model. Many objects which have surface texture or marks and several undercuts (but none too deep) will need a simple one-part flexible master mould. If the object has multiple deep undercuts then it may be necessary to make a two-part or more, flexible master mould. Remember that the wax has to be removed from the master mould, so if it is a struggle to get the original object out of a one-part mould, even if it is flexible, it may be better as a two or more part mould.

If the object is quite large and would need significant quantities of flexible mould material, or undercuts would entail thick sections of material, which can shrink considerably, it is possible to make an inner mould from vinyl or silicone, which is then supported by an outer plaster mould, or 'mother mould', thereby reducing the amount of flexible mould material needed. This type of mould also serves to retain the flexible mould itself in the correct position and give support.

We have discussed the relative qualities of vinyl (hot-melting) or silicone (cold-curing) as flexible mould materials, so when you have decided which is appropriate for your object or model, you can proceed with one of the techniques outlined next. If you use Gelflex then you must ensure that any boards or cottling you use can withstand the heat of the Gelflex.

GELFLEX OR VINYL

Gelflex is one of the most economical of flexible mould materials, as it is reusable. It is available in either a creamy coloured 'soft', or blue 'hard' variety, both of which may be mixed to give compounds of varying flexibility. Gelflex will not stick to itself, therefore you need to do a single pour per piece of the mould, and be sure you have melted enough for your requirements.

Gelflex begins to liquefy at about 130°C, and should be melted at a temperature of around 160°C. It must be melted in a suitable manner, as previously discussed, such as a special thermostatically controlled melting pot. Although these are expensive, you will be saving money each time you use Gelflex as opposed to silicone, so it may be worth the investment. As it is being melted, it gives off a slight smell, but it should not be heated so that it gives off fumes. Avoid burning at all costs,

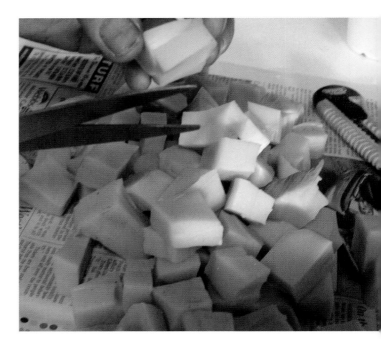

Chopping Gelflex.

as this can happen at temperatures of 170°C and above, and will ruin the Gelflex and give off potentially harmful fumes. Make sure you set the thermostat on the pot accurately.

Safety Note: *Preferably use extraction when melting Gelflex, or at the least wear a mask in case of fumes.*

Work out how much Gelflex you will need by subtracting the volume of your model from the volume inside your mould box or cottle. 1kg of Gelflex makes about 1 litre of volume (remember to allow a little extra as the Gelflex will shrink). Cut the Gelflex into 20–30 mm cubes or smaller and add a handful at a time to the melting pot, stirring often with a wooden spoon. Once all the Gelflex is melted reset the temperature control to 145°C for pouring, and leave until this temperature is reached.

The liquid Gelflex needs to be poured in a steady stream onto the lowest part of the mould, and preferably against the cottling or board, so that the level rises slowly, expelling air. Fill to a point above where you would normally want the mould to finish, as the Gelflex shrinks on cooling.

Safety note: *Be extremely careful when pouring Gelflex – it will burn and stick to skin; wear adequate protective clothing and heavy gloves.*

Leave to cool – this can take between an hour and several hours depending on the quantity used. Gelflex is self-releasing so you will not need to use a release agent when making a two-part mould.

Another possibility for melting Gelflex is to use a microwave oven. This method is only suitable for small quantities. You must use an oven which will not be used for food again. A small quantity of the Gelflex can be melted by placing the cubes in a microwave-proof dish, such as a pyrex bowl.

Safety note: *Make sure you are wearing heat proof gloves when checking or unloading the bowl from the oven.*

Set the timer to no more than 30 seconds at a time, and stir with a wooden spoon after each heating. This will keep the heat distribution even, and will ensure the Gelflex doesn't burn.

Safety note: *Do not heat for longer than 30 seconds until you have checked the degree of melting, as Gelflex can burn very quickly and give off fumes.*

If you see any discolouration in the melt, stir and allow the temperature to equalize. Use a thermometer if necessary each time you take the bowl out of the oven to make sure the Gelflex is not getting too hot. Be very careful not to overheat as lots of air bubbles will form. Keep stirring while it cools to disperse bubbles, if you do get them. When all the Gelflex is melted proceed to pour as above.

SILICONE

The best silicone to use for a flexible master mould is a two-part liquid RTV (Room Temperature Vulcanizing) silicone. This consists of a rubber compound which is mixed with a catalyst to trigger the setting process. It comes in various hardnesses, so you may need to seek advice when purchasing to be sure you have the appropriate variety. The more undercuts in your model, the more flexible the silicone you will need to use, as you will need to bend the mould more when removing it from difficult places.

Work out how much rubber you will need for the mould. Pour the correct amount of rubber into a mixing jug. Then

A silicone mould.

'G8! Co-Operate! It's Getting H2OT!', Margareth Troli, kiln-cast glass, H: 36cm, W: 26cm, D: 6cm (Photograph by Simon Bruntnell).

measure out the catalyst which you will have received with the silicone rubber. Most silicones need 2 per cent catalyst by weight, but check this on the manufacturer's instructions. Add the catalyst to the rubber, and stir in thoroughly. You will want to avoid mixing in air, which will create bubbles, so mix the silicone slowly and carefully.

Pour the silicone very slowly into the mould, again preferably against the inner surface of the mould box or cottling, in a thin stream, allowing the level to slowly rise, reducing the risk of trapped air. Tap the mould a few times to free any trapped air bubbles. Look out for any leaks and plug immediately with clay.

Leave the mould to cure – many silicones cure in a few hours, but it is often best to leave them for 24 hours to be sure. Once the mould has cured, cut to extract the model, or gently peel the mould off the part. Mould release agent needs to be used when making multiple parts to help release one part from the other.

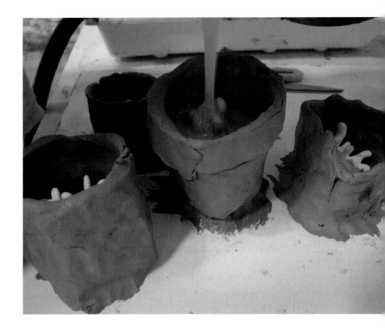

Pouring Gelflex for one-part moulds (Courtesy Liquid Glass Centre).

MAKING A FLEXIBLE MASTER MOULD

We will now run through the procedures for making simple and more complex master moulds. To determine the best method to use, look at your model and assess how many undercuts are on it and how extreme they are. Remember that some of these procedures are quite complex, so start or practise with small models before you work on anything bigger.

Cutting a key in a flexible mould (Courtesy Liquid Glass Centre).

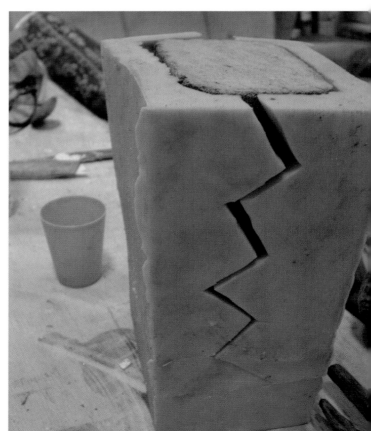

One-Part Flexible Mould

To make a one-part flexible mould, set up your model on a small clay pedestal, which will simply serve as a pouring aperture for wax later, and build a mould box or cottling around the model. There needs to be about 20–30mm space between the cottle and the model, to give sufficient strength to the mould. Seal all joints or gaps around the cottling with clay. Heat up your Gelflex or prepare your silicone, and pour in a steady stream around your model until you have reached a level 20–40 or so above the highest point of the model (remember you need to allow extra Gelflex for this top level as it shrinks).

Safety note: *Ensure you take extreme caution when pouring Gelflex – it is very hot!*

'The Ghost of Taxis Yet to Come' (Detail), Rachel Elliot, lost-wax kiln-cast lead crystal, L: 5.5cm, D: 2cm, H: 2cm (Photograph by Ester Segarra).

Waxes for 'The Ghost of Taxis Yet to Come'.

When the mould has set, you will need to remove the original object. If you have taken an impression of a fairly flat or open object this can be done simply by peeling the vinyl or silicone back. If the object is more encased by the mould, however, you will need to cut the master mould open to remove it. Minimal cuts should be made – only one if possible, and only as far into the mould as necessary to allow the object to be eased from the mould. Use a special jelly knife (available from sculpture suppliers) which creates a v-shaped cut, making a keyway for registration of the two halves; or cut in a zigzag, rather than straight, to achieve correct registration afterwards. Remove the object, re-align the mould and tie to hold together, and the mould is ready for a wax pour.

Two-Part Flexible Mould

Use this type of mould for deeper undercuts and complex forms. A two-part flexible mould can be made in a similar fashion to a two-part plaster master mould. Decide on a line of separation and make a small clay funnel on the line of separation and attached to the object, to act as a pouring aperture later for the wax. Embed half of the object in clay, and make small keys in the uppermost surface of the clay, to act as reg-

istration marks for the silicone. Set up a mould box or cottling around this, leaving a 20–30 mm gap between the boards and the object. Apply mould release agent to the surfaces if you are using silicone. Calculate the amount of material you will need for pouring this first part. Heat up your Gelflex or prepare your silicone, and pour in a steady stream around your model until you have reached a level 20–40 mm or so above the highest point of the model (remember you need to allow extra Gelflex for this top level as it shrinks).

Safety note: Ensure you take extreme caution when pouring Gelflex – it is very hot!

When your first part has set, remove cottling and clay, leaving the funnel in place, and set up for pouring over the other half of the object. Apply a mould release agent, such as petroleum jelly, to the surfaces if you are using silicone. Calculate the amount of material you will need for pouring this second part. Heat up your Gelflex or prepare your silicone, and pour in a steady stream around your model until you have reached a level 20–40 mm or so above the highest point of the model (remember you need to allow extra Gelflex for this top level as it shrinks).

When the second part has set, remove cottling and clay funnel, and gently prise the two parts away from each other.

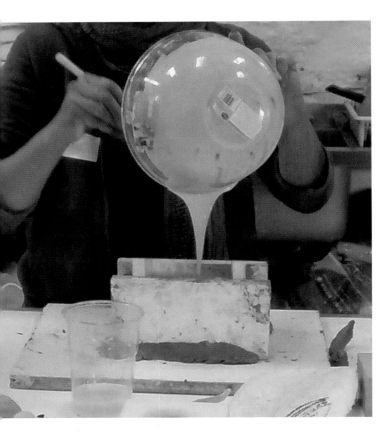

Pouring Gelflex (Courtesy Liquid Glass Centre).

Diagram of a master/mother mould. Clay is used to cover the object, which has a mother mould formed or poured over the clay. When the clay is removed, this leaves a space where flexible mould material can be poured.

Remove the original object. When the two parts are put back together, strap or tie together, and the master mould is ready for pouring wax.

MAKING A FLEXIBLE MASTER MOULD WITH A MOTHER MOULD

As we have discussed, a plaster-based mother mould can be used to reduce the quantity of material needed to make a flexible master mould. This might be necessary when making a large master mould, or where the shape of the original object might result in a floppy or weak master mould. The technique involves making a plaster 'jacket' for the flexible mould material, which will add support and strength to the whole assemblage. The technique can be used for one- or two-part moulds or more – it is simply a case of creating the outer plaster 'mother mould' at the same time as creating the flexible parts.

To make a two-part flexible and mother mould, take the object and lay it on a board. Provide the original with a clay funnel for pouring the wax in later, usually on the base of the piece. Embed it up to a half-way separation line (as in making a two-part plaster mould) in clay. Cover the object in cling film to protect it from the clay you will be using next to cover it.

Roll out some smooth buff clay to about 10–20 mm thick. Lay this clay over the top of the original model, covering it so that it follows the shape of your original with an allowance of 20–30 mm all the way round, laying over the bed of clay the model is embedded in. This layer of clay will determine the thickness of the rubber as it will eventually be replaced by the silicone. Make small clay 'keys' and place around the edge of the top covering layer of clay to enable the rubber mould to be securely seated within its plaster jacket. Place funnels made from rolled-up clay on top of the clay layer covering the original, which also act as breather holes and help to secure the rubber in position in the plaster jacket. Set up cottling or a mould box. Calculate how much plaster you will need.

Prepare a plaster mix (refer to the section earlier in this chapter on how to make a two-part plaster master mould) and pour it slowly over the clay/model assembly. If you are working on a very large mother mould you may need to reinforce this with scrim (hessian webbing).

Once the plaster has set turn the whole over, remove

the clay used for embedding (but not the visible edges of the clay jacket), to reveal the other side of the model. The exposed side of the original is again covered with a thin layer of clay to the desired thickness along with the clay keys and pouring funnels. Make registration marks in the plaster mould surface, so that when the two parts of plaster are put back together they realign perfectly. Treat the exposed plaster with petroleum jelly or soft soap, and set up the cottling again. Once again pour a plaster mix into the cottle to cover the original.

Once the plaster has set remove the cottling and carefully separate the two plaster mother moulds. Now you have made the two halves of the mother mould.

Making the two halves of the flexible mould is also a two-part process. Take out the clay from one half of the two plaster jackets leaving a negative space where the Gelflex or silicone will be poured. Clean this empty half and the original model in the other half carefully to avoid debris becoming trapped in the Gelflex or silicone. On the other half make small indentations a little way into the clay all the way round the original, which will form a key to enable each separate half of the inner flexible mould to fit together accurately within the plaster jacket. Place the two plaster mould parts back together, seal with clay, and position with the funnels for the empty half of the mould uppermost.

Prepare a correct quantity of Gelflex or silicone for one half of the flexible mould. Pour this through the funnel openings until full (fill to the top of the funnels when using Gelflex to allow for shrinkage). Allow to set.

Open the plaster mould parts again, ensuring that the original and the new half of the flexible mould stay in position in the plaster. Remove the remaining clay in the other half of the plaster mould and clean, and if using silicone, spray with mould release agent. Reassemble the plaster mould parts, this time with the funnels of the remaining empty half of the mould uppermost. Prepare and pour a second quantity of Gelflex or silicone. Allow to set.

When set, open and remove the original model and the clay funnel. Clean the silicone mould with soapy water and once dry, reassemble the rubber and place within the plaster mother mould. Seal the edges of the mould again with clay, strap with tape or other binding, and the mould is ready to receive molten wax, poured through the funnel opening.

POURING THE WAX

In general you will need to use an unmodified microcrystalline wax to pour a master mould, unless you intend to fashion it by hand after pouring, or perhaps machine it on a lathe. The wax should be heated in a safe manner, as discussed in the previous chapter, and strict health and safety issues should be observed.

When the wax has fully melted, it can be poured into the master mould. Allow the wax to cool before pouring into the mould – it should not be bubbling, as it is still too hot if it is. Leaving the wax to cool for a few minutes before pouring also allows any debris to sink to the bottom, which will leave the cleaner wax at the top, ready to pour.

Make sure that a plaster master mould is damp before you pour wax into it – if you have left a mould for some time after making it will have dried out, and should be soaked in water for half an hour or so to prevent the wax form sticking to it. Soak in water for a couple of hours if it is dry to the touch.

A master/mother mould.

Wax poured into Gelflex mould (Courtesy Liquid Glass Centre).

Waxes can be cast either solid or hollow. Whether to make a solid or hollow wax depends on the shape of the form. Smaller objects, perhaps up to 100mm in height/width, can be cast as a solid wax, but anything much bigger is better suited to making a hollow wax. This is because as the wax cools it shrinks and contracts, and this can distort the shape of the object to a high degree. Geometric forms, such as a cube, would show a marked distortion if they were large and poured as a solid wax, with the faces of the cube curving inwards, a consequence of the wax contraction. So it is best to experiment with your particular shape.

Wax which will become a solid form can simply be poured into the mould until it is full, and left to solidify. You may need to top up the wax a few times, as the level inside the mould will drop as the wax contracts. It can help to have your mould warm, as this will assist in creating a smooth, unmarked surface to your wax. Soak it in fairly hot water for half an hour before you pour. If you pour the wax in intermittently or the mould is fairly cold you will get chill lines that look like the grain in a piece of wood on the surface of the wax. Pour the wax slowly and carefully, and avoid splashing as this can create bubbles which will show up in the surface of your piece.

Hollow waxes can be made by pouring the wax into the mould until the level is reached, and then the molten wax poured out again. As the wax cools when it meets the master mould surface, it will coat the inside of the mould after it is filled and poured out again. This process is repeated to build up the desired thickness of wax. Again, the thickness desired will depend on your form and the strength required in the wax, but at least two or three pourings would be needed for an average wax. Another method is to leave the wax inside the mould for a longer length of time, so that it solidifies for longer, say 10 to 15 minutes, and then pour out the wax which is still molten from the middle, leaving a thicker wall of wax for the form. This hollow wax copy of the object is then removed from the mould.

Wax model emerging from Gelflex mould, ready for chasing (Courtesy Liquid Glass Centre).

WAX CHASING

The wax would now need to be prepared for the refractory mould making stage of the process. This may entail making a reservoir, setting up the cottling and venting, as we saw in the previous chapter, but first you need to ensure that any marks and imperfections in the wax have been dealt with.

Wax chasing is the process of removing seams and repairing imperfections with heated customized soldering irons or tools – dental tools are ideal. Because the wax has been made in a master mould, there may be a line or seam of excess wax or 'flashing' along any junctions between parts of the master mould, and you may need to tidy up any other blemishes in the wax. These can be cut away with a metal tool, and the surface burnished with another blunt tool.

You may also want to heat-polish the wax. When the wax is as you want it, it is ready to be set up and go through the stages of making a refractory mould (*see* Chapter 5) and firing the glass.

PROJECT 10: APPLE MASTER MOULD AND LOST-WAX CAST

For this project we will make a simple lost wax cast of a found object, an apple, using a master mould. We will make a two-part master mould in plaster and use standard microcrystalline wax to pour into it, to make a solid wax model of the apple. We will then use the wax model created to make a refractory mould for casting glass. You will gain experience in making a plaster master mould, which will allow you to make multiple waxes, and casting it in glass.

1. Take an apple and draw a line around its middle (horizontally as it stands upright) using a felt tip marker, so that neither half is undercut. Using this line of separation as a guide, create a funnel area to the side of the apple, on the line of separation. Embed the apple in clay up to this line so that you have a level area of clay surrounding the model up to your line of separation, about 20–30mm wide. Place a board upright against the flat bottom of the funnel, and support with clay or a heavy weight, and seal along the bottom edge with more clay. Position cottling around the clay, running up to the board.

2. Prepare a quantity of plaster, as described earlier in the chapter, and pour over the apple. Allow to set. Remove the cottling and board, turn the mould over, and remove the clay. Be careful not to remove the apple or the clay funnel. Make registration marks in the plaster, coat surface of plaster in petroleum jelly or soft soap, and set up the board and cottling again. Make up another mix of plaster and pour over the other exposed half of the apple. Allow to set.

3. Open the two halves of the master mould, and remove the apple. Clean the mould with water to remove any debris or traces of clay, and reposition back together again. Tie or strap together with tape. Prepare an appropriate quantity of microcrystalline wax, and pour into the mould through the funnel opening. When the wax reaches the top of the opening (this allows a little more wax for shrinkage), leave to cool. When cool open up the master mould and remove the wax apple. Cut off any seams of wax and correct any blemishes.

4. When you have finished working on the wax, prepare a refractory mould for glass casting. Create a reservoir in clay, a little larger than the apple, with a similar outer contour, tapering to a flattened point. Choose an entry point for the glass on your wax apple (usually the base, but also could be on the side) and anchor your model to the reservoir by pushing it onto a barbecue skewer (cut to length) protruding from the flattened point in the reservoir. Set up the apple and reservoir with cottling. Position the cottling 30mm away from the perimeter of the wax apple. Seal the bottom and side edges of the cottling. Mark a pouring line on the inside of the cottling, 30mm from the highest point of the model.

5. Calculate the amount of mould mix you need to make according to the information included in Mould Recipes in the previous chapter. Make up the mould mix, allowing a little extra to be sure you have enough.

 Safety note: make sure you wear a respiratory mask.

6. Pour required quantity of warm water into a bucket. Weigh out flint, pour into the bucket and stir to dissolve. Weigh plaster and add to bucket, agitating to mix. Add fibreglass strands.

7. When the mixture is smooth and has a consistency of single to double cream, pour mix into the mould. Tap the board below or the side of the mould very gently. Put your finger into the top of the mould mix whilst still liquid and agitate it gently to smooth the top of the mould, which will become the base of the mould.

8. The mould mix is set when it has warmed up and then cooled again. This should take around half an hour.

9. Leave the mould until completely cold. Set up a steamer, and position the mould upside down over a tray, with the steaming pipe position in the opening of the mould. Steam out all the wax. When you believe all the wax has been removed, boil a kettle and check for wax residues. Clean with one or two more flushes of boiled water. Smooth the top edges of the mould with a damp sponge.

10. Gather the glass you would like to use for casting in the mould – either frit or billets of glass. Use Method 1 for calculating the amount of glass needed to fill the mould. Remember to only pour the water into the mould to the level you want the glass to come to, not to the top of the reservoir.

11. Position your mould on a kiln shelf with vermiculite or sand. Level the mould. Fill the reservoir with the measured glass and any colour or metals.

12. Fire using **Firing Schedule 7**.

Wax apple (Courtesy Jackie Calderwood).

Master mould.

Cast-glass apple (Courtesy Jackie Calderwood).

When cool remove mould from kiln. Remove the mould by breaking it away from the glass. Remember the glass may have sharp edges where the glass flows around the entry point. Clean, and grind any sharp edges. Cold-work if desired.

We have now completed our investigation of the sometimes complex but highly rewarding technique of lost-wax casting. With a full understanding of these techniques you can make many diverse and complex forms in glass, and will have had an opportunity to explore the unique qualities of glass and the kiln-casting process – heat, flow, transparency, colour diffusion, viscosity and sculptural possibilities. In the next chapter we will look at some final techniques which will add to your skills and creative abilities in glass.

'Vessels', Deborah Timperley, lost-wax cast glass. Left: Curve with crumpled indent, H: 18cm, W: 13cm, D: 6cm. Right: Crumple with inverted relief, H: 17cm, W: 12cm, D: 6cm (Photograph by David Baird). The two vessels pictured here are both formed using the lost-wax casting method but the master mould was created using different techniques. The plaster model for the vessel on the left was made using 'sledging techniques' to form lengths of plaster (in the same way that plaster coving is made for decorative room/ceiling edges). This was cut up and reassembled to form a model exactly same as the finished vessel. Next a mould of several parts was made, surrounding the model and including a core (that is the negative space within the vessel), such that melted wax can be poured in, creating a wax model once the mould is removed. The model for the vessel on the right was cast directly into wax by first making plaster bats, textured and smooth, then casting wax sheets from these. They are then cut up and used to construct a model of the finished vessel – very similar to slab building in clay. So, two methods to arrive at a point where the wax models are ready to be cast into glass using the lost-wax technique.

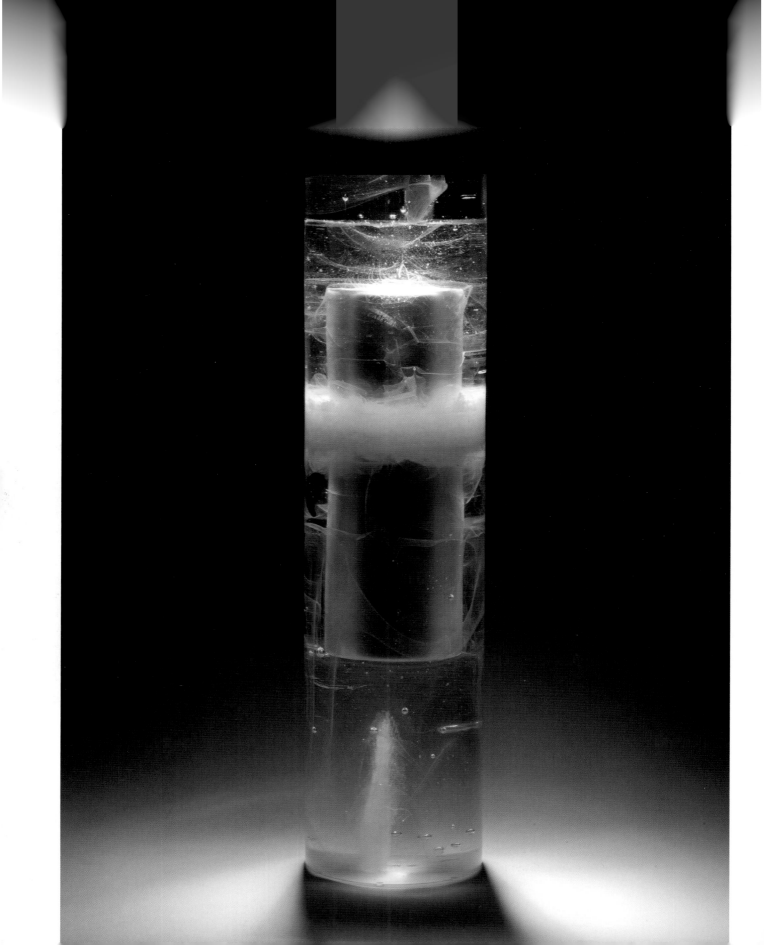

FURTHER MOULD-MAKING AND KILN TECHNIQUES

Now that we have examined the fundamental techniques involved in kiln-forming glass, namely fusing, slumping, basic casting and lost-wax casting, we can examine some further processes which will extend your knowledge and expertise. We will first look at additional mould-making methods, specifically the use of splash coats, grog layers and jacket coats for moulds, core casting, and the pâte de verre technique, which will conclude our survey of the range of mould-making techniques on offer to the glass artist. Considering these techniques will enable you to encompass the full range of creative processes for kiln-forming glass.

Other Mould-Making Techniques

LAYERS – COATS AND JACKETS

As you work in mould-making techniques and gain more experience, you may want to consider some of the advantages of working more interactively with your mould-making. Many glass artists consider that there are benefits in approaching their mould-making in a different way, by using layers with differing ingredients in the mould mix, in order to invest their models. These might consist of a two-layer method – an inner splash coat and a strong outer jacket mix, or even a three-layer system, consisting of an inner splash coat, an intermediate layer with some reinforcement, and a strong outer jacket mix. We will briefly discuss possible advantages and mixes which can be used.

There are a few reasons for creating a multi-layered mould for casting glass. For the most part these are based on a desire to improve the surface quality of the glass when it comes out of the mould. One of the major benefits of creating an inner or 'face' coat for your moulds is that you can vary the materials used in the mix for the mould face, which will be in direct contact with the glass that melts into the mould. By varying the inner mix you can create a mould face which releases from the mould more effectively, giving better quality on the surface of the glass, without compromising the strength and durability of the outer areas of the mould. For this reason you may want to reduce the amount of silica in the mould mix, which can affect the surface quality of the glass, and leave out the fibreglass strands, which can sometimes come into contact with the glass in the mould and leave slight marks.

Another advantage of an inner coat is that the viscosity of the mix can be adjusted to suit the original model. This may be of importance when the model contains a high degree of detail, which would respond better to a slightly thinner mould mix, enabling better replication. A thinner mix and hand application will also minimize trapped air and bubbles on the surface of the mould. This inner coat is soft and will keep the fine details of the cast. One of the best methods of application for this inner coat is by 'splashing' the mix onto the model, creating a thinner covering, as this inner coat only needs to be in contact with the model and does not form the bulk of the mould. By using this method of hand application it is possible to achieve an even coating of the inner mould mix on the model of about 10mm, which is then backed up with a thicker, normal mould mix, as a 'jacket', either by pouring into a cottle or mould box, or by continuing to apply by hand. Another significant advantage of a splash coat is that it helps to eliminate unwanted bubbles on the surface of the mould.

'Deep', Tania Porter, lost-wax core cast glass, Dia: 10cm.

Hand-building a mould (Courtesy Liquid Glass Centre).

MAKING A TWO-LAYER MOULD

Start by making up a mould mix for a splash coat. This is made with a slightly thinner mix, using a little bit more water than usual. You will only need to make enough mix to create a splash coat of about 10–20mm thick, so estimate the quantity of mix you will require. Use 1 part water to 1½ parts of dry

material (50 per cent flint, 50 per cent plaster). So if you use 1 litre by volume of water, you would use 1½kg of dry materials by weight (750g of dry plaster and 750g of silica). Do not add any fibreglass strands.

When this is mixed and beginning to set – look for a slight thickening – scoop up some mix in your hand and start to splash onto your model. This action is a combination of flicking and pouring the mix from your hand onto the model. At first the mix will run off, and you will need to keep scooping up any excess mix, as well as new mix, and re-splash. You could also use a brush dipped into the splash coat mix and brush it onto the model, to ensure the mix is evenly distributed on the surface of the model. As the mix continues to thicken you will find that you can begin to mould the mix around the model, which will start to become encased. Finish forming the mould mix around the object.

You can now make up a mix for the remainder of the mould as a jacket coat. This will include fibreglass, which will made according to the normal ratio outlined in a previous chapter:

> 1 litre water + 1kg dry plaster + 1kg silica
>
> plus 1 tablespoon fibreglass strands per litre of water used

Either pour this into a mould box or cottling around the model coated with the inner layer, or continue to apply by hand if you prefer once the mix has started to set a little bit,

Applying outer coat (Courtesy Liquid Glass Centre).

Finish with a standard mould mix as a jacket.

Three-layer moulds can also be useful for larger moulds as well as highly patterned or textured surfaces on models. They might consist of a plaster/silica or plaster/talc inner layer, an intermediate layer of plaster/silica with fibreglass, and a layer

Splashing an inner coat on shallow mould (Courtesy Liquid Glass Centre).

ensuring that you have an overall 30mm or so thickness all the way around your model.

A variation on the inner splash mould mix is to use a talc-and-plaster combination, eliminating the silica completely. This can give a much finer finish on the surface of the glass. You would use 50 per cent talc (available from potter's suppliers) and 50 per cent plaster, this time mixed together before you add to water. Aim for a very thin layer of about 5mm or so when applying this mix.

Hand-building a more upright mould (Courtesy Liquid Glass Centre).

Finished mould (Courtesy Liquid Glass Centre).

shell' casting for metal. The moulds are often used for casting hot glass, but they can equally be used for kiln casting. The compounds, which are based on refractory materials with a binder, reproduce detail very well.

One compound, zircar, is an alumina silica composite which comes as a paste, and after being applied to a suitably pre-pared wax model, hardens on drying. Thin even coats of the paste are applied to the surface of the wax. When the mould is completely dry, the wax is burnt out. In this case, dry heat must always be used to remove the wax, rather than steam, as adding moisture back to the mould material will make it dis-integrate. A propane torch is used for heating the mould and melting out the wax, but it must be done outdoors because of the risk of fumes. After the wax is completely melted out of the mould, it turns completely white, and is ready for melting glass into. The mould can be set up in the kiln with props and a separate reservoir.

One disadvantage of the technique is that the mould itself is not very strong for larger cast pieces – compared to a con-ventional, thicker and heavier plaster/silica mould. One way around this is to invest the shell mould in sand to support the mould, or experiment with pouring a conventional refractory mix around the zircar. Also the mould material itself does not contract as much as glass, so unless you are making quite small objects, or have quite open moulds, there may be prob-lems with pieces cracking when casting very enclosed moulds. One benefit of the technique is that it can release from the glass very well and give the glass a good cast surface.

of 'grog' in the outer layer to reinforce the mould with great strength. Grog is clay which has been fired then ground up, and can come in many particle sizes, from fine to coarse. Recent developments such as honeycomb moulds, which contain a high proportion of fibreglass in the mould wall, cre-ating a network of reinforcement and airways, are interesting areas in mould-making which you may want to investigate.

Alternative Mould Materials

Recent experimentation in glass casting has focused on the use of lightweight and thinner, more efficient refractory-based compounds which can replace the traditional plaster/silica-based refractory moulds. This method of making a mould for glass is a variation on the process called 'ceramic

Other Kiln-Glass Techniques

Core Casting

Core casting is a technique which enables the kiln caster to create a significant three-dimensional interior space within a solid block of glass. Many moulds used to make vessel forms are strictly core casts, as the interior of the vessel form is 'controlled' to create a cavity within the glass, and therefore makes a bowl or vase.

The technique can be used for more sculptural forms as well. If we look at a normal mould for creating a kiln-cast piece of glass, the refractory mould contains the negative form of the cast, which is filled with glass to make a posi-tive. If we include within the negative mould a positive form

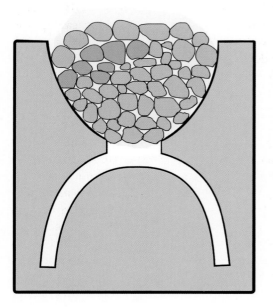

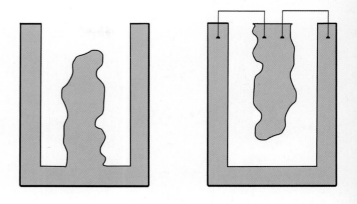

Two methods of core casting.

Diagram of a mould for casting a vessel form.

'Scattered', Rachel Elliot, lost-wax core-cast lead crystal and gilding, H: 9cm, W: 2cm, D: 2cm (Photograph by Sarah Rose Cameron).

in refractory material, a negative space is created within the positive glass cast. Interestingly, when this is viewed through transparent glass, it will have the appearance of a positive form. The technique can be used by making a core which is part of the refractory mould itself, and therefore projecting from below, up and into the negative space in the mould; or as a 'floating' core, which projects downwards into the space in the mould, and is held with steel pins, or as part of an interlocking mould. Core casting can be quite complex, but is very effective, and enables a new dimension to be explored in kiln casting, by exploiting the interior space of the glass. It must be remembered that the refractory core must be removed from the glass, and therefore a space large enough to enable manual removal of the core must be allowed for in the construction of the form.

Moulds for core casting 'Scattered', Rachel Elliot, moulds with a refractory core of the message in the bottle before being fired.

Pâte de Verre

There is one last area of kiln-forming glass which is concerned with mould making, and that is the ancient technique of *pâte de verre*. We will look at this technique in some detail, which will draw upon the skills you have acquired in mould making,

Body I, Gayle Matthias, 1996, *pâte de verre*, part polished, H: 25.5cm, W: 19cm (© Victoria and Albert Museum, London).

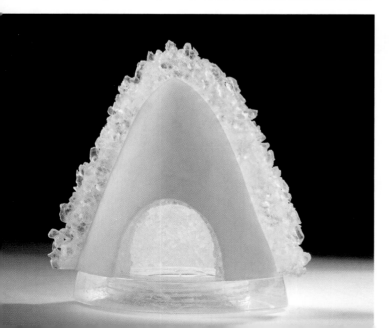

'Crustaceous', Tolly Nason, *pâte de verre*, H: 32cm, W: 7cm, D: 5cm.

enabling you to make fine and detailed glass pieces by a method of pressing glass powders or frits into a mould. *Pâte de verre* can sometimes be technically challenging, but the technique produces distinctive qualities which create unique and individual glass pieces.

The method is known from the Egyptian period, but was established as a common technique in the Art Nouveau period. *Pâte de verre* literally translated means 'glass paste', and involves creating a paste from clear or coloured crushed glass, sometimes mixed with powdered glass colour or enamels, along with fusing glue or gum arabic. This 'paste' is applied to the inner surface of a refractory mould forming an inner shell of one or more layers. The interior is filled with ludo, or old crushed-up mould material, to help the glass maintain its form, and the whole is fired in the kiln to melt the glass.

Pâte de verre is a form of fusing as opposed to casting glass, as the particles of glass do not reach a temperature where they flow into the mould but are held in place by the ludo and binder, in order to fuse together. Detailed areas can be created on the model and in the mould which can be packed with different coloured glass, creating highly controlled areas of colour and shape.

Because of the mould-making process involved in the technique it is more common to discuss *pâté de verre* in terms of the casting genre of glass. Essentially, working in the *pâte de verre* technique relies on the same mould-making skills as basic or lost-wax casting, and many moulds (mainly open or two-part) can be used for either *pâte de verre* work or casting. The *pâte de verre* technique, however, creates a highly detailed granular glass form, often hollow with thick or thin walls depending on the thickness of the glass applied.

Example of *pâte de verre* surface quality.

MODEL AND MOULD

The model for a *pâte de verre* mould can be made from clay, plasticine, wax or found objects. A simple one-piece open mould can be made as long as the model can be removed from the mould and has no undercuts, unless using clay for slight undercuts, or wax for more severe. This type of mould is predominantly used in *pâte de verre* for open forms such as shallow vessels. The model can be easily removed or dug out of the mould, and the mould is very open, which allows glass to be packed into it with easy access. The top surface edge of a *pâte de verre* piece is often 'uncontrolled', i.e. it can have a wavy edge where the glass simply fuses and is not controlled by a contour in the mould. This top edge can also reduce in size, depending on how well the firing of glass is controlled,

Two methods of preparing *pâte de verre*. In the upper diagram, the glass paste is packed into a concave mould, with an inner core of ludo (crushed fired mould mix) or other insulator packed against the glass to hold it in place. In the figure below, the glass paste is applied over a convex or 'hump' mould, with ludo filled over the top to secure the paste.

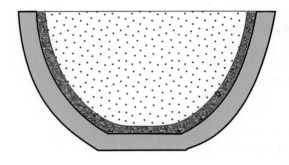

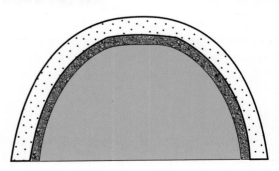

as the glass fuses and sometimes flows slightly, so it can be advisable to extend the height of the model by 10mm or so if you want to maintain a certain size in the finished glass piece. The interior of the mould packed with glass is then filled with ludo, and placed in the kiln for firing. It should be pointed out that glass can also be packed over the outside of a mould and fired, so that the piece is not formed in a hollow or cavity mould, but over a mould form.

With a two-piece mould it is possible to make deeper more complicated forms, with a smaller opening. The two-piece mould still needs to be open to some extent to allow the 'core' or inner mould material to be packed into the mould, but by making the form in two halves which are subsequently put together and fired, it is possible to gain access to the interior for laying in the glass paste. With a two-part mould both halves of the mould are packed with layers of glass, keeping the edges of the mould clean of excess glass. The two parts can be held together with nichrome or steel wire. The interior of the mould and glass shell is then filled with ludo. The mould is placed into the kiln and fired.

MOULD MIX

The mould mix for *pâte de verre* needs to be soft but resilient. The softness ensures that the glass, which can be quite thin in section, is not overly pressurized by the contraction of the mould when cooling. But it is also important that the mould is not so soft that it cracks during the firing, so a fine balance in the mix is required. A common recipe for a *pâte de verre* mould mix is as follows:

	1 part plaster + 2 parts silica
i.e.	⅓ kg dry plaster + ⅔ kg silica
added to	400ml water
plus	½ tablespoon of fibreglass strands per kg of dry ingredients

Mix up according to the method outlined in Chapter 6. If you have problems with the mould cracking, you could try an inner face of this softer mix, and an outer jacket of our standard refractory mix, or a stronger mix for larger moulds (see Resources section for other mould mixes).

GLASS

The glass used for *pâte de verre* work can be bought ready crushed as a glass powder or frit, or can be crushed down from glass cullet.

Safety note: Caution – always wear a respiratory mask when crushing or working with glass powders or frits.

The grade of frit or powder used is merely a question of the desired effect in the final fired piece. Fine powdered glass will give a very fine detail, through to more coarsely crushed frit which will have a more granular effect.

Safety note: If crushing glass yourself, make absolutely sure you are wearing adequate respiratory protection, and crush using a metal heavy-duty mortar and pestle for crushing glass available from art glass suppliers.

Take the crushed glass and put through a mesh sieve to remove larger particles, and wash if necessary. If you crush glass yourself, particles of metal from the glass crusher will be released into the glass frit. To remove these particles, which can contaminate the glass on firing, obtain a magnet and place in a bowl with your crushed glass. Agitate so that the glass frit is moved around the magnet, and it should be able to pick up any metal particles.

Placing crushed glass in mould (Courtesy Liquid Glass Centre).

Samples of frit tinted glass (Courtesy of Bullseye Glass Co.).

You can prepare different coloured glasses, or mix glass powder or frit with glass enamels to create different colours. This process is often called 'frit tinting' and can enable you to create a wide palette of colours and hues of glass for *pâte de verre* work. Start with transparent clear or opaque white glass frit. Glass powder will intensify the body of colour throughout the paste; the more you add the stronger the colour will be. Glass frits of differing grades will create a speckled, stippled effect in the body of the glass as the granular coloured frit melts into the base glass. Glass enamels can be used to colour the frit, but the result will be very different form glass powders and frits – slightly duller and muted. There is lots of room for experimentation with coloured frits, and indeed the frit-tinting method can be used for glass casting, as well as *pâte de verre* work, creating a more translucent coloured cast (from the use of frits rather than chunks of cullet for casting).

BULLSEYE'S FRIT TINTING METHOD

Frit tinting is a method that allows one to create specific colour blends for kiln casting and *pâte de verre*. The process involves 'tinting' or colouring clear glass by adhering coloured powder to larger-grained clear frit and then firing the mixture in a mould. By conducting careful tests with this method, one can learn to manipulate colour saturation and translucence in frit-cast pieces with predictable results. Both opalescent and transparent coloured powders can be used for this process, and coloured powders can be mixed to further extend one's palette.

A surprisingly small amount of Bullseye powder will add substantial colour to clear frit. The picture above shows the saturation resulting from various ratios of powder to frit. Note that the samples were cast as wedges, which allow the colour to be viewed at different thicknesses. The percentage of coloured powder to clear frit is indicated overleaf.

CHOOSING THE FRIT

Choose the percentage of coloured powder you want. It may be useful to make your own set of sample wedges to help predict results. Next, select the grain size of clear base frit to accomplish the look you desire. Note: the grain size will have a significant visual impact on the casting.

–0001 (fine frit) will tend to trap many small bubbles during the firing process. This will give the finished casting an opalescent appearance.

–0002 (medium frit) will trap larger and slightly fewer bubbles than are trapped when using –0001. The result will be a homogenous blend with good light transmission.

–0003 (coarse frit) will create fewer but larger bubbles than the mixes made with –0001 and –0002, and the final casting will appear to be less blended. Each grain of –0003 will seem to retain its shape and be 'coated' in colour.

WEIGHING THE FRIT

Once the weight of the glass needed to fill the mould has been determined the proportionate weights of frit and powder must be calculated, based on the percentage of colour desired. For example, if the mould requires a total of 500 grams of glass, and the colour is to be a 3% tint of 001426-0008 Spring Green powder with 0011 01-0002 Clear frit:

Calculate that 3% of 500 grams is 15 grams (500 x 0.03).

Therefore, filling the mould will take:

15 grams of 001426-0008 Spring Green powder, plus 485 grams of 0011 01-0002 Clear frit, for a total of 500 grams.

Weigh out the amounts of powder and frit needed in separate containers. The clear-frit container should have a lid and be large enough to allow for thorough mixing.

Reprinted with permission from Bullseye Glass Co.

MIXING THE FRIT

Using a spray bottle filled with water, lightly mist the clear frit. Close the lid and shake vigorously to coat every piece of glass with water. Next, sprinkle the coloured powder evenly over the top of the wet frit. Shake vigorously until each piece of clear frit is covered with powder. Even a small percentage of powder should be mixed with the base frit evenly. Load the mould with the damp frit mixture and fire promptly. Note that if the mixture is left to sit for an extended period of time, the powder can separate from the base frit. For this reason, it is best not to make more of the mixture than is needed for any one firing.

SURFACES

One can achieve a wide array of surfaces when using frit as the casting medium. Fired to a low temperature, frits can be simply fused together to produce a crusty/grainy surface. When fired hotter, the cast surface will become more glossy and smooth. After firing, surfaces can be altered further by employing the same cold-working methods applied to other types of kiln-formed glass.

METHOD

We will now look at the method of construction and filling for both one- and two-part moulds. Small details can also be carved directly into the mould if desired.

One-Piece Mould: Make a model from clay, plasticine or wax. This may be a simple shallow-to-medium depth vessel form. Build a cottle and pour the mould, or hand-build a mould (gives better results for even thickness of mould around the model if it is a rounded form). When set, remove the original model, clean the inner surface of the mould if necessary, and the mould is then ready for packing glass.

Two-Piece Mould: A two-piece mould for *pâte de verre* is made in exactly the same way as a two-piece master mould (*see* Chapter 8) except that instead of using just a straight plaster mix, you will need to use a refractory mix, as this mould will be going into the kiln.

PREPARING AND APPLYING GLASS

The glass frit is mixed with water and a little gum arabic or fusing glue in a container. The quantity of binder to use will depend on the fineness of the glass, but the mixture should be 'wet' enough to hold its shape when a small section is divided off. You can now prepare different colours of the *pâte de verre* mixture if you want to. Divide off as much and as many different quantities of the paste as you will need different colours, and put each into a small container. Mix each quantity with coloured powder, frit or enamel to the desired shade. The glass paste is then applied to the surface of the mould with a brush, if filling very small areas, or a spatula or small spoon. Make sure your mould is damp – either recently made, or soaked in water – as if it is dry the surface will suck up the liquid in the paste too quickly, and the glass will not stay in place. The glass must also be compacted as you fill the mould, as this helps it stay in position – carefully push on the glass paste with the back of a teaspoon. The first layer of glass is laid into the mould like this, incorporating any colours or other inclusions. Metal foils and leaf can be embedded into the glass by placing either on the inner face of the mould to pick up onto the outer surface of the glass, or on the inner face of the glass itself.

A second layer of glass or more can then be applied to the first to add strength to the glass structure. Remember that if the glass piece is too fragile it will be very vulnerable, especially when removing from the mould. When you have a sufficient thickness of paste (typically around 10–20mm), the cavity must be filled with ludo.

Penny Carter works with recycled cullet and glass frits to create unique and highly individual *pâte de verre* pieces.

ABOVE: **Making the mould from a clay model.**

BELOW: **Filling rest of mould with recycled glass cullet.**

ABOVE: **Filling with coloured glass frit for colour detail.**

BELOW: **'Copper Spot Jug', Penny Carter, *pâte de verre*, H: 47cm, W: 28cm, D: 5cm.**

Safety note: *Make sure you wear a respiratory mask when crushing fired moulds.*

The glue holds the frit together during the packing process, but a core will be needed to hold everything in place once the glue has burned off during the heating phase of the firing process. Fill the cavity with ludo, compacting slightly as you fill, so that the ludo holds the glass in place. If you have made a two-piece *pâte de verre* mould, you will need to fill the pieces separately with glass, and then place the two moulds together tying or securing with steel wire or clips. Fill the interior with ludo, again compacting slightly. If you were packing over a mould, you would pack ludo *over* the glass and compact to hold in position. Sometimes talc can be used as a core/packing material. As talc is a good separator for glass, this can give a better finish on the inner surface of the glass, but talc is very insulative, so the firing of the piece may result in a more crystalline appearance, unless you fire slightly hotter.

FIRING

After all the glass and a core has been placed in or on the mould, it must be fired. Firing *pâte de verre* is a complex process, as each mould is different and will require a firing schedule which is dependent on the size of the piece and the thickness of the mould. See **Firing Schedule 8** for a typical firing for a piece of *pâte de verre* up to 150mm tall/round, with a thickness of 10mm in the section of the glass layer. Place the mould in the kiln, with a piece of ceramic blanket on top to provide a final layer of insulation.

DE-MOULDING AND FINISHING

When it is completely cool, the mould is removed from the kiln and the mould material is broken away. You must take extra caution when removing the mould as this type of glass work can be very fragile. Once all the mould material is removed, the piece is cleaned.

You may find that mould material becomes trapped in the granular surface of the glass, and so a *pâte de verre* piece often takes a lot of cleaning. Once you have removed the bulk of the mould you might try soaking the piece in warm water to help dislodge the mould particles. Another option in the case of stubborn residues is to soak the glass in a solution of acetic acid (such as vinegar) or citric acid.

Cold-working can be necessary to finish the *pâte de verre*, especially where you may have an irregular edge along the top, or uncontrolled, edge of a piece. You may wish to grind this rim down, or cold-work the base of a piece, but much caution must be exercised – *pâte de verre* pieces can be very delicate, as the main body of the glass is comprised of fused glass particles rather than a solid glass wall.

Freeze and Fuse

Freeze and fuse was developed in the US a few years ago. It is a *pâte de verre* method which involves taking powdered glass, mixing it with water and packing into a mould, and then freezing the glass and mould to help the glass hold its shape. The frozen glass piece is then put into the kiln and fused, forming a solid glass object. The glass is simply fused together in the form it was frozen in. It is a very simple technique, which enables those beginning to work in three-dimensional glass to form glass without elaborate mould making. Any proprietary open moulds can be used – for cakes, soap, jelly, concrete – as long as they can withstand freezing. Of course you could also make your own flexible moulds if you wished from rubber, silicon or vinyl. Freeze and fuse pieces can be used as jewellery or fused onto other pieces of glass to make items such as plates or bowls.

The method for making a freeze and fuse object is as follows. Combine some fine glass powder with any colour you want, or use coloured glass powder, and mix with water.

Safety note: *Caution – always wear a respiratory mask when crushing or working with glass powders or frits.*

'Whimsicals', Tolly Nason, *pâte de verre*, 3.5cm × 3.5cm (each)].

Removing water by blotting after packing glass into mould.

Removing frozen glass prior to firing.

Powdered glass works best because it compresses well, which is essential for the piece to hold together when frozen – larger frit does pack together as well. You need enough water to thoroughly wet the glass and make a soggy paste – the water will separate from the glass, so pour off this excess water onto a paper towel. Pack the paste that is left into your mould in layers, tapping them with the back of a spoon or spatula, until they are tightly packed. The tapping helps release and remove air bubbles. Blot off the water from the top of the layer each time with absorbent cloths or paper towels. Keep packing and blotting until the top surface is as dry as possible.

When the mould has been filled with glass, check once more for water by tapping and blotting, and then place in the freezer. You need to freeze the glass for ½–1 hour, depending on the size – do not freeze the mould for too long as the glass can crumble when removed from the mould.

Then remove from the freezer and de-mould the glass – turn over and flex the mould, just as you would with any frozen object. Be careful with small or delicate objects as they can break with excessive pressure. If the piece doesn't release from the mould, it is not completely frozen. If it breaks when removing from the mould, you can reuse the glass by soaking it in water to thaw and start the process again.

Place your glass object on a kiln shelf lined with kiln paper, and load into the kiln immediately. If you leave the piece to defrost, it may collapse as you load it into the kiln.

The most challenging aspect of this technique is getting the firing right. If the glass is fired too hot, the shape may deform, or if too cool, it may not fuse properly and crumble. Here is a typical firing schedule for the freeze and fuse technique:

Ramp	**100°C/hr**	to **200°C**
Hold at	**200°C**	soak for 30 min (this dries the glass)
Ramp	**200°C/hr**	to **700°C**
Hold at	**720°C**	for 30 min, depending on your kiln or piece
Cool to	**482°C***	as fast as possible
Hold and Soak at	**482°C***	for 120 mins depending on your piece
Ramp	**100°C/hr**	to **200°C** then kiln off, cools on its own

* This temperature assumes you are using Bullseye glass. Adjust the annealing temperature to the compatible glass you are using and time to the thickness of glass.

For larger pieces, a lower and slower schedule is advisable to avoid the piece slumping – try 150–700°C, and soak for 30 minutes. This schedule is only an example. It is important that you adjust it according to the size and shape of your piece. If you can check visually, the glass is fired when it appears to be shiny rather than dull. After firing the glass itself will shrink, as it fuses and flows slightly.

Again, as with the standard *pâte de verre* technique, glass pieces made by his method may need grinding to remove sharp edges and finishing with cold working.

COMBING

Combing is the process of manipulating sheet glass whilst still hot in a kiln. Only attempt this technique once you have had some considerable experience of firing glass in a kiln. You must have the correct equipment – glass and kilns during this process are extremely hot and you need to be prepared for this.

Safety note:

To undertake this technique you need safety equipment and clothes. Only attempt this technique with small kilns – 400mm or less square or equivalent – as the body of heat which will leave a larger kiln will be too great for safety.

You will need heat resistant gloves, cotton clothing, a heat or flame-resistant jacket, safety glasses (providing infra-red and ultra-violet protection), and an ordinary safety shield, which can be used to protect your face from the heat.

For combing you will need a stainless steel tool, called a fusing rake, which is flame resistant and used to draw through your coloured glass while molten in the kiln.

The outline of this technique is for guidance only – use all the appropriate safety equipment you consider necessary, and proceed with caution.

Combed glass tiles in kiln (Courtesy Liquid Glass Centre).

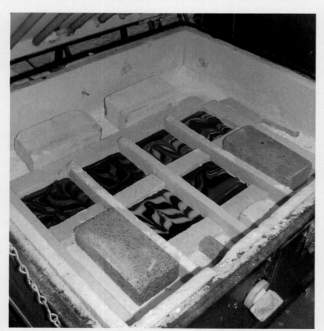

Make a fused glass tile assemblage of three or so layers of compatible glass, using different coloured pieces or strips in the top layer to provide variations in colour when you comb. Lay this on a kiln shelf in the kiln, and set the following kiln program:

Ramp	**150°C/hr**	to **520°C**
Ramp	**999°C/hr**	to **900°C** depending on kiln
Hold at	**900°C**	for as long as you need to comb
Cool to	**482°C***	as fast as possible
Hold and Soak at	**482°C***	for 60 mins depending on your piece
Ramp	**75°C/hr**	to **370°C**
Ramp	**150°C/hr**	to **200°C** then kiln off, cools on its own

* This temperature assumes you are using Bullseye glass. Adjust the annealing temperature to the compatible glass you are using and time to the thickness of glass.

By setting the controller to 900°C you are allowing for the fact that the glass needs to be very hot to comb – depending on your kiln you may need it hotter – up to 920°C should be sufficient. Make sure you are wearing all the safety clothes mentioned above.

Safety note: *Very important – turn off the kiln at electrical source before opening the kiln door.*

When the kiln door is open, begin the combing process. You will need to work very quickly – you will have just a few seconds each time to work the glass. Pull and push the rake across the glass surface, making sure you work quickly before the glass cools and becomes stiff. After each combing you can close the kiln, turn the power back on and wait for the temperature to reach 900°C again, repeating the combing until the desired pattern is achieved. If the glass sticks to the tip of the rake, withdraw it from the kiln and cool it in water before trying again. When you are finished, take the temperature back up to 900°C one more time to flatten the top surface of the glass. Then proceed with the cooling part of the firing schedule.

We have now looked at many of the kiln-forming and mould-making techniques which are available to the glass artist. One of the great secrets of visually appealing and attractive glass work is the degree of finishing which is undertaken in order to present the piece to a high standard. We will look at the range of cold-working and finishing techniques which will enable you to do this in the next chapter.

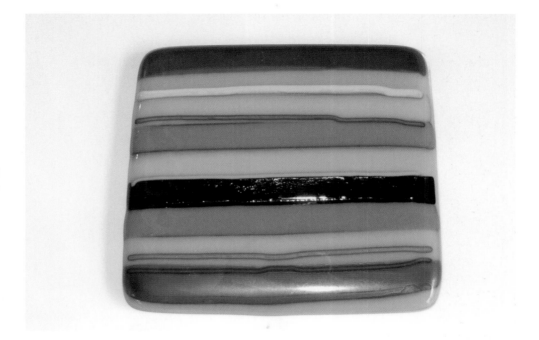

Glass tile before combing (Courtesy Liquid Glass Centre).

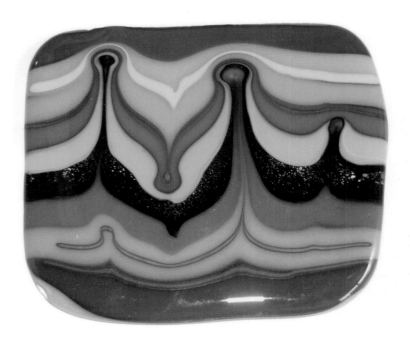

Glass tile after combing (Courtesy Liquid Glass Centre).

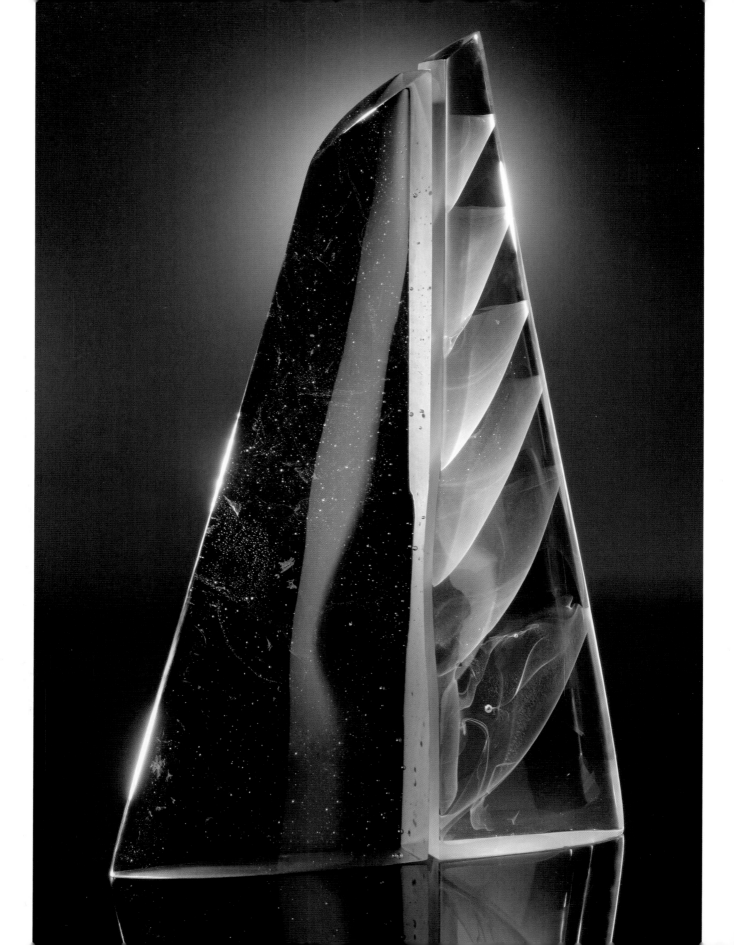

COLD-WORKING AND FINISHING

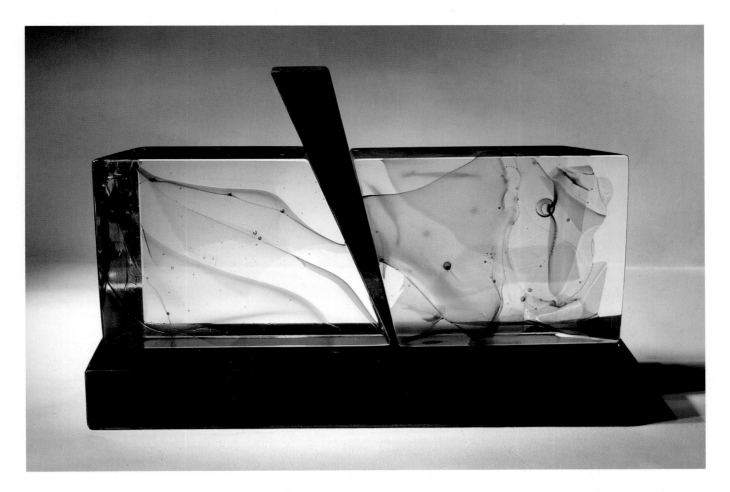

'Strata', Joanne Mitchell, 2009, kiln-cast glass and granite, H: 17cm, W: 26cm, D: 7.5cm.

OPPOSITE PAGE:
'Semblance', Fiaz Elson, 2007, cast optical glass with groove and veils, L: 38cm, D: 9cm, H: 60cm.

Finishing is a procedure which takes place when a glass piece has been through its firing cycle for the last time, and needs further work to refine or decorate the form. It can refer to an array of processes, often termed as 'cold-working', which can range from cutting and sawing the body of the glass though to abrasion and polishing of its surfaces.

A wide range of equipment is available to accomplish these processes, all increasing in size from small hand-held tools to large industrial machinery. The cost and practicality of larger machines is a consideration for the glass artist, although these machines will cut down on the amount of time spent cold-working glass. In this chapter we will discuss the various techniques which are available for the glass artist, and the relative merits of different types of equipment.

Essentially any cold-working techniques involve the removal of glass. For this reason it must be remembered that it can be difficult to polish highly textured areas of glass, as grinding and polishing will inevitably remove detail. Polishing can often work best therefore on flat surfaces.

Whilst we will be looking principally at the use of such techniques after a piece has been fired, many, such as sandblasting, may also be used to alter the glass before it goes through the firing process. For instance, you may want to engrave or sandblast a pattern onto a sheet of glass before it is fused, or sandblast a piece of cullet before it is cast to create bubbles and veils in the glass.

There are as many ways of cold-working glass as there are warm glass techniques. Cold-working glass is generally performed as a wet process, because of the tendency for glass to heat as it is being abraded, which can cause it to crack. Cooling the glass with water, or sometimes oil, helps avoid this danger, and also keeps dust to a minimum, which is very important for health and safety reasons. Never grind or polish glass without a coolant. We will look at each of the principle techniques involved in cold-working in turn. Please first refer to the Health and Safety section as this is of paramount importance when cold-working glass.

MATERIALS USED FOR GLASS FINISHING

Two materials are commonly used for cutting and abrading glass. *Silicon carbide*, also known as carborundum, is an abrasive material which is a compound of silicon and carbon. It is relatively inexpensive, and is used for grinding glass. It is the second hardest surface after diamonds on the Mohs scale of mineral hardness, and has a rating of 9.5. It comes as a powder or grit, which can be applied as a paste to glass

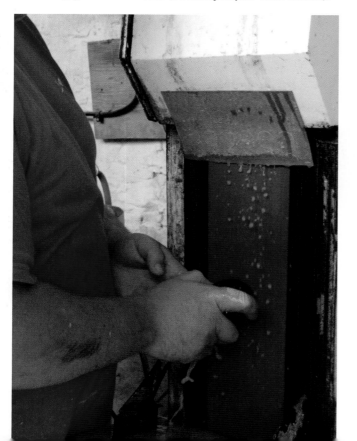

Grinding glass on a linisher (Courtesy Liquid Glass Centre).

CARBORUNDUM

The discovery of silicon carbide was an important development in the engineering industry. About 100 years ago, Dr. Edward Goodrich Acheson, a struggling scientist, who had been employed by Thomas Edison, had begun working on the development of cubic zirconium (artificial diamonds). He wanted to develop ways of creating artificial diamonds in an electric furnace. He began to experiment with clay and coke, and attached one lead from a dynamo to a discarded iron bowl, filled the bowl with clay and powdered coke, inserted the other lead into the mix and charged it with electricity. Nothing seemed to happen. He was disappointed until he noticed a few shiny specks on the metal conductor on one of the leads. When he drew the metal conductor on the lead across a pane of glass, it scratched the surface like a diamond. Dr Acheson had invented the first man-made abrasive and substance hard enough to cut glass. Acheson's discovery became Carborundum, the trademark for silicon carbide and the name given to the company he started.

for cold-working, or bonded to certain tools. *Diamond* is the hardest natural material known, with a rating of 10 (hardest) on the Mohs scale. The hardness of diamond has been known since antiquity, and is the source of its name, which is derived from the ancient Greek for 'unbreakable'. Diamonds are used for cutting and grinding glass, and being harder are more efficient at doing so than silicon carbide, but more expensive. They do, however, work faster than traditional carborundum, as they can be used at faster speeds, and so can cut down the grinding or cutting process by two or three times compared to carborundum. They are electroplated to various tools and blades or bonded using a resin, which as it wears away grinds the surface of the glass.

Both silicon carbide grits and diamond tools can be classified according to the grade of their abrasiveness, similar to that used for sandpaper. The coarser the grit the more rapidly it will abrade the surface of the glass – the abrasiveness becomes finer as the number increases. They start at grades of around 40–80 grit, which are comparatively coarse and remove glass fairly quickly, through to 120, 220, 320, 400, 600 and 800 grit (and variants of), which progressively grind to a finer finish.

Beyond this point, the fineness of the grinding means that the glass is effectively being polished. Polishing compounds such as pumice (a volcanic form of ash) and cerium oxide (an oxide of the metal cerium), applied to the glass as a wet paste, can polish the glass to a mirror finish and have an abrasive rating of about 1000 grit. Cork is used to apply pumice to the surface of the glass. It is applied as a paste and worked onto the glass with a cork belt or wheel. Cerium oxide is used with a felt wheel, and gives the final brilliant polish to the glass.

ABOVE: **Carborundum 120 grit.**

BELOW: **Carborundum 220 grit.**

WORKING THROUGH THE GRADES

The common feature of all grinding and polishing is the progression through various stages of grits or diamonds and polishing compounds. The key is to make sure that all surfaces are sufficiently and evenly ground with the grit you are using. If you grind with an 80 grit, go onto a 120, and then a 220; if you have not adequately ground the entire surface with the 120, you will find it very difficult to remove the grinding marks of the 80 grit with the 220 grit. Patience and perseverance are the prerequisites for finishing glass. It is critical that you also wash and remove all traces of the previous grit before going on to the next one.

The grits and stages can be categorized as follows:

COARSE GRINDING

40 grit Used on occasions where a lot of glass needs to be removed quickly, grinding off large parts.

60 grit Again used when a comparatively large amount of glass needs to be removed quickly.

80 grit The most common grit to start with, as it is rough enough to quickly take off enough glass to remove surface undulations, imperfections and achieve a uniform surface.

INTERMEDIATE GRINDING

100 grit Can be used instead of an 80 grit when there is just a little glass to remove, as a preparation for further grits and polishing.

120 grit Used to further grind following an 80 grit (but not 100).

220 grit To further grind following either 100 or 120 grit; also useful for where there is no glass to remove, perhaps just scratches, as a preparation for further grits and polishing.

PRE POLISHING

400 grit Used to begin the process of polishing, in preparation for 600 grit or even polishing.

600 grit Prior to final polishing, or can be sufficient in itself for a light polish.

FINAL POLISHING

Cork and pumice Cork gives a polished but dull effect, and must be run wet, combined with pumice paste prior to a fine polish.

Felt and cerium oxide Cerium produces a high polish on glass; applied as a paste to the felt wheel and worked onto the glass until the glass is polished to brilliance.

Polishing a piece of glass with cerium (Courtesy Liquid Glass Centre).

COLD-WORKING TECHNIQUES

Cutting or Sawing

The first technique you may find necessary to use for certain types of kiln-formed work, most notably kiln-casting, is cutting or sawing, to achieve the shape or level surface that you want.

GLASS SAW

This process refers to the more severe method of sawing through solid glass to reduce or remove certain areas, rather than the more basic procedure of scoring and snapping sheet glass. Sawing is best applied when you have a considerable amount of glass to remove, rather than a smaller amount which can be ground away. You may need to use this technique when you have an excessive amount of glass left in a reservoir when casting glass, or you may simply want to reduce the size of a piece of glass, or cut it in half etc.

To achieve this, you will need to use a diamond-bladed tile or masonry wet-saw. A wet-saw is a power saw that is built into a table, with a water reservoir that keeps the steel disc or blade cool as it cuts. It works by applying the blade, which is edged with diamonds, to the glass, with water cooling the glass as it is cut – the diamonds on the disc cut through the glass as it is pushed against the blade. Wet saw blades for cutting glass tiles are similar to blades for cutting ceramic tiles or stone. It should be remembered, however, that diamond saws should always be fitted with a continuous rimmed diamond blade, rather than the serrated version for cutting stone, as these will seriously chip and break the glass as they cut through it. Only use a blade specifically made for cutting glass. Tiny fragments of synthetic diamond are embedded into a soft metal base, and as the blade rotates, some of the soft metal wears off and exposes the cutting diamond surface. Coarser materials like ceramics or stone can be cut with fewer, larger pieces of diamond, but glass requires a much larger quantity of very fine diamond particles to cut smoothly.

You will lose a small amount of glass as the disc cuts through, about 2–3mm wide. The size of these machines can vary from small-scale pieces of equipment through to large industrial machines, with the size of the glass they are able to

ABOVE: **Smaller wet diamond saw (Courtesy Liquid Glass Centre).**

BELOW: **Larger wet diamond saw (Courtesy Liquid Glass Centre).**

Small band saw (Courtesy Liquid Glass Centre).

cut increasing according to the size of the machinery. There are relatively small power tile cutters which will cut tiles or blocks of glass from 10mm high, through to large masonry saws which can cut glass in the region of 300–500mm thick.

A diamond band-saw will also cut through glass, and uses a band of thin metal encrusted with diamonds, fed through a motor so that it runs continuously. It is used for cutting sheet glass into intricate shapes which are not possible with the standard scoring and snapping technique. Diamond band-saws can also cut through glass that has already been fused, up to a thickness of about 10mm, again useful for cutting intricate shapes which can be incorporated into other firings.

201

Diamond hand pads.

Glass grinder.

Grinding and Polishing

When small amounts of glass need to be removed, or larger areas made even, grinding the glass piece is the best option. Grinding is also the preliminary process to be undertaken before polishing. Grinding can be achieved with a number of different pieces of equipment. The most basic are hand-held diamond pads and tools. They are applied to the glass manually, with a rubbing action, to smooth small areas of glass. They are only really suitable for very small areas, due to the time involved in grinding by hand. Small hand tools with the same resin-bonded diamond coating as the pads come in a number of different shapes and sizes, similar in scale to small modelling tools for clay, and can be used for grinding or working on glass in difficult-to-reach areas and textures.

GLASS GRINDER

Edges of sheet glass prior to fusing can be ground or smoothed using a glass grinder. This is a small box with a flat surface and a motor inside, which drives a small grinding wheel about 20mm diameter and this grinds the edge of the sheet glass. A small flexible-shaft rotary tool will enable you to work on small areas of glass for grinding or polishing, since they use small discs for grinding or felt pads for polishing, by taking the tool to the glass. Again, this is only really suitable

for fine detailed areas which would be unsuitable for treatment with a larger piece of equipment, due to the amount of time needed to work on larger areas.

Removing glass with rotary tool.

FLAT-BED GRINDER

If you are seeking to grind and polish glass, you will probably want to use slightly larger pieces of equipment, as the size of the area on the glass you will want to treat will be larger than is convenient to grind and polish with hand tools. For this reason, you may want to invest in a smaller scale flat-bed grinder as well as a small motorized wet-belt sander, or linisher.

The flat-bed grinder, or 'flat lap' will enable you to grind the bottom, or any flat surfaces, of a glass piece to a completely flat plane. A flat-bed grinder consists of a fairly heavy horizontal flat metal disc, a little like a turntable, which revolves with either a water-fed slurry of carborundum dripped onto it, or a diamond pad placed onto it. Glass held on this flat surface is ground flat by either the carborundum or diamonds. It is very useful for grinding large areas of glass to a uniform level, and is often the precursor to highly polished flat face on a piece of glass. The different grades of carborundum or diamonds can be used on the flat bed, with the aim of working through to a polish. Flat-bed grinders can come in many sizes, from a small tabletop version with a diameter of about 150mm to a large and heavy 600mm diameter or more. Obviously, the larger the scale you work in or the bigger the area you want to grind or polish, then the larger the flat-bed you will need.

It is also possible to hand-lap glass objects, by simply moving your glass piece backwards and forwards over a surface which is loaded with varying size grits and water. Clearly, this takes much more time, but is an option when budgets are limited. Set up a hand-lapping station by laying out four or so glass sheets, say 300mm square, depending on the size of the glass you want to grind. Sprinkle each of

A flat-bed grinder (Courtesy Liquid Glass Centre).

A hand-lapping station.

these with grits, one with an 80 grit, one with 220 grit, and one with 400. Puddle the grits with some water, and apply the surface of the glass which you want to grind face down onto the grit. Hold firmly and move around the glass sheet in a circular motion until the piece is ground to your satisfaction. Move up the grits as necessary, remembering to wash off the previous grade of grit each time.

BELT SANDER OR LINISHER

A wet-belt sander, or on a larger scale a linisher, grinds glass in much the same way as a flat-bed grinder, but on a different plane and over a different surface, using carborundum or diamond belts. It works by means of a motor driving two drums lined up vertically, one above the other, with a belt suspended between the two. The belt revolves vertically in a continuous manner and grinds or polishes the glass as it is applied. Again, the belts are fed through or sprayed with water to keep the process wet. The smaller tabletop machine, which has a belt width of about 50–70mm, is used mainly for grinding or polishing the edges of sheet or fused glass, but can be good for the edges of deep-fused blocks of glass, or slabs of glass cast into open-faced moulds.

A belt sander or linisher is best used for grinding and polishing straight edges – it works on a flat vertical plane, and often has a runner back plate to push against, so tends to be used for flat edges, although it is possible to grind/polish in the round with some practice. The great convenience of a wet-belt sander or linisher is the ease with which belts can be changed

A linisher.

Working glass on the linisher.

A lathe for glass working.

to work up the grades for grinding, changing to cork for polishing. On the larger scale a linisher can grind and polish edges on pieces of kiln-cast glass up to 100–200mm or more.

GLASS LATHE

A glass lathe will enable you to work with grinding and polishing wheels to finish a glass piece, or to use a decorative technique called wheel 'cutting' or wheel engraving. For grinding and polishing, various grades of wheel are available, with diamond wheels proving very popular recently for their speed of cutting. Polishing is achieved by using cork or felt wheels with pumice or cerium. We will look at the decorative possibilities of wheel engraving shortly.

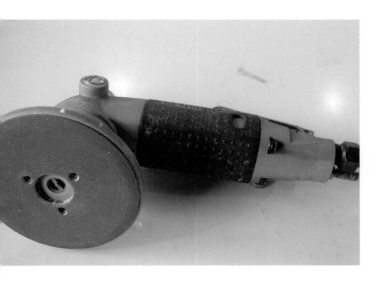

A hand-held grinder or air tool.

HAND-HELD DISC GRINDER

One of the most useful tools for grinding and polishing larger glass pieces is a hand-held disc grinder, or air tool, which is similar to a metal angle grinder in appearance. This is often driven by compressed air, with a variable speed trigger, and is a reliable hard-working tool. It is water fed, with diamond discs

Polishing glass using air tool (Courtesy Liquid Glass Centre).

fitted on to the grinder, again varying in grades, right through to polishing pads. When used with diamond pads and discs this machine is ideal for removing sharp edges, grinding and polishing glass. The great advantage is that it is hand held, and can be 'taken' to the glass piece, rather than the glass needing to be held or processed at a larger machine. This means it works particularly well for polishing large kiln-cast glass objects. The size of the grinding/polishing head – about 100mm – also means that it can work over larger, curved glass surfaces. As with other glass processing, diamond pads are fitted to the machine and grades worked through, until a final polish with a felt pad and cerium is achieved.

OTHER GLASS PROCESSES

The following processes can be used on glass either prior to or after firing and so are not strictly finishing techniques but simply other methods which can be applied to the glass involving cutting or abrasion. They are often used for practical purposes, such as making holes, or for decorative reasons, such as engraving.

Drilling

Drilling glass creates holes in the glass, and can be useful for a number of reasons – to create a means of hanging glass, for applying other types of fixings, to create small discs or cores of glass and many more uses. Drilling can be performed on sheet glass before it is fired, for instance on the glass for a fused project, to create holes which will 'round off' after firing. Glass can also be drilled after it has been fired, but great care must be taken that the glass does not shatter.

Again, glass drilling machines are available in a variety of sizes, from a tabletop version to a full size floor drill. They are fitted with a diamond drill bit onto a chuck. Diamond drill bits come in many different sizes and shapes but are primarily of two basic styles – blunt nose bits and core drill bits. Since blunt nose bits drill out the complete hole, they are only effective for smaller holes up to about ⅜in. Diamond core drill bits saw a circle at the edge of the tip rather than the full diameter, which results in a hole the size of the tip and a smaller 'core' that comes from the middle of the hole. These are much quicker at drilling bigger holes. Sometimes they are used primarily to create a large core, or disc of glass, for instance on a

Glass core drill bits
(Courtesy Liquid Glass Centre).

piece of fused glass to create a small disc for jewellery making or fusing on to other projects.

As with all other glass processes, the procedure must be performed wet, and a water-fed chuck on the drill head is common for cooling the glass. As a very basic way of drilling, a hand-held rotary or flexi-pendant drill can be used with smaller blunt-nosed drill bits. It should be remembered when drilling glass that the drill bit should be revolving fairly slowly. If it is drilling too fast then the drill bit and diamonds will be damaged, the hole will not cut, and you may crack the glass. It can be a slow process which requires patience. You should view glass drilling not so much as drilling but grinding the glass away.

The procedure for drilling glass is as follows.

Safety note: *Always make sure you are wearing protective gloves and safety glasses when processing glass.*

If a hole is required to pass through a piece of glass completely, for example through sheet or fused glass, if at all possible the glass is always drilled from both sides, so that the two holes meet in the middle and make a complete hole. Sometimes this is not possible, but it does ensure that the glass does not chip or even break as the drill emerges through the back of the glass, which can often happen.

The position of the hole is marked with a permanent marker on both sides of the glass, lining up as accurately as possible. The glass is placed on a block or piece of wood on a surface under the drill head, and held securely. The drill bit is applied to the marked area, and gentle pressure applied to the drill head so that it starts to cut into the glass. Water should be feeding through the drill chuck into the drill bit, if you are using a water-fed bit, or if you are manually applying water you should make sure that it is in constant contact. Keep raising the drill bit clear of the cut every so often to clear the hole of glass debris (a solution of glass dust and water).

Safety note: *If at any point the drill bit gets stuck in the hole and starts to pull the glass in a spinning motion, pull your hands back out of the way of the glass and let it spin – it is safer to let go.*

When you have drilled approximately halfway through the glass, remove, turn over, and drill again from the reverse side, on the mark you made earlier. At some point soon you will feel the drill bit reach the other half of the hole. Be careful to hold the glass sheet firmly at this point – you have finished drilling the hole.

If you are then fusing the glass you will find that the rough edge of the hole rounds over during the firing process. If you are drilling a hole as a last procedure on the glass, then it may

GLUING GLASS

Another aspect of working with glass is the occasional need to glue elements of glass to metal, to fittings, or to other pieces of glass. This can facilitate elements of presenting work, such as hanging or joining, or become part of the piece itself, such as laminating glass together to join elements to make a final piece. There are many glass glues available which serve different purposes according to the application you are intending. However, just as we have seen that glasses with different co-efficients of expansion cannot be joined together by kiln-forming without causing stress, it is very difficult to join glass with different rates of expansion, or to another material like metal, with a rigid glue, as this too can cause strain and eventually result in cracking.

Here are some of the properties and uses of various glues.

SILICONE

Silicone sealant can be used to join glass together, and is very effective as it is flexible and will not cause expansion problems, so can be used to join glass to other types of glass, and metal. Its disadvantages are that it is very viscous, and therefore does not give an 'invisible' join, as the silicone is usually evident. It is also translucent, and can yellow over time.

EPOXY

Epoxy has the advantage of being very strong, and can come in very clear varieties, which would be suitable for joining glass to retain optical properties. A truly transparent adhesive is a two-part epoxy called Hxtal. As with many epoxies, the two parts need to be weighed out carefully before mixing. Epoxy is often used for gluing fused glass jewellery elements to metal findings. One of the disadvantages of epoxy is that it can sometimes be too strong, when used to glue glass to metal or other glasses, for example, and can cause stress.

UV GLUE

Another type of adhesive used for glass is the ultra-violet curing adhesive, known as UV glue. It requires a portable UV lamp or direct sunlight to cure. Again, this has good clarity, and can be very strong, so is suitable for retaining optical properties in the glass. It can also cure quite quickly, when using a UV lamp. Again, compatibility issues can be a problem. A disadvantage is that opaque or blue and green glass, or any metal or fittings, can block the UV light, so this needs to be taken into consideration, with at least one side of the assemblage allowing transmission of light. Another option is to use an ultra-violet glue with a separate activator, which can be mixed in, like a two-part glue, negating the need for UV light.

HYBRIDS

Some of the most successful glues to use for glass are 'hybrid' glues, such as UV glues with high elasticity, whose properties are similar to the effect of mixing UV glue, with its clarity and strength, with the flexibility of a silicone glue.

Applying UV glue.

Drill with water-fed chuck (Courtesy Liquid Glass Centre).

Glass engraving rotary tool (Courtesy Liquid Glass Centre).

need a final finish with a small reaming drill bit on a hand-held flexi-drill. Remember when fusing glass with pre-drilled holes that they will need to line up as the glass is stacked, and must be at least 3mm in diameter to stop them closing as the glass flows when fused.

Engraving

Engraving is one of the most ancient techniques for decorating glass, practised since at least the Roman period to a high degree of craftsmanship. The tools for engraving have changed very little over the centuries, only shifting with the advent of a motor to power the equipment.

The simplest engraving, using diamond or tungsten steel 'points', cuts into the surface of glass to make an engraved design using a stippled effect. It has been practised with some skill since the sixteenth century. More recently, engraving with a flexi-drive pendant or hand-held rotary motor using burrs, or small tungsten or diamond bits, has extended the range and quality of surface engraving on glass. The portability

Hole in glass after drilling.

Glass cutting using lathe.

**Selection of glass grinding wheels
(Courtesy Liquid Glass Centre).**

of the hand-held tool means that a free-hand approach can be taken with respect to the decoration of the glass surface. Water is used to lubricate the glass surface as it is worked on, and the wide variety of burrs available gives an extensive array of textural and mark-making effects, from fine, delicate marks to larger scale cutting. Rubber, silicone or felt polishing burrs and wheels with cerium oxide or pumice can be used to polish the cut surfaces.

Copper-wheel engraving uses a copper wheel mounted on a lathe to engrave glass. It was established in Germany and Holland in the fifteenth and sixteenth centuries, and produces line effects and deep cutting on the glass surface. Carborundum or alumina is fed into the wheel to create the abrasive action. Diamond or abrasive wheel cutting, using a lathe, is similar to copper-wheel engraving, in that the glass is applied to the wheel as it rotates on the lathe, but uses larger wheels made from resin-bound carborundum or diamond-impregnated belts. It can be used variously to cut, grind, polish and decorate the glass surface.

Sandblasting

Sandblasting is an industrial glass process, developed in the late nineteenth century, which uses compressed air to force an abrasive grit out through a sandblasting gun against the surface of glass, making an abraded, matt effect. The speed of the abrasive particles chips away tiny, precise bits of glass from the surface of the glass being blasted. The process is performed inside a sandblasting cabinet, to contain the grit and dust which is produced. Contrary to the name of the technique, sand is not used for the process; silicon carbide (carborundum) or aluminium oxide is used as a blasting material.

When sandblasting, it is possible to achieve an even matt surface over the entire piece of glass, which can be of varying fineness, according to the grit size used – the finest gives a silky smooth sandblasted surface, the coarser a rougher surface. Some glass artists use the sandblaster's ability to remove glass fairly evenly over a large area to sculpt or decorate the surface. Silicon carbide works better as a grit for sculpting the surface of the glass, as it 'bites' into the glass more effectively.

Sandblasting cabinet (Courtesy Liquid Glass Centre).

Sandblasting on glass billets for casting.

masked and sandblasted areas. If you want to achieve this effect, make sure you do not fire the glass too high, at full fusing temperatures for instance, as this will liquefy the glass and the sandblasted pattern will largely disappear. For precisely this reason you can use sandblasting with a very fine grit and re-firing to return a contaminated surface back to a fire-polished one.

Sandblasting the surface of glass can also allow uneven surfaces to be made uniform, can remove devitrification or fired-on batt wash. Sandblast these surfaces lightly with a fine aluminium oxide grit, which seems to work better than a silicon carbide grit, until the problem has been removed, and run the glass sandblasted side up through the fire polishing schedule in the Firing Schedules section. The surface which was sandblasted will become shiny and polished again. This technique should be used only to a limited extent, however, as although the fire polished surface is fairly shiny, it can never compare in terms of surface quality to firing successfully first time around.

A decorative effect for creating 'veils' in cast glass can be achieved by the use of sandblasting. This technique involves sandblasting the surface of larger pieces of glass-casting cullet, prior to loading in the mould or reservoir for casting. The sandblasted surfaces must be positioned faced against or sandwiched with another piece of cullet, to 'trap' the sandblasted surface against the glass as it melts. When the glass

The surface of the glass can be masked with a resist material such as masking tape, sticky-back plastic or PVA glue allowed to dry out, to protect areas which are not to be treated. This masking effect also gives the glass artist possibilities for decorative effects using the contrast between the masked, polished glass surface and the unmasked matt surface. The intensity of the blasting can also be used to create textural effects, as well as varying the grit sizes used.

Decoration on the surface of glass can often be used to create effects in the glass prior to tack fusing or slumping and casting. A decorative sandblasted surface on fused glass, which is then used for slumping, will create an interesting contrast of shiny and slightly matt surfaces between the

Sandblasted decorative effects on glass which have been fused afterwards.

reaches top temperature and melts into the mould, minute pockets of air are trapped between the layers of glass, creating a veil, or floating plane of bubbles within the cast glass matrix. With experimentation and testing it is possible to control this effect when casting glass, and create another interesting decorative device within the glass. The technique can also be used to create bubbles within fused pieces of glass.

Safety note: As the sandblasting cabinet door is opened dust will escape from the cabinet, so wearing a mask is essential when loading and unloading glass.

WATERJET CUTTING

A recent development in cold-glass processing has been the advent of waterjet cutting technology. This technique is used to cut shapes from glass which would otherwise be impossible, by means of a jet of water mixed with an abrasive at high velocity and pressure.

The physical action of abrasive waterjet cutting is a form of erosion using only water and an abrasive – usually aluminium oxide or garnet. Garnet, the hard sharp grains found on common sandpaper, flows into the water stream and through a ceramic nozzle at high velocity. The water and abrasive slurry quickly erodes the glass along a set line, with a cutting width of about 0.5–1mm.

Waterjet cutting is considered a 'green' technology as it produces no hazardous waste, no dust or contaminants, and the cutting materials used in the machine are re-used.

Glass artists are now using the technology to create glass shapes and forms which are pushing forward the frontiers of decorative glass.

Vanessa Cutler's work is concerned with pushing forward the parameters of waterjet-cutting.

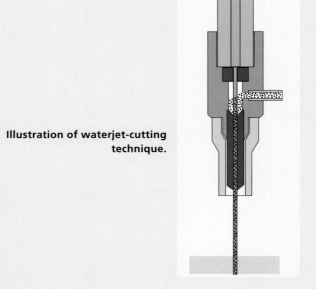

Illustration of waterjet-cutting technique.

'Interlocking Glass Comb' (Detail), 4mm float glass, waterjet-cut and kiln-formed.

After firing.

'Spinal Wave' waterjet-cut components set up in kiln.

Detail of slumping.

COLD-WORKING EQUIPMENT

We will now look at some possibilities for setting up cold-working or finishing equipment on different scales of size and affordability.

Small-Scale Setup

A small *glass grinder* will be useful for grinding the edges of glass as you are cutting it for assembling prior to fusing, but can also be used with other bits for contouring the edges of the glass, as well as drilling holes.

Some of the easiest and cheapest tools for cold-working will enable you to do some work on your glass piece, but will probably entail extra time on your part. Hand tools such as *diamond grade sanding blocks* are available, which will enable you to grind and smooth edges and small areas of glass, but will be of little use for polishing. For this you can try pumice or cerium oxide mixed with water as a paste on a hand-held felt pad, but progress will be very slow. A *hand-lapping station* will allow you to grind small areas of glass flat, and work towards polishing them if desired.

For much of the small-scale work such as grinding, polishing on very small areas or engraving, various tool bits can be used in a flexi-drive pendant or hand-held rotary motor tool. A small water-fed tile saw, which is also available as a budget version, will enable you to cut small (in depth) pieces of glass down to size. A kit for converting a standard pillar drill, as used for woodworking, is available, and consists of a *flushing head* chuck attachment which feeds water through the drill bits, and a water tray, and is a good budget option for setting up a glass-drilling facility.

Safety note: It is best to fit the electric pillar drill with a circuit breaker device.

Medium-Scale Setup

With these pieces of equipment you will be able to achieve more intricate cutting and slightly larger scale grinding and polishing on glass pieces. Difficult cuts in sheet glass or fused projects can be achieved with a *glass ring saw*. This is a mini-sized equivalent of a glass band-saw, and can make almost any shape, even sharp curves, possible in glass. A larger sized *tile* or *wet saw*, with a built-in table, which can be used either on a tabletop or freestanding, will enable you to make deeper cuts into and through glass.

A tabletop *wet-belt sander*, which is the smaller equivalent of a larger linisher, consisting of a motor which drives a belt, can be used as an edge-grinding tool, but with different belts can also be used to polish edges of glass. A smaller *flat-bed grinder*, with a metal disc of about 200mm as a grinding surface, can be obtained, which will grind smaller pieces of glass flat.

Some medium-scale pieces of glass equipment *combine several functions* – one such item combines an interchangeable 200mm flat-bed grinder, a glass saw, and an edge grinder into one piece of equipment. A table-mounted wet-belt grinder and polishing wheel combination can also be obtained.

Interestingly, although it is usually used for larger pieces of kiln-cast glass, a hand-held *water-fed disc grinder* is relatively inexpensive. As we have discussed, unlike most other medium to large scale tools, with the hand-held grinder you bring the tool to the glass, rather than the glass to the tool, and consequently the equipment is smaller and more cost effective.

With many of these medium-scale pieces of equipment, you may find that it is the diamond belts, drill bits and discs which are adding to the overall cost of buying, but they can be considered as an investment in terms of the effects you will be able to add to the glass and the quality you will be able to finish to.

Large-Scale Setup

Larger scale, full-size floor-standing *linishers* can be obtained, with belt sizes of around 2.5 metres. *Slab* or *lap-saws*, which are large diamond-bladed saws, and can saw glass up to around 400mm in depth, are also available. Full-sized glass *lathes* will allow you to polish with felt wheels, as well as cut or carve into glass with grinding wheels. In addition, *flat-bed grinders* with a plate size of up to 500mm, will enable you to grind very large glass pieces flat. The hand-held *water-fed disc grinder* also fits in well with this setup, as it is a useful, flexible tool for polishing large areas of glass. A *sandblaster* will also allow you to work with the decorative effects of surface abrasion over larger areas of glass.

Budget-Conscious

Cold-working and finishing equipment may seem like an additional drain on your budget for kiln-working glass, but they

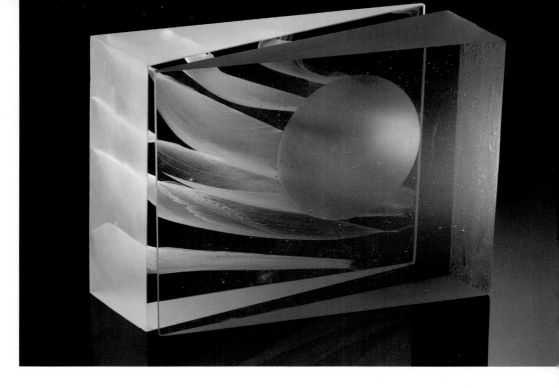

'Inner Ombrae', Fiaz Elson, 2008, kiln-cast optical glass with veils, cut and polished, L: 40, D: 9, H: 34cm.

will enable you to master other decorative techniques and finish your glass to a high standard. It is also worth remembering it is increasingly possible to obtain many pieces of equipment secondhand, although you may have to wait longer for bigger pieces. When looking for large-scale equipment for glass consider lapidary suppliers and masonry businesses, as much of the equipment is very similar.

The more budget you can put towards your glass coldworking and finishing equipment, the bigger the pieces of glass you will be able to work on, but it is worth remembering that it is also possible to achieve professional results on smaller pieces of glass with many cost-effective tools and processes.

IN CONCLUSION...

Kiln-forming can be an extremely rewarding method of working with glass. The techniques we have looked at in this book have shown the versatility of the material and will have given you insight into the intricacies of kiln-forming.

I hope this introduction will mark the beginning of a long working relationship for you with glass, one which will witness periods of discovery, trial, consolidation, and ultimately, great satisfaction.

Above all, fresh approaches and new techniques are developing all the time, and this contributes to the overall feeling of excitement and anticipation which many glass makers experience throughout their relationship with the material.

'Vortices', Helga Watkins-Baker, kiln-cast glass, L: 34cm, W: 25cm.

HEALTH AND SAFETY

Studio

Keeping a clean and tidy studio and using common sense go a long way to insuring safety in the glass-forming studio. Ventilate your studio well, keep dust levels to a minimum, and confine hazardous materials within a limited area.

Avoid eating and drinking in the studio area. Toxins and dusts are readily ingested when you handle food and kiln-working materials in the same space.

Wash your hands when leaving the studio and, if you cannot change clothes after a day in the studio, wear an apron whilst working.

Obtain and read the health and safety guidelines for all equipment used, as well as the material data safety sheets for all materials.

What follows is a common-sense guide to health and safety factors when following any of the techniques outlined in this book or when using any equipment mentioned.

Essential Basic Safety Equipment

- Safety glasses, preferably with side shields.
- Respiratory masks, approved to EN or NIOSH standards, and approved for specific processes: one designed to filter dust or particulates, one for fumes and vapours.
- Heat-resistant gloves, non-asbestos, made from Zetex or Kevlar.
- Surgical gloves to protect skin from irritating dusts or fibres.
- First aid kit.

Glass Preparation

Wear safety glasses when scoring, breaking and crushing glass. Gloves provide some protection against cuts but can hamper dexterity. Glass cuts are generally clean; wash and dress with a bandage.

Always wear a respirator when measuring or mixing dry glass powder. Powders may irritate the eyes, skin, and respiratory system. Be cautious of powders and frits from lead-bearing glasses – they may be both irritating and toxic. Once glass powder is mixed with water, dust will be contained.

Kiln

Always turn off the power before reaching into a hot kiln (e.g. during glass combing or other manual forming).

Operate kilns only in well-ventilated areas. Firings can release vapours and fumes from glazes and other materials.

Wear safety glasses when working with kilns. If you are looking into the kiln at your work while it is firing, wear glasses that protect your eyes from infrared (IR) radiation, to avoid the risk of eye damage due to prolonged exposure. Glasses with IR protection usually have a metallic gold coating.

Wear protective high temp gloves as you open the door to the kiln. Be aware that synthetic fabrics are dangerous at these temperatures – it is safer to be wearing cotton.

Wear an appropriate respiratory mask when mixing dry batt wash and when scraping fired shelves.

Wear an appropriate respiratory mask and gloves when handling ceramic fibre products, as they cause irritation of eyes, skin, and respiratory system, particularly when fibres are cut or torn.

After firing, fibre products readily release dusts that may be dangerous to breathe. Avoid contact with skin. Wear an appropriate respiratory mask and clean the residual fibres from the glass with running water.

Dispose of used materials in a sealed plastic bag. Thin fire kiln paper disintegrates into a dusty tissue on firing.

Vacuum out kiln using a HEPA filter vacuum or remove detritus from kiln shelf by saturating with water and collecting in a plastic bag.

Mould-Making

Always pour and mix dry powders away from your face, and work in a well-ventilated room. Wear safety goggles and a particulate filter respirator while mixing investment and while de-moulding moulds, and consider using local ventilation.

- *Plaster* is a skin, eye, and respiratory irritant. When mixed with water, this material hardens and then slowly becomes hot. DO NOT attempt to make a cast enclosing any part of the body using this material. Use a protective cream and/or gloves for skin and hands.
- *Silica* irritates the respiratory system and can cause significant damage. Wear an appropriate respiratory mask and consider using local ventilation.
- *Talc* is a respiratory irritant. Dusts may irritate the eyes. Wear safety goggles and an appropriate respiratory mask and consider using local ventilation.
- *Wax* when overheated and burnt is a respiratory irritant. There is no approved respirator that filters out all of the hazardous components present in wax vapours. Never leave melting wax unattended. Always have a lid available for the container you are melting in – it can be used to smother a smoking pot or fire. Never use water to extinguish a wax fire. The flash point of wax (i.e. the point at which it spontaneously turns into flames) can be anything above 150°C, so it is safest not to heat it above 100°C, and never directly over a hot plate.
- *Gelflex* when molten is considerably hotter than boiling water and will stick to the skin. Only heat in a safe manner, and handle with care using suitable gloves and eye protection. Prolonged skin contact with cool Gelflex should be avoided, and people with particularly sensitive skins should use barrier cream. Adequate ventilation is very important.

Cold-Working and Glass-Processing

Your eyes should be protected from the possibilities of flying chips of glass.

Ear protection should be used due to the loud high pitch sounds of the machines.

Do not wear any loose clothing.

Use water when grinding or polishing to keep tools and glass cool.

Use water when grinding or polishing to keep dust down. Clean up ground glass slurry while it is still wet to prevent it from becoming airborne.

When dealing with dry glass dusts and powders, wear an appropriate respiratory mask.

Wearing a rubber apron to protect you from the water spray is also highly recommended.

To deal with dust and fumes consider using local ventilation.

For further information on health and safety in the studio refer to *The Artist's Complete Health and Safety Guide: Third Edition* by Monona Rossol (Allworth Press, 2001).

FIRING SCHEDULES

These kiln firings have been written to accompany the projects contained in this book. They are intended for a digital controller. See the guide in Chapter 4 for guidance on programming your controller. If you do not have a digital controller then you will have to set temperatures/ramps manually throughout the firing. Remember, all kilns are different and these temperatures and timings may need some adjustment. Any prescriptive schedule which follows here is meant as a starting point. Your kiln will have variables such as its size and temperature reading, which will affect the desired results, so remember that you may need to adjust these firings. No guarantees can be undertaken in the results when using these firing schedules.

KILN-FIRING SCHEDULES FOR PROJECTS

AFAP= as fast as possible, i.e. whatever cooling rate results from the kiln power being cut off by the controller; Bullseye do not advocate crash cooling – leave your kiln closed, allowing it to cool naturally to the anneal soak temperature.
*This temperature assuming you are using Bullseye glass; if not, adjust the annealing temperature to the compatible glass you are using, and soak and anneal time depending on the size of your piece.
**Adjust according to the effect you want.

Firing Schedule 1: Float Glass Samples or Lattice Bowl (Fusing)

Ramp	**150°C/hr**	to **550°C**
Ramp	**999°C/hr**	to **820°C**
Hold at	**820°C**	for 20 mins depending on your kiln
Cool to	**550°C**	as fast as possible
Hold and soak at	**550°C** for	for 30 mins
Ramp	**150°C/hr**	to **200°C** then kiln off, cools on its own

Firing Schedule 2: Fused Tile or Kiln Carved Glass Platter (Fusing)

Ramp	**150°C/hr**	to **520°C**
Ramp	**999°C/hr**	to **760°C**
Hold at	**760°C**	for 30 mins depending on your kiln
Cool to	**482°C***	as fast as possible
Hold and soak at	**482°C***	for 30 mins
Ramp	**75°C/hr**	to **370°C**
Ramp	**150°C/hr**	to **200°C** then kiln off, cools on its own

Firing Schedule 3: Autonomous Panel

Ramp	**150°C/hr**	to **520°C**
Ramp	**999°C/hr**	to **760°C**
Hold at	**760°C**	for 30 mins depending on your kiln
Cool to	**482°C***	as fast as possible
Hold and soak at	**482°C***	for 60 mins
Ramp	**75°C/hr**	to **370°C**
Ramp	**150°C/hr**	to **200°C** then kiln off, cools on its own

Firing Schedule 4: Slumped Glass Bowl or Kiln Carved Glass Platter (Slumping)

Ramp	**100°C/hr**	to **680°C**
Hold and soak at	**680°C**	for 20 mins
Cool to	**482°C***	as fast as possible
Hold and soak at	**482°C***	for 60 mins
Ramp	**50°C/hr**	to **370°C**
Ramp	**100°C/hr**	to **200°C** then kiln off, cools on its own

Firing Schedule 5: Float Glass Lattice Bowl Slumping

Ramp	**150°C/hr**	to **700°C**
Hold and soak at	**750°C**	for 20 mins
Cool to	**550°C**	as fast as possible
Hold and soak at	**550°C**	for 60 mins
Ramp	**50°C/hr**	to **370°C**
Ramp	**150°C/hr**	to **200°C** then kiln off, cools on its own

Firing Schedule 6: Open Face Cast

Ramp	**100°C/hr**	to **650°C**
Hold and soak at	**650°C**	for 120 mins
Ramp	**200°C/hr**	to **800°C**
Hold at	**800°C**	for 60 mins depending on your kiln
Cool to	**482°C***	as fast as possible
Hold and soak at	**482°C***	for 240 mins
Ramp	**10°C/hr**	to **430°C**
Ramp	**20°C/hr**	to **370°C**
Ramp	**50°C/hr**	to **100°C** then kiln off, cools on its own

Firing Schedule 7: Simple 3D Cast or Hand Modelled Lost Wax Sculpture

Ramp	**100°C/hr**	to **650°C**
Hold and soak at	**650°C**	for 120 mins
Ramp	**200°C/hr**	to **850°C**
Hold at	**850°C**	for 90 to 120 min depending on your kiln
Cool to	**482°C***	as fast as possible
Hold and soak at	**482°C***	for 480 mins
Ramp	**5°C/hr**	to **430°C**
Ramp	**10°C/hr**	to **370°C**
Ramp	**25°C/hr**	to **100°C** then kiln off, cools on its own

Firing Schedule 8: *Pâte de Verre*

Ramp	**100°C/hr**	to **650°C**
Hold and soak at	**650°C**	for 120 min
Ramp	**150°C/hr**	to **760-800°C** depending on your piece/kiln
Hold at	**760–800°C***	for 30 mins depending on your piece/kiln
Cool to	**482°C***	as fast as possible
Hold and soak at	**482°C***	for 360 mins depending on your piece
Ramp	**25°C/hr**	to **370°C**
Ramp	**50°C/hr**	to **200°C** then kiln off, cools on its own

Safety Note: *Do not open the kiln until it is 50°C or less, and then only with the door cracked/ajar, making sure the kiln is switched off completely.*

The work can safely be unloaded when the kiln is off and the glass is at room temperature. In open moulds with large or thick work the kiln can be opened (under 50°C) and several layers of newspaper laid down on top of the glass. This will give some insulation to the face of the glass while it catches up with the mould, but it is not as safe as leaving the kiln closed for longer (down to room temperature).

OTHER KILN GLASS
FIRING SCHEDULES

All of the firings below assume you are annealing Bullseye glass – if not, adjust the annealing temperature to the compatible glass you are using.
*This temperature assuming you are using Bullseye glass; if not, adjust the annealing temperature to the compatible glass you are using, and soak and anneal time depending on the size of your piece.
**800°C for compatible glasses, 850°C for float glass

Fire Polishing

Ramp	100°C/hr	to 520°C
Ramp	999°C/hr	to 750°C
Hold at	740°C	for 5 mins depending on kiln or piece
Cool to	482°C*	as fast as possible
Hold and soak at	482°C*	for 30 mins depending on your piece
Ramp	100°C/hr	to 200°C then kiln off, cools on its own

Deep Fusing

Ramp	100°C/hr	to 520°C
Ramp	999°C/hr	to 750°C
Hold and soak at	750°C	for 60 mins
Ramp	999°C/hr	to 800°C**
Hold at	800°C**	for 60 mins depending on your kiln
Cool to	482°C*	as fast as possible
Hold and soak at	482°C*	for 240 mins depending on your piece
Ramp	10°C/hr	to 430°C
Ramp	20°C/hr	to 370°C
Ramp	50°C/hr	to 100°C then kiln off, cools on its own

Pot Melting

Ramp	200°C/hr	to 520°C
Ramp	999°C/hr	to 900°C depending on your kiln
Hold at	900°C	for 90 mins depending on kiln
Ramp	999°C/hr	to 820°C depending on your kiln
Hold at	820°C	for 30 mins
Cool to	482°C*	as fast as possible
Hold and soak at	482°C*	for 60 mins depending on your piece
Ramp	50°C/hr	to 370°C
Ramp	100°C/hr	to 200°C then kiln off, cools on its own

Pattern Bar

Ramp	150°C/hr	to 520°C
Ramp	999°C/hr	to 820°C
Hold at	820°C	for 20 mins depending on your kiln
Cool to	482°C*	as fast as possible
Hold and soak at	482°C*	for 90 mins depending on thickness of bar
Ramp	50°C/hr	to 370°C
Ramp	100°C/hr	to 200°C then kiln off, cools on its own

Kiln Casting

See Firing Schedules 6 and 7 above for smaller work.
 For larger work refer to the manufacturers' suggested glass firing schedules.

Freeze and Fuse

Ramp	**100°C/hr**	to **200°C**
Hold at	**200°C**	soak for 30 mins (this dries the glass)
Ramp	**200°C/hr**	to **720°C**
Hold at	**720 °C**	for 30 mins depending on kiln or piece
Cool to	**482°C***	as fast as possible
Hold and soak at	**482°C***	for 60 mins depending on your piece
Ramp	**100°C/hr**	to **200°C** then kiln off, cools on its own

Glass Combing

Ramp	**150°C/hr**	to **520°C**
Ramp	**999°C/hr**	to **900°C** depending on kiln
Hold at	**900°C**	for as long as you need to comb
Cool to	**482°C***	as fast as possible
Hold and soak at	**482°C***	for 60 mins depending on your piece
Ramp	**75°C/hr**	to **370°C**
Ramp	**150°C/hr**	to **200°C** then kiln off, cools on its own

MANUFACTURERS' SUGGESTED GLASS FIRING SCHEDULES

Many manufacturers now provide important information about the co-efficient of expansion of their glasses, as well as typical firing schedules. These can save valuable time in trial and error, but it is still important to remember that these are only a guide, as the conditions in your kiln, and even factors such as the type of slumping mould you use, will affect the final outcome. Absorb the information provided, but try to assimilate it into the conditions and environment of your projects and kiln. The following are suggested firings based on manufacturers' information.

Bullseye

TECHNICAL DATA
* Depending on colour/type of glass.
** Bullseye point out that the fitting of two different glasses is a function of both viscosity and expansion, not COE alone.
*** Bullseye changed their annealing temperature in 2009 from 516°C to 482°C for thicker slabs, as they discovered that strain was relieved more quickly at the lower temperature. Whilst you can still anneal at the old annealing temperature, using the new one will shorten firing times for thicker pieces. 516°C can still be used for thinner projects.

Co-efficient of Expansion = 90**

Strain Point	Annealing Point
436–493°C*	482°C (or 516°C***)

Bullseye recommend that firing schedules should be treated only as a point of departure. As we have already seen, the firing schedule is just one of many conditions and variables which can affect the outcome of a glass project. Bullseye use a fairly conservative approach to most firings. The following schedule is provided as an illustration of a typical schedule for the piece described. Their description of the stages of the firing process has been included as an illustration of their method—it may differ to those already provided in other sections of the book. For instance, Bullseye in this schedule fire a full fuse hotter for a shorter period of time, whereas for some it is felt that it can be preferable to fire cooler for a longer time, which is the method adopted in the project firing schedules.

BULLSEYE RECOMMENDED FIRING
First tack fuse firing of a piece composed of one layer of 4mm base glass and an application of frits and powders in a smaller top loading kiln with top, side, and door elements:

Initial heat/ Process soak
Ramp	**222°C/hr**	to **788°C**
Hold at	**788°C**	soak for 10 mins

Rapid cool/Anneal soak
Ramp	**AFAP**	to **482°C**
Hold at	**482°C**	soak for 60 mins

Anneal cool
Ramp	**55°C/hr**	to **371°C**

Final cool
Ramp	**AFAP**	to **21°C**

Full fuse firing of a 300mm diameter piece composed of two layers of 3mm Bullseye glass in a smaller top loading kiln with top, side, and door elements:

Initial heat/Pre-rapid heat soak
Ramp **222°C/hr** to **677°C**
Hold at **677°C** soak for 30 mins

Rapid heat/Process soak
Ramp **333°C/hr** to **804°C**
Hold at **804°C** soak for 10 mins

Rapid cool/Anneal soak
Ramp **AFAP** to **482°C**
Hold at **482°C** soak for 30 mins

Anneal cool
Ramp **83°C/hr** to **371°C**

Final cool
Ramp **AFAP** to **21°C**

Slumping schedule for the same piece (fused 300mm diameter piece composed of two layers of 3mm Bullseye glass):

Initial heat/ Process soak
Ramp **166°C/hr** to **638°C**
Hold at **638°C** soak for 10 mins

Rapid cool/Anneal soak
Ramp **AFAP** to **482°C**
Hold at **482°C** soak for 60 mins

Anneal cool
Ramp **55°C/hr** to **371°C**

Final cool
Ramp **AFAP** to **21°C**

Bullseye do provide a chart for annealing schedules for thicker glass, as used in deep fusing and box casting, when casting with sheet glass, frits or casting billets:

Thickness	Anneal soak time	Initial cooling rate	Initial cooling range	2nd cooling rate	2nd cooling range	Final cooling rate	Final cooling range	Total minimum time
mm	at 482°C	°C/hr	°C	°C/hr	°C	°C/hr	°C	
12 mm	2 hr	55	482–427	99	427–371	330	371–21	5 hr
19 mm	3 hr	25	482–427	45	427–371	150	371–21	9 hr
25 mm	4 hr	15	482–427	27	427–371	90	371–21	14 hr
38 mm	6 hr	6.7	482–427	12	427–371	40	371–21	28 hr
50 mm	8 hr	3.8	482–427	6.8	427–371	22	371–21	47 hr
62 mm	10 hr	2.4	482–427	4.3	427–371	14.4	371–21	70 hr
75 mm	12 hr	1.7	482–427	3.1	427–371	10	371–21	99 hr
100 mm	16 hr	0.94	482–427	1.7	427–371	5.6	371–21	170 hr
150 mm	24 hr	0.42	482–427	0.76	427–371	2.5	371–21	375 hr
200 mm	32 hr	0.23	482–427	0.42	427–371	1.4	371–21	654 hr

Spectrum

TECHNICAL DATA

Co-efficient of Expansion = 96

Strain Point	Annealing Point	Softening Point
476°C (+/–12)	513°C (+/–12)	680°C (+/–12)

These schedules are those recommended by Spectrum for fusing and slumping using the System 96 family of tested-compatible products. They point out that these are guidelines, not strict rules. Times and temperatures will vary with equipment and project size.

Full fuse firing of a piece up to 9mm thick:

Ramp	148°C/hr	to 624°C
Hold at	624°C	soak for 30 mins
Ramp	93°C/hr	to 743°C
Hold at	743°C	soak for 20 mins
Ramp	204°C	to 793-804°C depending on kiln
Hold at	793-804°C	until achieved desired effect
Ramp	AFAP*	to 510°C
Hold at	510°C	soak for 60 mins
Ramp	66°C/hr	to 425°C
Hold at	425°C	soak for 10 mins
Ramp	148°C/hr	to 38°C

Mid-fuse firing of a piece up to 9mm thick:

Ramp	148°C/hr	to 624°C
Hold at	624°C	soak for 30 mins
Ramp	93°C/hr	to 743°C
Hold at	743°C	soak for 20 mins
Ramp	204°C	to 760–788°C depending on kiln
Hold at	760–788°C	until achieved desired effect
Ramp	AFAP*	to 510°C
Hold at	510°C	soak for 60 mins
Ramp	66°C/hr	to 425°C
Hold at	425°C	soak for 10 mins
Ramp	148°C/hr	to 38°C

Tack fuse firing of a piece up to 9mm thick:

Ramp	148°C/hr	to 624°C
Hold at	624°C	soak for 30 mins
Ramp	93°C/hr	to 743°C
Hold at	743°C	soak for 20 mins
Ramp	204°C	to 732–743°C depending on kiln
Hold at	732–743°C	until achieved desired effect
Ramp	AFAP*	to 510°C
Hold at	510°C	soak for 60 mins
Ramp	66°C/hr	to 425°C
Hold at	425°C	soak for 10 mins
Ramp	148°C/hr	to 38°C

Slumping schedule for a piece up to 9mm thick:

Ramp	66°C/hr	to 148°C
Hold at	148°C	soak for 15 mins
Ramp	148°C/hr	to 593°C
Hold at	593°C	soak for 20 mins
Ramp	66°C/hr	to 657–677°C depending on kiln
Hold at	657–677°C	until achieved desired effect
Ramp	204°C/hr	to 510°C
Hold at	510°C	soak for 60 mins
Ramp	66°C/hr	to 425°C
Hold at	425°C	soak for 10 mins
Ramp	148°C/hr	to 38°C

Schedules for thicker pieces:

Up to 13mm:

Ramp	55°C/hr	to 150°C
Hold at	150°C	soak for 15 mins
Ramp	140°C/hr	to 570°C
Hold at	570°C	soak for 10 mins
Ramp	variable*	to 815°C
Hold at	815°C	until achieved desired effect
Ramp	AFAP	to 510°C
Hold at	510°C	soak for 90 mins
Ramp	55°C/hr	to 425°C
Hold at	425°C	soak for 10 mins
Ramp	150°C/hr	to 40°C

Up to 25mm:

Ramp	55°C/hr	to 150°C
Hold at	150°C	soak for 15 mins
Ramp	110°C/hr	to 315°C
Hold at	315°C	soak for 15 mins
Ramp	165°C/hr	to 570°C
Hold at	570°C	soak for 15 mins
Ramp	variable*	to 815°C
Hold at	815°C	until achieved desired effect
Ramp	AFAP	to 510°C
Hold at	510°C	soak for 120 mins
Ramp	4°C/hr	to 425°C
Hold at	425°C	soak for 15 mins
Ramp	5°C/hr	to 370°C
Hold at	370°C	soak for 10 mins
Ramp	140°C/hr	to 40°C

Up to 38mm:

Ramp	55°C/hr	to 150°C
Hold at	150°C	soak for 25 mins
Ramp	110°C/hr	to 315°C
Hold at	315°C	soak for 25 mins
Ramp	165°C/hr	to 570°C
Hold at	570°C	soak for 20 mins
Ramp	variable*	to 815°C
Hold at	815°C	until achieved desired effect
Ramp	AFAP	to 510°C
Hold at	510°C	soak for 180 mins
Ramp	2°C/hr	to 425°C
Hold at	425°C	soak for 15 mins
Ramp	3°C/hr	to 370°C
Hold at	370°C	soak for 10 mins
Ramp	28°C/hr	to 40°C

Up to 51mm:

Ramp	55°C/hr	to 150°C
Hold at	150°C	soak for 40 mins
Ramp	110°C/hr	to 315°C
Hold at	315°C	soak for 40 mins
Ramp	165°C/hr	to 570°C
Hold at	570°C	soak for 30 mins
Ramp	variable*	to 815°C
Hold at	815°C	until achieved desired effect
Ramp	AFAP	to 510°C
Hold at	510°C	soak for 240 mins
Ramp	1°C/hr	to 425°C
Hold at	425°C	soak for 30 mins
Ramp	2°C/hr	to 370°C
Hold at	370°C	soak for 30 mins
Ramp	10°C/hr	to 40°C

*This rate varies based on what you want to accomplish. For instance, heat faster to fire polish, slower to minimize air bubbles.

Gaffer Casting Glass

TECHNICAL DATA

Co-efficient of Expansion = 92

Strain Point	Annealing Point	Recommend Casting Temperature
400° C	460°C	780° C–850° C

Gaffer produce a glass specially designed for casting which has a low viscosity at casting temperature. Their suggested annealing schedule, again, should be used as a guide only:

Thickness	Anneal soak time	Initial cooling rate	Initial cooling range	Second cooling rate	Second cooling range	Final cooling rate	Final cooling range	Total elapsed time
mm	at 440°C	°C/hr	°C	°C/hr	°C	°C/hr	°C	mm
12 mm	1.0 hr	67	440–368	133	368–318	670	318–24	2hrs 53mins
19 mm	1.5 hr	29	440–360	58	360–310	290	310–24	6hrs 6mins
25 mm	2.0 hr	16	440–353	32	353–303	160	303–24	10hrs 44mins
38 mm	3.0 hr	7.2	440–330	14.4	330–280	72	280–24	25hrs 30mins
50 mm	4.0 hr	4.3	440–312	8.6	312–262	43	262–24	45hrs
60 mm	5.0 hr	2.9	440–296	5.8	296–246	29	246–24	71hrs
75 mm	6.0 hr	1.8	440–273	3.6	273–223	18	223–24	124 hrs
88 mm	7.0 hr	1.4	440–253	2.8	253–203	14	203–24	168 hrs
100 mm	8.0 hr	1.0	440–234	2.0	234–184	10	184–24	255 hrs
113 mm	9.0 hr	0.9	440–214	1.8	214–164	9	164–24	302 hrs
125 mm	10.0 hr	0.7	440–195	1.4	195–145	7	145–24	412 hrs
138 mm	11.0 hr	0.6	440–175	1.2	175–125	6	125–24	510 hrs
150 mm	12.0 hr	0.5	440–156	1.0	156–106	5	106–24	648 hrs
200 mm	16.0 hr	0.26	440–78	0.52	78–24	-	-	1488 hrs

FIRING LOG RECORD

Included here is a blank firing log for you to photocopy for
your own use when keeping records of your firings.

**Temperature
Conversion**

Kiln Used	Date	Glass Used	Colours	Thickness

Start Time	Aims

End Time	Firing Schedule	°C/hr	to	°C	Hold

Kiln Preparation Position in Kiln	
	Results

Notes	Drawing/Photo

Centigrade °C	Fahrenheit °F
100	212
110	230
120	248
130	266
140	284
150	302
160	320
170	338
180	356
190	374
200	392
210	410
220	428
230	446
240	464
250	482
260	500
270	518
280	536
290	554
300	572
310	590
320	608
330	626
340	644
350	662
360	680
370	698
380	716
390	743
400	752
410	770
420	788
430	806
480	896
490	914
500	932
510	950
520	968
530	986
540	1004
550	1022
560	1040
570	1058
580	1076
590	1094
600	1112
610	1130
620	1148
630	1166
640	1184
650	1202
660	1220
670	1238
680	1256
690	1274
700	1292
710	1310
720	1328
730	1346
760	1400
770	1418
820	1508
830	1526
840	1544
850	1562
860	1580
870	1598
880	1616
890	1634
900	1652
910	1670
920	1688
930	1706
940	1724
950	1742
960	1760
970	1778
980	1796
990	1814
1000	1832

PROBLEMS AND TROUBLESHOOTING

There are so many variable factors in the kiln-forming of glass that it is inevitable that you will come across technical problems at some point. What follows is a selection of discussions on some of the most common problems, but it is by no means all-encompassing.

For further technical help it can be useful to refer to glass manufacturers' websites, as they contain much information about the properties of individual glasses and problems which the kiln-former might encounter. There are also many useful online discussion forums focused on technical issue for kiln formers. Refer to the section Resources for further information on these.

Colour

If the colour of the glass you are using has completely *changed after a firing*, then you have used a 'striking' glass. This is a glass that contains very small particles of certain metals which, when they reach a certain temperature in the kiln, react and radically change colour. The colour usually becomes deeper and more intense. The colours associated with this are reds and oranges, as well as some opaque glasses. A slightly tinted sheet of compatible glass can, for instance, strike to red after firing. All such glasses sold at suppliers should be marked as 'striking', and you should make sure that you mark any of this glass if you divide it up so that you are aware of this in any future use.

Sticking

Sometimes kiln or batt wash, or even kiln paper, *sticks* to the underside of the glass. This can depend on the type of glass being fired. Some opaque glasses tend to pick up batt wash more readily. If batt wash is sticking regularly to the underside of your glass, you should consider applying fresh coats, and firing at a lower temperature, or soaking for a shorter time at top temperature. You can also try a different type of kiln wash, to test if the wash itself is at fault. To remedy a continuing problem, fire on kiln paper. Although some kiln papers can stick to certain glasses, they simply wash off with water.

If you have batt wash stuck to a glass piece and want to *remove* it, abrade the surface under water with some fine steel wool, which should remove it. If particularly stubborn, soak for a day in water with some vinegar added, and try abrading again. If you have batt wash that will simply not shift, the only solution is to sandblast the surface away. This will change the appearance of the piece, but it is the only remaining remedy.

Glass sticking to a *slumping mould* indicates either that you have not batt washed the mould prior to firing, or that the batt wash has deteriorated and you need to apply fresh coatings.

Shape

If, when fusing, your glass piece is *misshapen* or has *flattened out* more than you wanted it to, you have over-fired it, i.e. fired too high a temperature or for too long.

If the edges of fused glass have *not rounded* sufficiently, then you need to soak for longer at top temperature or take to a slightly higher temperature. You also need to ensure you are using a sufficient volume of glass to get a rounded edge – two layers of 3mm glass, for instance, round over more successfully than two layers of 1.5 mm glass.

Over-firing thin sheet glass can cause the glass to *pull in* and *contract* in shape. Soak for a shorter time, or lower the top temperature.

Cracking

Glass cracking after taking out of the kiln could be caused by *thermal shock*, i.e. you took it out of the kiln too soon – make sure it is at least under 50°C, or preferably wait until at room temperature.

Cracking could also be caused by *insufficient annealing* – allow a longer soak at annealing temperature, and/or longer cooling through the transformation range.

If your sheet glass cracked in the kiln, on the way up to top temperature, it will have an *'S' shaped* curve, which will have become softened by the firing – this can be rectified by slowing down the heating ramp.

If the crack *follows a line* where two colours of glass meet then the two pieces are incompatible.

Cracks around *inclusions*, such as metals, also indicate incompatibility, i.e. they have not contracted at the same rate as the glass and have caused stress.

Bubbles

Bubbles in glass can sometimes be caused by heating too quickly between 700°C and the final fusing temperature. Fire more slowly through this stage to allow air to escape.

Air can also be trapped by the physical placement of inclusions such as stringers etc. If you have uneven placements of inclusions between layers such as metal, stringer, frit or little pieces of glass, think about escape routes for the air, by placing inclusions so that they have contact with the edges of the assemblage. If you have an enclosed design then there will be no way for the air to escape.

You can also consider placing a 'prop' between two layers to create a vent. A tiny scrap of glass of the same colour can be placed at the edge of a project, between two layers, lifting the upper layer to allow air to escape. This 'prop' should be invisible in the final, fired piece.

For similar reasons, when fusing or slumping, air can sometimes become trapped between the glass and kiln shelf or slumping mould, creating a large bubble on the *underside* of the glass. Interestingly, as kiln products get better at leaving smoother glass surfaces, they also leave less space between the bottom of the glass and the separator around the edges, causing air to be trapped. Make sure the very small holes, which can be found in the bottom of most slumping moulds, are not blocked. Otherwise, prevent this problem by holding at around 700°C for 20–30 minutes during the heating phase. At this temperature the glass is still stiff enough to retain its shape and the air will have time to find another avenue of escape.

Devitrification

Devitrification is a term which is used generally to describe an effect on the surface of kiln-formed glass which resembles a hazy 'bloom' or surface crazing, or sometimes opaque wrinkles. It can be the result of the structure of the glass breaking down into crystalline solids and thereby losing its shiny, fire-polished surface. It is also often used as a term to describe other deposits on the glass surface which appear after firing, such as a haze from the binder in kiln paper. We will look a number of causes and cures for this effect:

- If glass is kept at high temperatures – above 800°C – for too long, it will begin to crystallize, so keep the top soak of your kiln-firing schedules to the absolute minimum length of time you can for the effect you desire.
- Make sure glass is very clean before firing. Dust, oils and other contaminants can cause a devitrified effect on the surface of the glass when fired. Similarly, make sure the inside of your kiln is kept free of dust.
- Tin bloom can occur on the tin side of float glass, and can be detected with a UV light. To avoid tin bloom, fire the glass tin side down.
- Substances which burn off during firing in the kiln, such as glass glue, kiln fibre binder or substances in inclusions, can leave deposits on the glass. Try venting the kiln when you are firing up to top temperature, or pre-fire kiln fibre or paper if you are experiencing this problem when using them. Test other substances and glues to find the cause of other problems.

- A hazy, wrinkled surface on the glass in an open-cast mould can be an indication of firing the glass too hot for too long – the glass which was in contact with the sides of the refractory mould has started to pull into the top surface. Fire at a lower top temperature, or soak for a shorter time.

Devit spray is a product often used to overcome some of the problems highlighted above. It is made from a solution of borax, which is a substance often used as a glass flux, and is sprayed onto the surface of glass prior to firing. It can help prevent devitrification from forming, but does coat the glass with a layer of the flux, which is more likely to deteriorate over time than a true glass surface. It should not be a substitute for firing correctly or rectifying any of the problems above.

Casting

If air is trapped in a mould, you will find *pockets* or *voids* in the mould with no glass in them, and sharp surfaces on the glass which was in contact with the interior of the mould. This can be remedied by adding more vents.

Sometimes, kiln-cast glass will come out of the mould with *depressions* or *wrinkles* which were not present in the original model. These are known as suckers, which are areas of the cast which were in contact with the inner mould wall, but then shrank away from it. They occur during the cooling process, while the glass is contracting. If the cast glass cools and contracts uniformly while it is all still fully liquid, then no suckers will form. However, suckers may form if there are thicker areas in the cast or areas that are likely to stay hot longer than other areas during the cooling process. Bullseye have researched this problem, and came up with a solution. Suckers can usually be prevented by combining two techniques: (1) by soaking the glass at about 680°C during the rapid cooling stage for about 3 hours, depending on glass piece; and (2) by incorporating a large reservoir into the casting, which will act as a heat sink – it will be the thickest part of the casting and therefore the last area to cool; this allows a meniscus, or skin formed by surface tension in the cooling glass, to form in the reservoir and not in the casting.

Fine, *crinkly lines* of glass rising from the surface of the cast glass, sometimes called 'flashing', are in fact the reverse impressions of hairline cracks in the mould. They are not usually a major problem, as they can be ground off and cold-worked to remove, unless you are looking for a good finish direct from the mould. If your mould has small cracks appearing after it has been fired, then you may have heated the mould too quickly in the initial heat range, as the mould comes up to around 300°C. The water is being forced from the mould at these temperatures, and can cause cracking as the inside and the outside of the mould mix are at different heats. Try slowing down the ramp slightly to alleviate this problem.

Large cracks in the mould indicate that it may be too hard and, as it reaches high temperatures in the kiln, its rigidity is causing it to fracture. The mould walls may be too thick, so try making them thinner, or you could try adding more silica to the mix to make the mould softer and more resistant to cracking at high temperatures.

ALTERNATIVE MOULD RECIPES

The following are some examples of alternative mould mixes which you might like to try. They are suitable for different situations, and it is worth testing them before you make final moulds. Percentages of material are listed first, with the equivalent parts for each material as an alternative.

Unless otherwise stated, use one litre of water for each kg of plaster – this makes a medium-thick mix, if you want something a little runnier use a little more water. The amount of water to use will vary slightly with the type of ingredients used, so again it is best to test a mix first.

Preferred form of silica is flint, but quartz and investrite can also be used.

Preferred form of plaster is potter's plaster, or fine casting plaster.

HT aggregate is a high alumina refractory substance.

Grog, also known as firesand and chamotte, is a ceramic raw material, available from pottery suppliers.

Fibreglass strands can be added to any mixes to add strength if needed.

Standard Mix
50% plaster = 1 part plaster
50% silica = 1 part silica
Plus one tablespoon of fibreglass strands per litre of water used

Safety note: Read the Health and Safety section and make sure you wear the appropriate respiratory mask.

Soft Mould Mix (good for *pâte de verre* etc)
60% silica = 1½ parts silica
40% plaster = 1part plaster
Plus one tablespoon of fibreglass strands per litre of water used

66.6% silica = 2 parts silica
33.3% plaster = 1 part plaster
Added to 400ml water per kg dry mix
Plus half tablespoon of fibreglass strands per kg of dry mix

Stronger Mixes (good for larger moulds)
40% plaster = 2 parts plaster
30% silica = 1½ parts silica
30% ludo, or pre-fired refractory mould, crushed = 1½ parts ludo

33.3% plaster = 1 part plaster
33.3% silica = 1 part silica
33.3% HT aggregate = 1 part HT aggregate

Inner Coat Mix
50% plaster = 1 part plaster
50% silica = 1 part silica
Added to 1 litre water per 1½kg dry mix

60% plaster = 1½ parts plaster
40% talc = 1 part talc

Outer Coat Mix
Use Standard Mix or

50% plaster = 1 part plaster
50% grog = 1 part grog

RESOURCES

SUPPLIERS/EQUIPMENT

4D Modelshop Ltd.
General modelling supplies, including plaster, clay, silicones, gelflex, foam, metal sheets and meshes
The Arches
120 Leman Street
London E1 8EU
+44 (0)20 7264 1288
info@modelshop.co.uk
www.modelshop.co.uk

B&H Services
Engraving supplies, burs, drills, mandrels and glass working equipment
Colin Hayward
B & H Services
PO Box 54
Cardiff CF11 7YQ
+44 (0)29 2023 1183
colin@bandhservices.co.uk
www.bandhservices.co.uk

Bohle UK Ltd
Glass cutting and processing machinery, bonding, fitments
Fifth Avenue
Tameside Park, Dukinfield
Cheshire SK16 4PP
+44 (0)161 342 1100
info@bohle.ltd.uk
www.bohle.de

Bullseye UK
Billets, powders, frits and other Bullseye products
The Square
Whaligoe, Ulbster
Caithness, Scotland, KW2 6AA
+44 (0)1955 651 742
karen@bullseyeglass.com
www.bullseyeglass.co.uk

Creative Glass Guild
Kiln forming glass supplier, tools, equipment
16 Whitehouse Street
Bedminster
Bristol BS3 4AY
+44(0)871 200 3389
sales@creativeglassguild.co.uk
www.creativeglassguild.co.uk

Creative Glass UK
Kiln forming glass suppliers, tools, equipment
Unit 12 Sextant Park
Neptune Close
Medway City Estate
Rochester
Kent ME2 4LU
+44(0)1634 735 416
email: creativeglassuk@btconnect.com
www.creative-glass.com

Dyson Precision
Refractory materials for kilns and furnaces, kiln furniture
Shelton New Road
Hartshill
Stoke-on-Trent ST4 6EP
+44 (0) 1782 711 511
enq@dysontt.com
www.dyson-precision.com

Ebor

Glass cutting and processing equipment

Gorrels Way

Trans-Pennine Trading Estate

Rochdale OL11 2PX

+44(0) 1706 863 600

general.enquires@ebor.co.uk

www.ebor.co.uk

Essex Kilns Ltd.

Manufacturer of kilns

Woodrolfe Rd

Tollesbury

Maldon

Essex CM9 8SE

+44(0)1621 869 342

sales@essexkilns.co.uk

www.essexkilns.co.uk

Gaffer Glass

Glass casting billets and powders

Unit 36

Limberline SpurEstate

Hilsea

Portsmouth P03 5DX

+44(0)2392 677 674

gafferglass@btconnect.co.uk

www.gafferglass.co.uk

Glasswork Services

Glass batch/pellets, glassblowing tools, polishing powders, wheels, UK agents for Kugler-coloured glass powders.

Unit 8

Broomhouse Lane Ind. Estate

Edlington, Doncaster

South Yorkshire DN12 1EQ

+44(0)1709 770 801

enquiries@glassworksservices.co.uk

www.glassworksservices.co.uk

Guyson International Ltd.

Manufacturers of blast finishing equipment

Snaygill Industrial Estate

Keighley Road

Skipton

North Yorks BD23 2QR

+44 (0)1756 799 911

info@guyson.co.uk

www.guyson.co.uk

Johnson Matthey

Glass enamels and lustres

Blythe Park Business Base

Sandon Road, Cresswell

Stoke-on-Trent

ST11 9RD

+44(0)1782 384100

www.glassmatthey.com

Kilncare

Extensive range of electric glass kilns, standard sizes or manufactured specification, also cold working tools and equipment

The Kiln Works

907 Leek New Rd

Baddeley Green

Stoke on Trent ST2 7HQ

+44(0)1782 535 915

sales@kilncare.co.uk

www.kilncare.co.uk

Laser Kilns

A wide range of kilns and control equipment for glass painting, fusing, slumping, casting and annealing

Unit C9

Angel Rd Works

Advent Way

London N18 3AH

+44 (0)20 8803 1016

info @laser-kilns.co.uk

www.laser-kilns.co.uk

Lead & Light

Glass supply, tools

35a Hartland Rd

London NW1 8DB

tel: 0207 485 0997 fax: 0207 284 2660

info@leadandlight.co.uk

www.leadandlight.co.uk

Liquid Glass Centre

Kiln forming glass suppliers, tools, equipment, kilns

Stowford Manor Farm

Wingfield

Wiltshire BA14 9LH

+44(0)1225 768 888

sales@liquidglassshop.co.uk

www.liquidglassshop.co.uk

Pearsons Glass Ltd
Kiln forming glass suppliers, equipment, tools
Maddrell St
Liverpool L3 7EH
+44(0)151 207 1474/2874
Unit 9, Lyon Way, Greenford, Middx UB6 0BN
+44(0)208 578 5788

65 James Watt Place, College Milton North, East Kilbride
G74 5HG, Scotland
+44(0)1355 230175
info@pearsonsglass.co.uk
www. pearsonsglass.co.uk

Plowden & Thompson
Specialist glass products for studio glass making, including soda glass rods, powders and chips
Dial Glassworks
Stewkins, Stourbridge
West Midlands DY8 4YN
+44()01384 393398
sales@plowden-thompson.com
www.plowden-thompson.com

Potterycrafts Ltd.
Clay, plaster, flint, fibreglass, glass enamels, kiln furniture
Campbell Road
Stoke-on-Trent
Staffordshire ST4 4ET
Tel: +44 (0)1782 745000
enquiries@potterycrafts.co.uk
www.potterycrafts.co.uk

Schott UK
Produces a range of special glass products
Drummond Road
Astonfields Industrial Estate
Stafford ST16 3EL
+44(0)1785 223 166
info.uk@schott.com
www.schott.com/uk

South West Industrial Plasters
63 Netherstreet
Bromham
Chippenham
Wiltshire SN15 2DP
+44(0)1380 850 616

Tempsford Stained Glass
Kiln-forming glass supplies
The Old School
Tempsford
Bedfordshire SG19 2AW
+44(0)1767 641014
info@tempsfordstainedglass.co.uk
www.tempsfordstainedglass.co.uk

Tiranti's
Sculpture supplies (gelflex, silicones, fibreglass strands, waxes, modelling tools etc.), metal foils and leaf
3 Pipers Court, Berkshire Drive
Thatcham, Berkshire
RG19 4ER
+44(0)845 123 2100
enquiries@tiranti.co.uk
www.tiranti.co.uk

Warm Glass UK
Fusing and dichroic glass supplier
5 Havyat Park
Havyat Road
Wrington BS40 5PA
+44(0)1934 863 344
info@warm-glass.co.uk
www.warm-glass.co.uk

SHORT COURSES

The Liquid Glass Centre
The Liquid Glass Centre in Wiltshire runs a year round programme of courses in glass making, including Fusing and Slumping, Kiln Casting and other kiln techniques, as well as hot-glass courses.
Stowford Manor Farm
Wingfield
Wiltshire BA14 9LH
+44(0)1225 768 888
info@lquidglasscentre.com
www.liquidglasscentre.com

North Lands Creative Glass

North Lands Creative Glass is situated in Lybster, a small fishing village on the North East Coast of Scotland. Through its programme of summer master classes, its annual conference and its residencies, North Lands aims to stimulate a lively exchange of ideas whilst also allowing time for reflection and action in a professional environment.
North Lands Creative Glass
Quatre Bras, Lybster
Caithness, KW3 6BN
+44 (0)1593 721 229
info@northlandsglass.com
www.northlandsglass.com

STUDIO AND EQUIPMENT HIRE

The Liquid Glass Centre

Hot Glass Hire, Sandcasting, Flat Glass and Casting Kilns, Cold Working equipment – flat bed, linisher, lathe, air tool, diamond saw, sandblaster, Lampworking equipment.
Stowford Manor Farm
Wingfield
Wiltshire BA14 9LH
+44(0)1225 768 888
info@liquidglasscentre.com
www.liquidglasscentre.com

IGF Studios

Large Kiln (2.5 x 1.5m), Small Kiln, Spaghetti Kiln, Glass Casting Kiln (Small), Glass Saw, Glass Drill, Laminating, Safety Break Coating
Integrated Glass Forming
31 Templar Road
Yate, Bristol BS37 5TF
+44(0)1454 880 892
mikerowe@igfstudios.co.uk
www.igfstudios.co.uk

National Glass Centre

Hot-glass studio, cold workshop – sandblaster, linisher, lathe, mould making area, kiln hire.
The Glass Studio
Liberty Way
Sunderland SR6 0GL
+44(0)191 515 5555
info@nationalglasscentre.com
www.nationalglasscentre.com

Lead & Light

Studio hire: bench, sandblasting and kiln facilities available.
35a Hartland Rd
London NW1 8DB
+44(0)207 485 0997
leadandlight@msn.com
www.leadandlight.co.uk

North Lands Creative Glass

Hot shop, kiln room, cold shop, finishing room.
Quatre Bras
Lybster
Caithness KW3 6BN
+44 (0)1593 721 229
info@northlandsglass.com
www.northlandsglass.com

GLASS ORGANIZATIONS AND SOCIETIES

Contemporary Glass Society

CGS is a non-profit making limited company by guarantee, founded with dual objectives of encouraging excellence in glass as a creative medium and developing a greater awareness and appreciation of contemporary glass worldwide.
CGS, c/o Broadfield House Glass Museum, Compton Drive, Kingswinford, West Midlands, DY6 9NS
+44 (0)1603 507 737
info@cgs.org.uk
www.cgs.org.uk

North Lands Creative Glass

North Lands runs programme of summer masterclasses, annual conference and residencies, aiming to stimulate a lively exchange of ideas whilst also allowing time for reflection and action in a professional environment.
North Lands Creative Glass, Quatre Bras, Lybster, Caithness, KW3 6BN
+44 (0)1593 721 229
info@northlandsglass.com
www.northlandsglass.com

Scottish Glass Society

The Society was established in 1979 to promote the development of the art and craftsmanship of glass-making in its many variations in Scotland and to advance the public appreciation of glass-making as an art form.

Scottish Glass Society
PO Box 29329
Glasgow, G20 2BA
email via website
www.scottishglasssociety.com

Cohesion Glassmakers Network

Originating in the North of England and sponsored by the City of Sunderland, Cohesion aims to assist and support glass businesses and practitioners to develop their skills, to create new opportunities and to promote the quality and diversity of their work to wider markets.

City of Sunderland, Office of the Chief Executive, Business Investment Team, Civic Centre, Sunderland, SR2 7DN
+44 (0)191 561 1219
anne.tye@sunderland.gov.uk
www.cohesionglassnetwork.org

Glass Association

Founded in England in 1983 at the Stourbridge College of Art, the Glass Association is a registered charity established to promote the understanding and appreciation of glass and glass-making methods, and to generally increase public interest in the whole subject of glass.

info@glassassociation.org.uk
www.glassassociation.org.uk

USEFUL WEBSITES

Bullseye Glass

Bullseye offers technical notes, tip sheets and much more on the education pages of their website.
www.bullseyeglass.com

Glass Messages

Internet-based community of glass enthusiasts.
www.glassmessages.com

Warm Glass

An important resource for information about glass fusing, slumping, kiln-forming, casting, and more.
www.warmglass.com

Fusenews

A voice for the fusing community focusing on creating valuable, accessible and unbiased information on the art of kiln-forming glass.
www.fusenews.net

Kiln-Formed-Glass

Information, technical tips, resources and discussion on all aspects of kiln-forming glass.
www.kiln-formed-glass.com

Cast Glass

A showcase and information website on kiln-cast glass.
www.castglass.co.uk

Dichroic Glass

News, information, help, advice and tutorials for glass fusing and dichroic glass.
www.dichroicglass.co.uk

Glass Facts

Everything you wanted to know, plus online tools – Firing Schedules, Casting and Pot Melt Calculators.
www.glassfacts.info

Glass Fusing Made Easy

A resource dedicated to fusing techniques and fused-glass related questions.
www.glass-fusing-made-easy.com

Kiln Glass

Articles and information on kiln-forming glass.
www.kiln-glass.co.uk

WorldArtGlass.Com

Guide to art glass information – links, articles, news and exhibitions – bringing together an array of sites from around the globe geared to all aspects of art glass: equipment and material, resources, education sites, fabrication in the glass studio and glass works.
www.worldartglass.com

Frit Happens

UK forum for bead making, lamp working, some warm glass.
www.frit-happens.co.uk

His Glassworks

Excellent site for cold-working information, carrying links to a wide range of glass polishing information and equipment.
www.hisglassworks.com

BIBLIOGRAPHY AND FURTHER READING

Beveridge, P., Domenech, I. and Pacual, E., *Warm Glass: A Complete Guide to Kiln-Forming Techniques – Fusing, Slumping, Casting* (Lark Books, 2008)

Bloch-Dermant, J., *G. Argy-Rousseau: Glassware as Art – With a Catalogue Raisonne of the Pâtes de Verre* (Thames & Hudson, 1991)

Bray, C., *A Dictionary of Glass* (A & C Black, 2001)

Clarke, K., *The Potter's Manual* (Chartwell, 2002)

Cummings, K., *A History of Glassforming* (A & C Black, 2002)

Cummings, K., *Techniques of Kiln-formed Glass* (A & C Black, 2002)

Halem, H., *Glass Notes: A Reference for the Glass Artist* (Franklin Mills, 2006)

Layton, P., *Glass Art* (A & C Black, 1996)

Rich, J.C., *The Materials and Methods of Sculpture* (Dover, 1989)

GLOSSARY

annealing process by which a glass object is, after forming in the kiln, cooled to a given temperature and stabilized to remove heat inequalities, and then gradually cooled down over many hours, in order to reduce strain and make it less likely to crack when subjected to changes of temperature (*see* transformation range).

art glass decorative glass, which may or may not have a function but which is essentially hand-made, often as one-off or limited edition pieces.

blowing process where glass is heated in a furnace to around 1100°C, at which temperature it maintains a molten state, and a blowing iron – a hollow steel tube – is used to gather the molten glass, which is then blown and moulded to the desired shape.

cane rod of multi-coloured glass, made up of smaller individual rods fused together, then stretched.

coeffecent of expansion measurement of the degree of expansion of glass as it is heated; often expressed as the last digit of the figure which represents the expansion, i.e. 0.000009 (or 9x10–6), multiplied by ten, which would be expressed as 90 COE.

cold-working generic term to describe techniques of working with cold glass, which include cutting, polishing, diamond-sawing and drilling.

compatibility degree to which glasses are compatible with each other, usually but not always reliant on having the same or similar coeffecent of expansion; many glass artists now understand that in order to be truly compatible glass must have the same or very similar *coefficients of expansion* and viscosity.

confetti shards of very thin glass, broken to create random shapes for decorative use when kiln-working.

copper-wheel engraving engraving using foot- or machine-powered small copper wheels coated with abrasive paste.

cullet waste or scrap glass which results from production of other glass techniques, and which can used for kiln-casting, i.e. melting into a mould.

cure to promote the hardening of a setting material, by an analogous process such as heating, or simply allowing time for a catalyst to react.

diamond point method of hand-engraving by scratching or stipple-engraving glass with a diamond-pointed tool.

devitrification process which changes glass into a crystalline material through very high heating; sometimes a similar effect can be caused by firing glass which has been contaminated with other substances.

enamels coloured opaque or transparent pigments composed of glass powder, metallic oxides and a flux, which are usually applied onto cold glass, then fired in a kiln so that they fuse into the surface of the glass.

engraving lines and patterns worked into the surface of glass using tungsten or diamond tools.

etching decorating the surface of glass articles by means of scratching with a diamond-point tool or treating with acid.

flux a material which helps glass flow more easily, by reacting with other materials in the glass to reduce the melting temperature; common fluxes are natural soda, sodium sulphate and potassium oxide.

frit granules of crushed glass, of varying size, from a grade similar to castor sugar through to granulated sugar, as well as coarser grades.

fusing process of firing glass in a kiln to a temperature where the glass softens enough to merge with other pieces of glass.

glass artificial material made by fusing silica, such as sand or flint, at a high temperature with an alkali, such as soda or potash; other materials such as lead can also be added to alter its qualities (*see also* lead crystal, soda glass).

inclusions any metallic materials, foil, wires, or any other substance embedded in the body of kiln-formed glass.

kiln insulated box, usually electrically powered, used for heating glass to high temperatures which enables a range of kiln-working techniques to be used.

kiln-casting process of heating glass pieces in a plaster/silica mould in the kiln until the glass runs into the mould and takes its form.

kiln-working techniques of forming glass which use a kiln, including fusing, slumping, kiln-casting and *pâte de verre*.

lead crystal glass containing a high proportion (about 25–45%) of lead oxide; lead softens the glass making it a good choice for kiln-casting, and also gives the glass greater weight, strength and brilliance, making it desirable for engraving and cutting.

lost mould refractory mould used for glass-casting, made from plaster and silica, which is sometimes referred to as a lost mould, since it is often broken to remove the glass cast.

lost wax technique for mould-making whereby a model of the final article is produced in wax, then invested in a plaster/silica mould before being steamed until the wax liquefies and is drained off; the cavity in the mould can then be cast with glass.

ludo mould mix which has been fired once already, and which has been crushed into small particles for re-use in a new mould recipe, or for packing into moulds against the surface of crushed glass to provide an insulative layer before firing.

mother mould plaster mould which acts as a jacket, and helps hold other mould materials in place or gives support.

mould hollow form containing a negative impression into which glass can be cast; usually made from a mixture of plaster and silica.

opaque glass glass which allows no or very little light to pass through its substance.

oxides metallic compounds which are used to colour glass.

pâte de verre (French for glass paste) casting technique in which powdered glass and a binder are loaded into or over a mould and then fired to fuse, giving a translucent and sometimes granular effect.

polishing process of finishing glass with rotating wheels or belts, using progressively finer abrasive pastes and powders, to give a high sheen finish.

ramp the rate of heating or cooling in a kiln over a certain period of time, i.e. 150°C per hour to 550°C.

sandblasting decorating technique in which a stream of compressed air is used to blast abrasive grit onto the surface of the glass, gradually removing glass and creating a diffused effect.

sculptural glass art glass which uses sculptural forms for expression.

separator substance commonly called batt wash, and made from alumina hydrate, which stops glass sticking to a ceramic mould or kiln shelf; other separators can be used, such as whiting or chalk, plaster and boron nitride.

slumping method of shaping glass by heating in a kiln until it softens enough to sag over or into a mould or other material.

soda glass type of glass in which soda, in the form of sodium carbonate, is used as the flux to bind the silica together; most kiln glasses are made from soda glass.

strain point the point at the bottom of the transformation range when cooling glass, at which the glass becomes solid and the molecules remain static; the strain point varies for each glass depending on the manufacturer, the constituent materials and the coefficient of the glass.

super cooled liquid substance which when cooled to its freezing point (or until it solidifies) does not revert back to a crystalline state but retains an amorphous structure.

tin side the surface of molten glass which comes into contact with a bath of molten tin during the production of float glass, depositing traces of tin or tin oxide metal on the surface of glass as it is removed from the molten tin bath; the opposite side of the glass is known as the 'air side'.

transformation range the range of temperature over which glass gradually transforms from a solid into a liquid, becoming less viscous as it becomes hotter; this range will be different for a particular type of glass (*see* annealing).

translucent glass glass which allows light to pass through, but which diffuses the light slightly.

transparent glass allows light to pass through without any significant diffusion or intervention.

viscosity refers to the degree of flow of glass: high viscosity refers to glass which is relatively thick and slow to flow, whereas lower viscosity refers to glass with increasing fluidity, flowing in a thinner stream and with faster movement; raising the temperature of glass usually reduces its viscosity.

INDEX

Page numbers in italics indicate illustrations.